Dalai Lama

Photographs by Manuel Bauer
1990–2024

Dalai Lama

Photographs by
Manuel Bauer
1990–2024

Edited by the Gaden Phodrang Foundation
of the Dalai Lama

Texts by Thupten Jinpa

Captions by Christian Schmidt

Scheidegger & Spiess

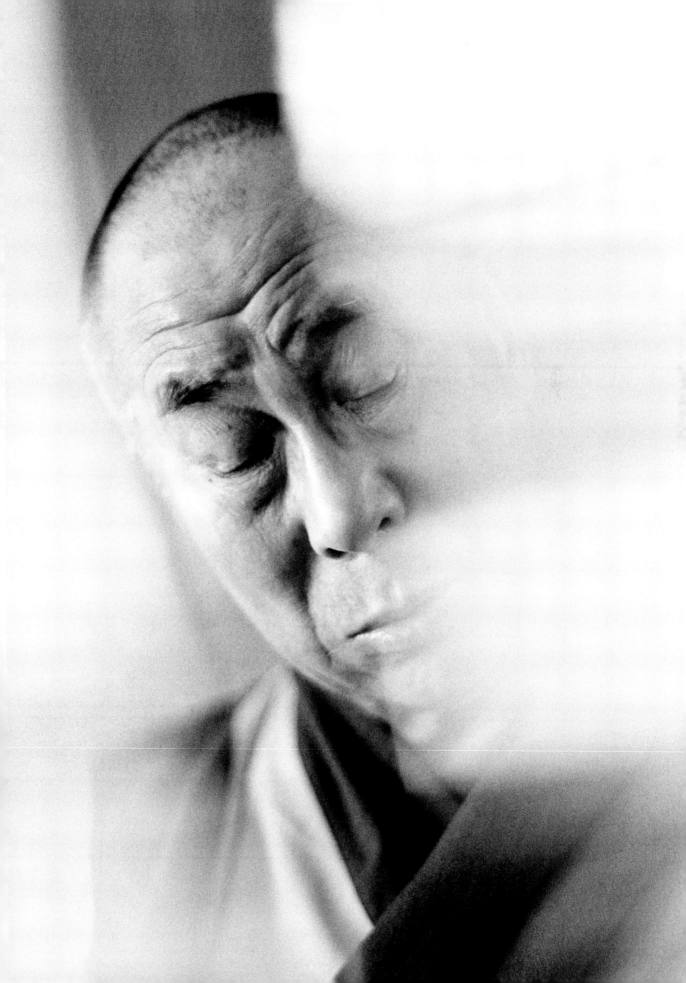

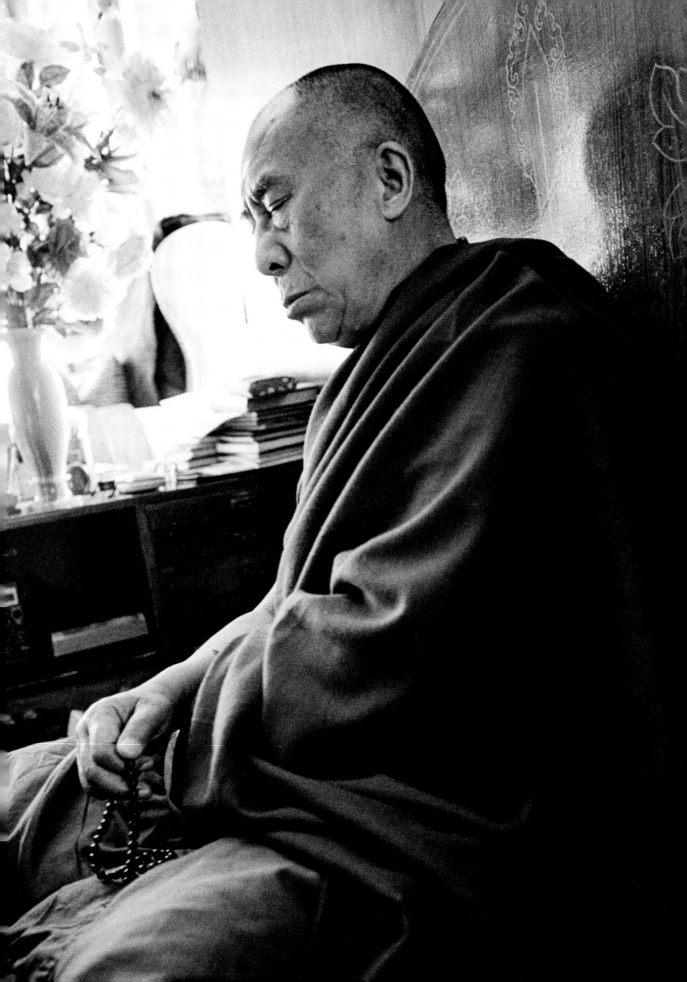

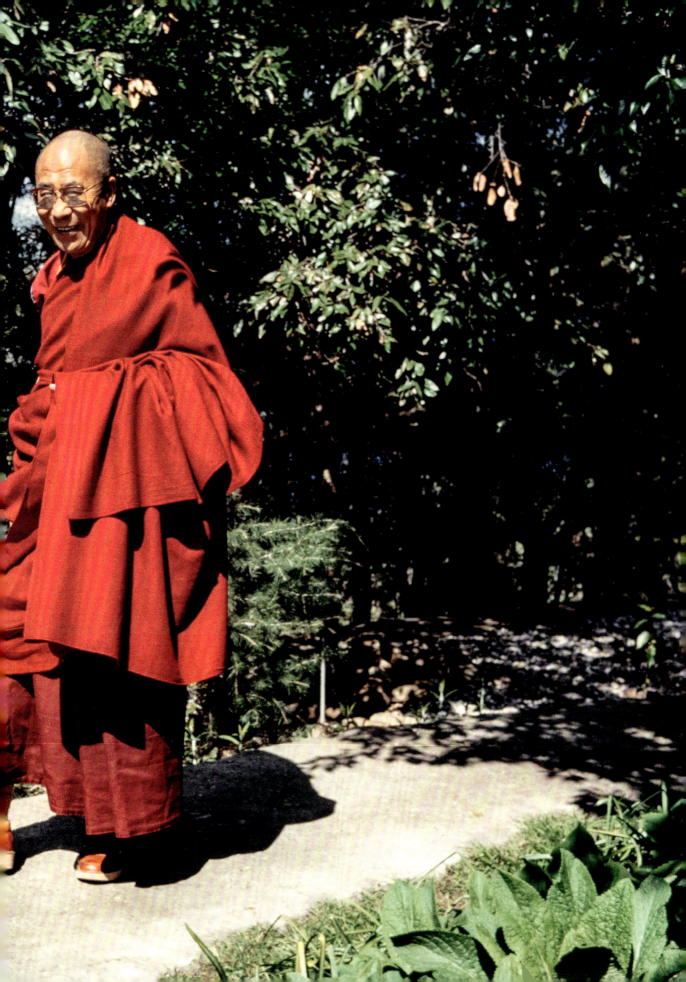

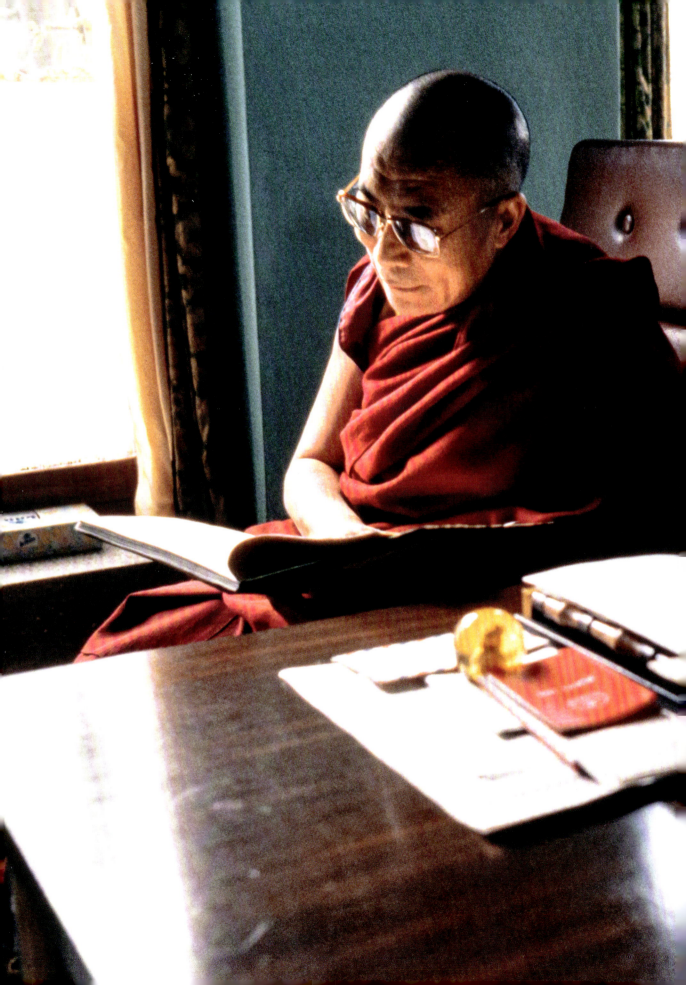

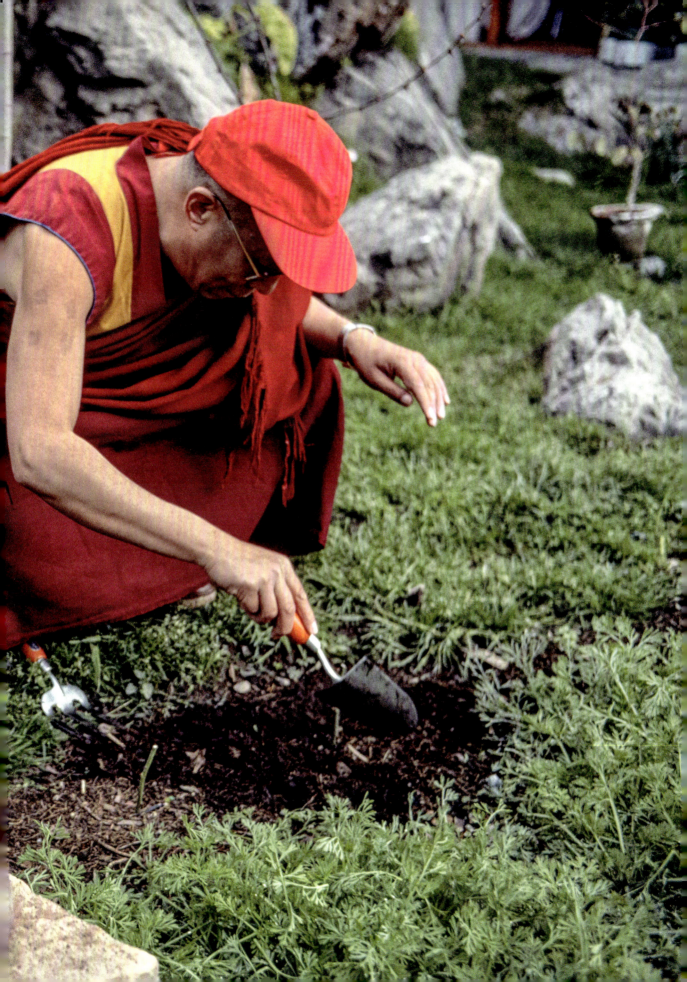

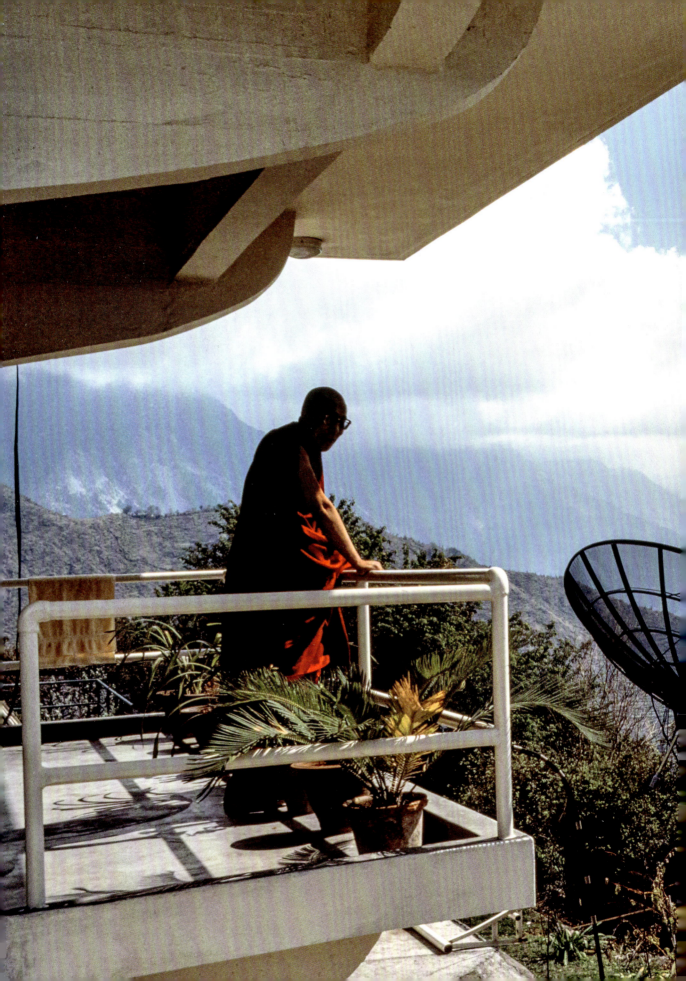

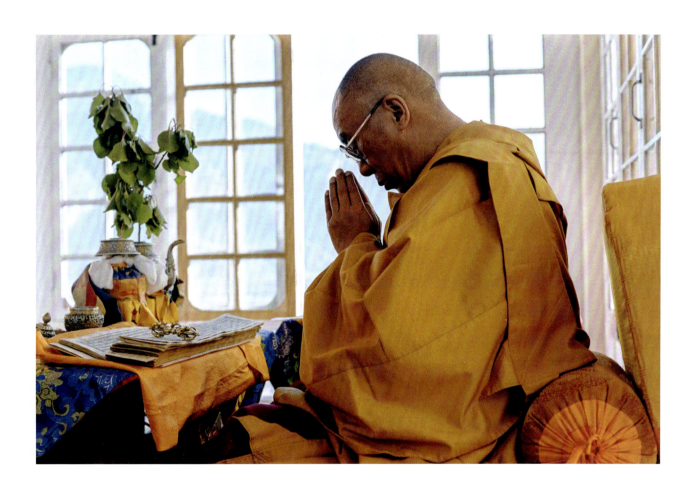

Table of Contents

Photographs by Manuel Bauer
1990–2024

His Holiness the Dalai Lama	21
A Simple Buddhist Monk	51
Spiritual Teacher to the World	97
The Kalachakra Ceremony	133
Leader of the Tibetan People	201
Dialogue with Science	237
Ambassador for Buddhism	261
Interreligious Understanding and Mutual Reverence	277
Ecology and Human Responsibility	299
The Voice of Compassion and Education of the Heart	325

Epilogue 351
Captions 354

HIS HOLINESS THE DALAI LAMA

Asked to name a single figure who has been a global constant from the second half of the twentieth century to the present, many would envision the smiling face of Tibet's Dalai Lama, clad in his characteristic maroon robes. Born in 1935 to a peasant family in Amdo (north-eastern Tibet), the child named Lhamo Dhondup was recognized at the age of two as the reincarnation of the Thirteenth Dalai Lama, Tibet's spiritual and temporal leader who had passed away in 1933. At the age of four, the young boy was brought to Lhasa, Tibet's capital city, where he was formally enthroned as the Fourteenth Dalai Lama. For the man who would come to be known across the world simply as "the Dalai Lama," that event marked the beginning of an extraordinary journey.

The title "Dalai" derives from the Mongolian word for "ocean" and was first bestowed on the Third Dalai Lama, whom the influential Mongol chieftain Altan Khan embraced as his spiritual teacher in the

sixteenth century. The equivalent term in Tibetan is *Gyatso* ("ocean"), which would henceforth be a defining part of the names of all subsequent Dalai Lamas. The present Dalai Lama's full name, Tenzin Gyatso, carries this tradition forward.

 The Dalai Lama first captured global attention with his dramatic escape into exile, a story that in 1959 unfolded on television screens across the world. Communist China had invaded Tibet in 1950, and by the end of 1958, it was clear that Tibet's young leader could no longer effectively serve his people from within his occupied homeland. It was soon after the spontaneous uprising of the Tibetan people against Chinese rule in Lhasa in March 1959 that the Dalai Lama fled to India. Since then, for more than six decades, he has lived as a stateless person in northern India, leading his people's quest for freedom and dignity. In the course of his exile, he has emerged as one of the most admired figures on the global stage—a beacon of hope and a voice of conscience. An unwavering advocate of nonviolence and world peace, he was awarded the Nobel Peace Prize in 1989. He is also the recipient of U.S. Congressional Gold Medal, and numerous awards of peace, human rights, and democracy, as well as Honorary Citizenships, such as that of Canada. For millions across the globe, the Dalai Lama has become a symbol of humanity's potential for compassion, reminding us of our common humanity and shared responsibility for creating a kinder, more peaceful world.

The Dalai Lama's tireless efforts to bridge divides—whether of race, religion, or ideology—have established him as a unifying figure in an oft-fractured world. He frequently emphasizes the need for collaboration that transcends all superficial differences, and is firmly convinced that humanity's greatest challenges can only be addressed through collective action. Reflecting on the twentieth century's devastating legacy of two world wars, he has called for the twenty-first century to be an era of dialogue, not conflict.

When asked about the personal tragedy of losing his homeland, the Dalai Lama often responds with characteristic humility and grace: "Yes, I lost my own country, but I have found the world. Although I am not a citizen of any country, I am truly a citizen of the world."

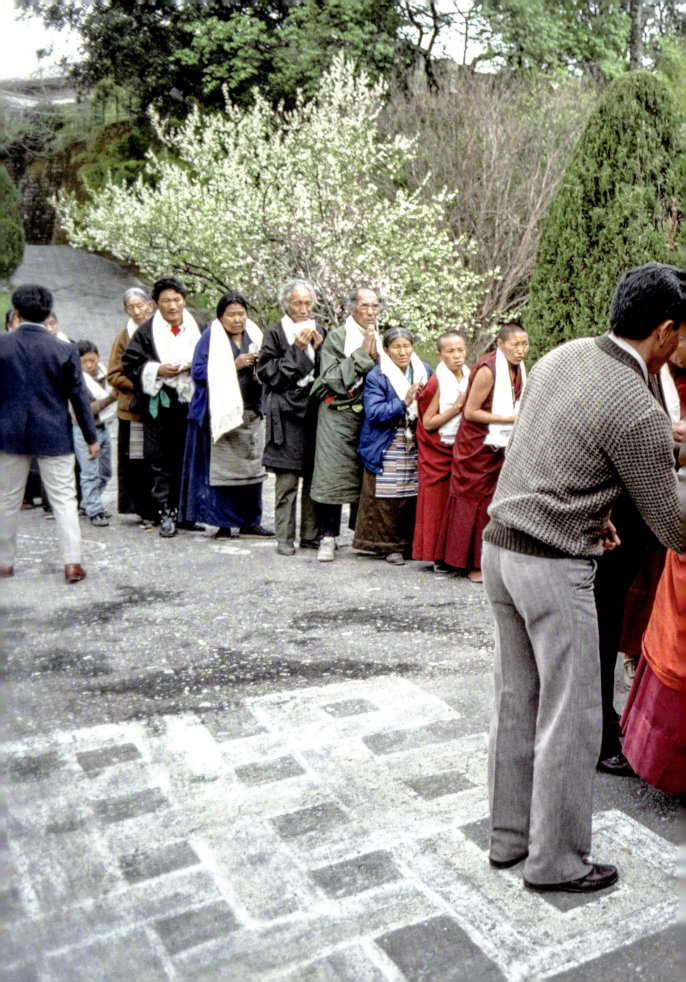

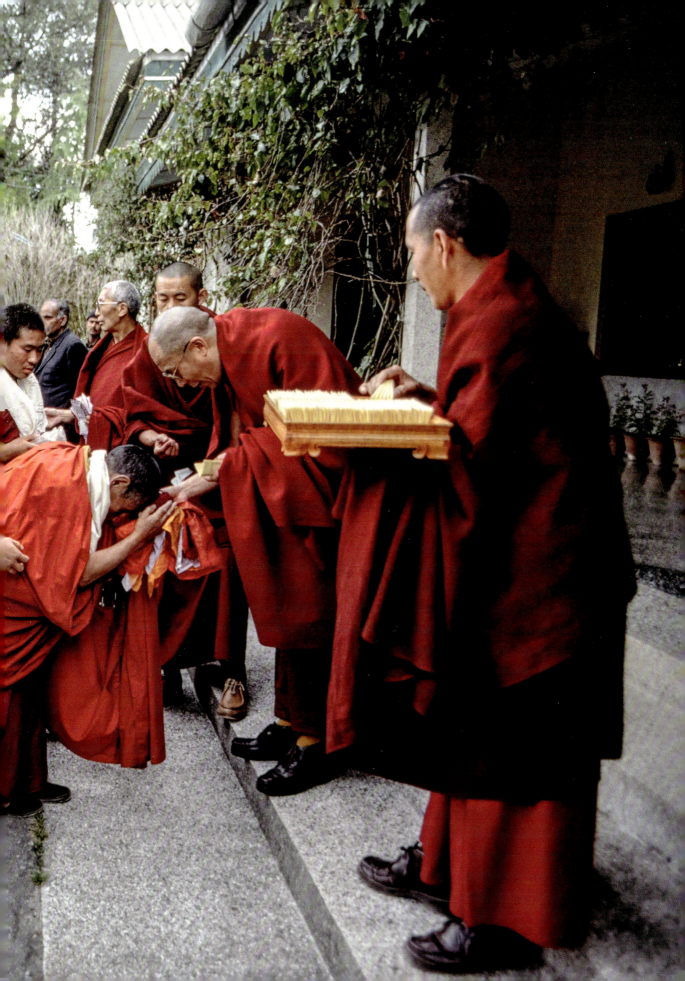

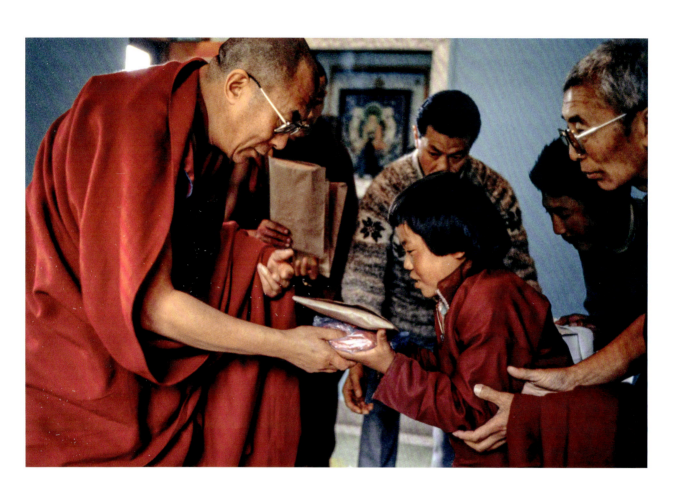

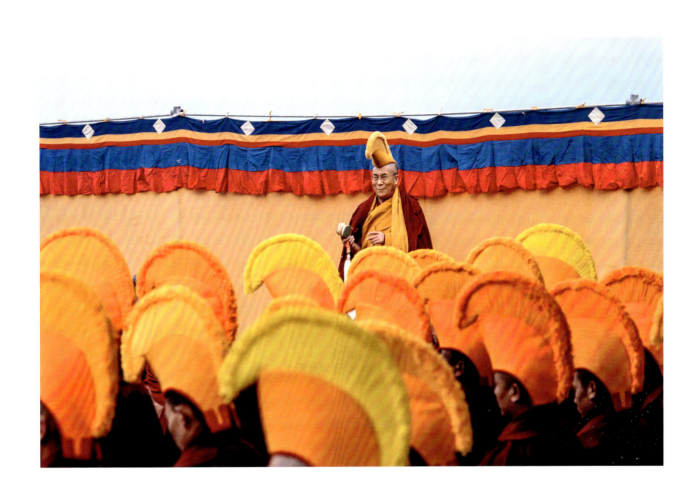

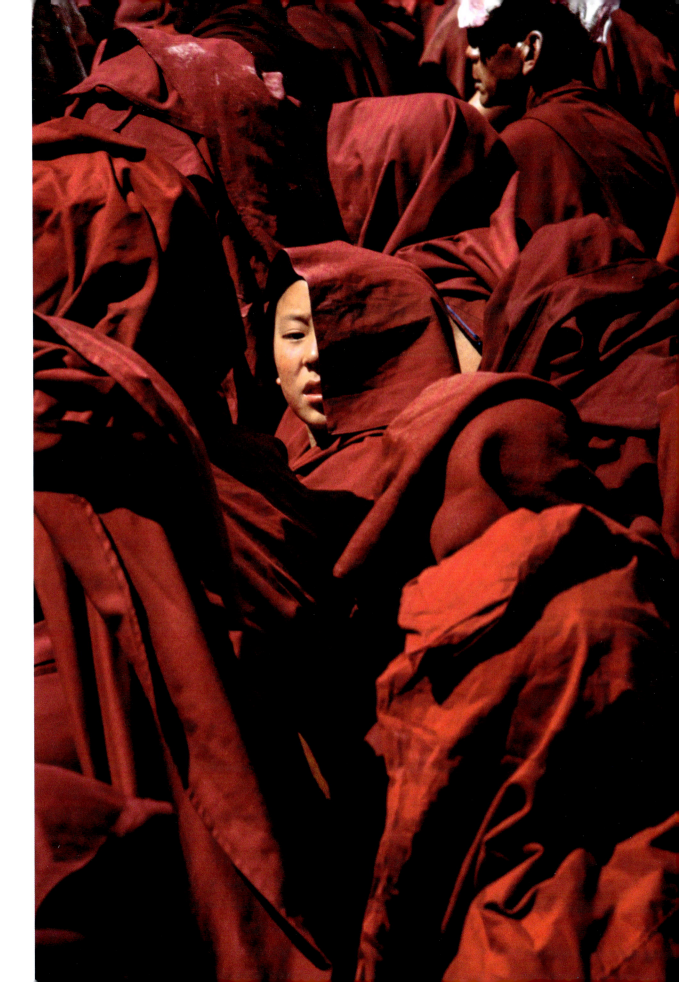

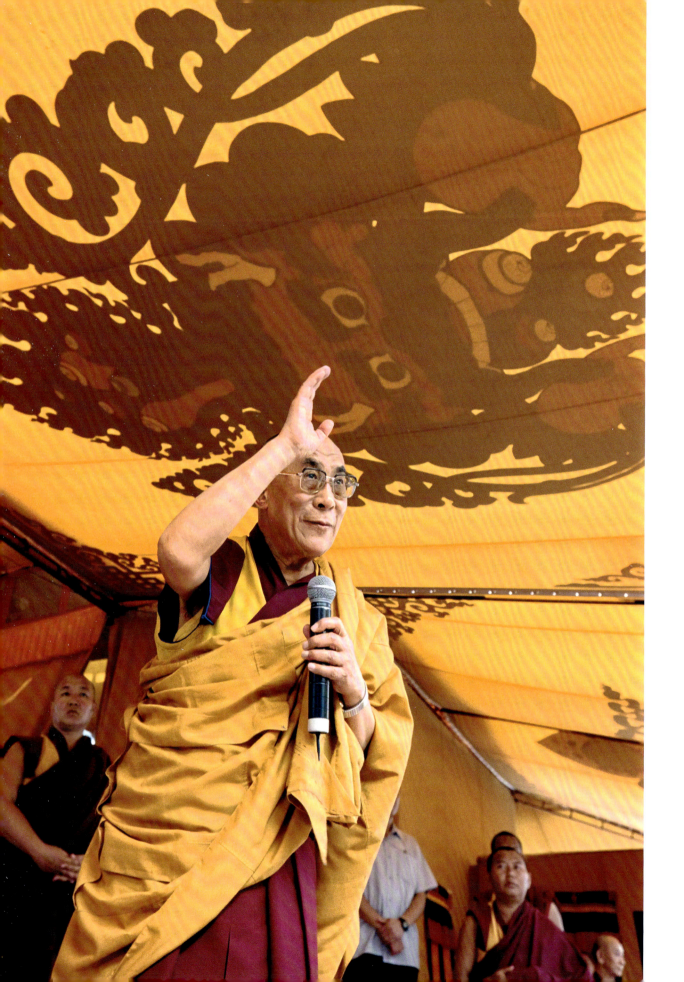

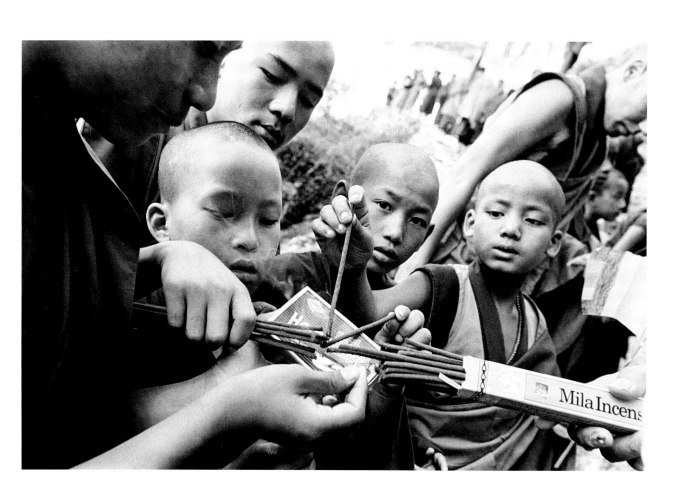

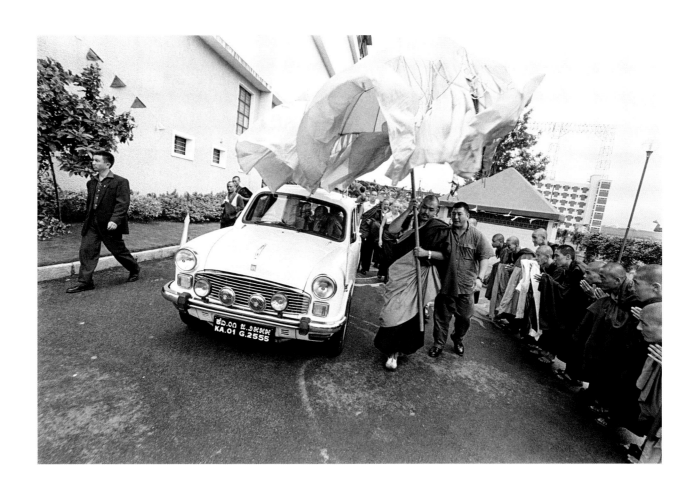

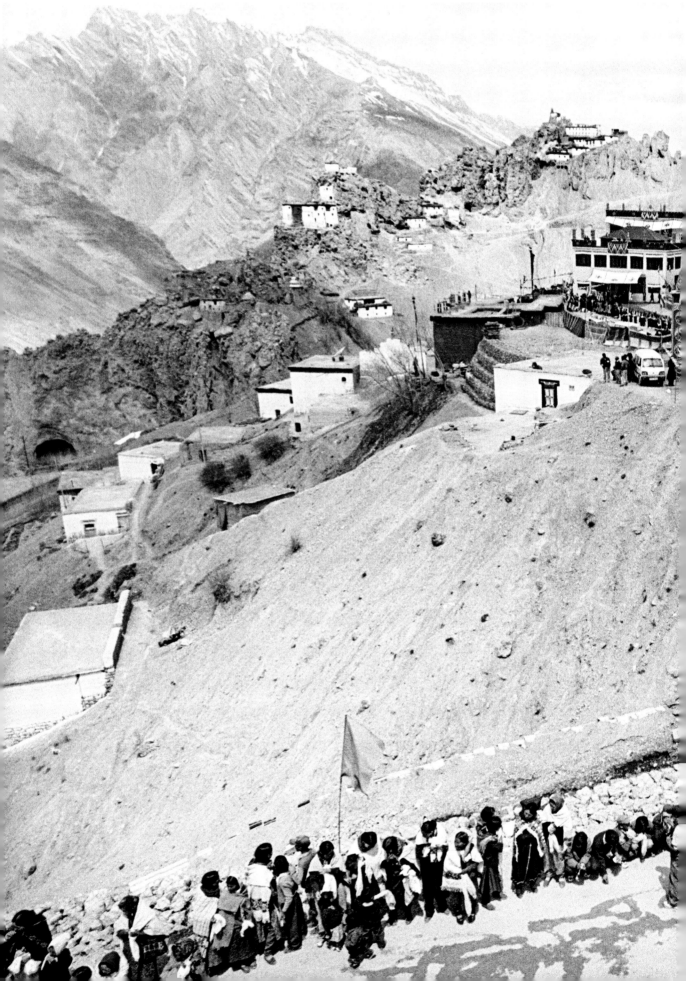

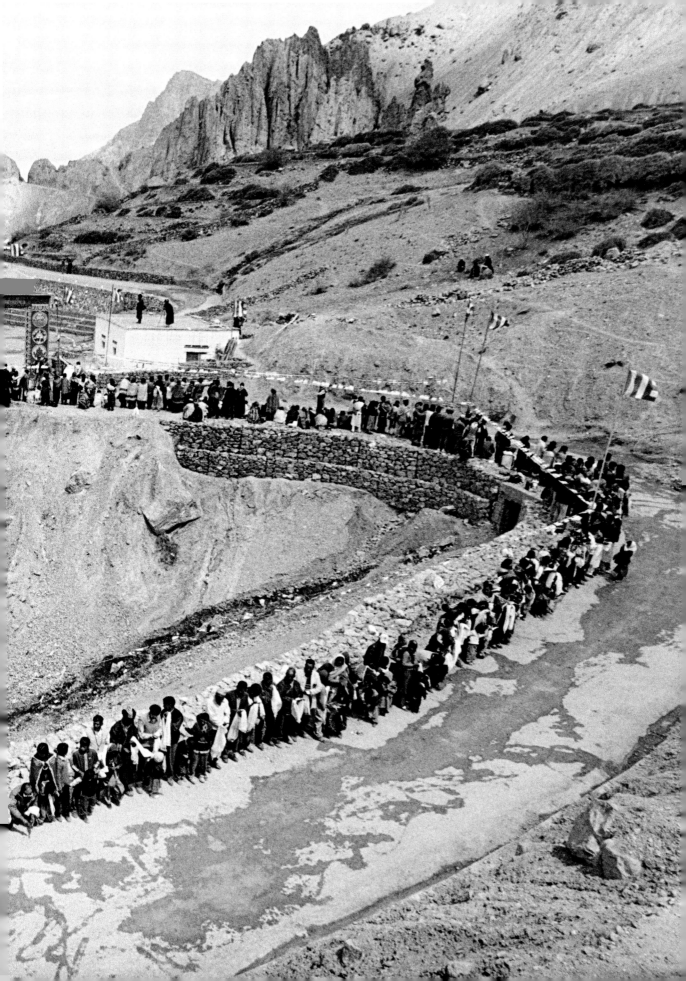

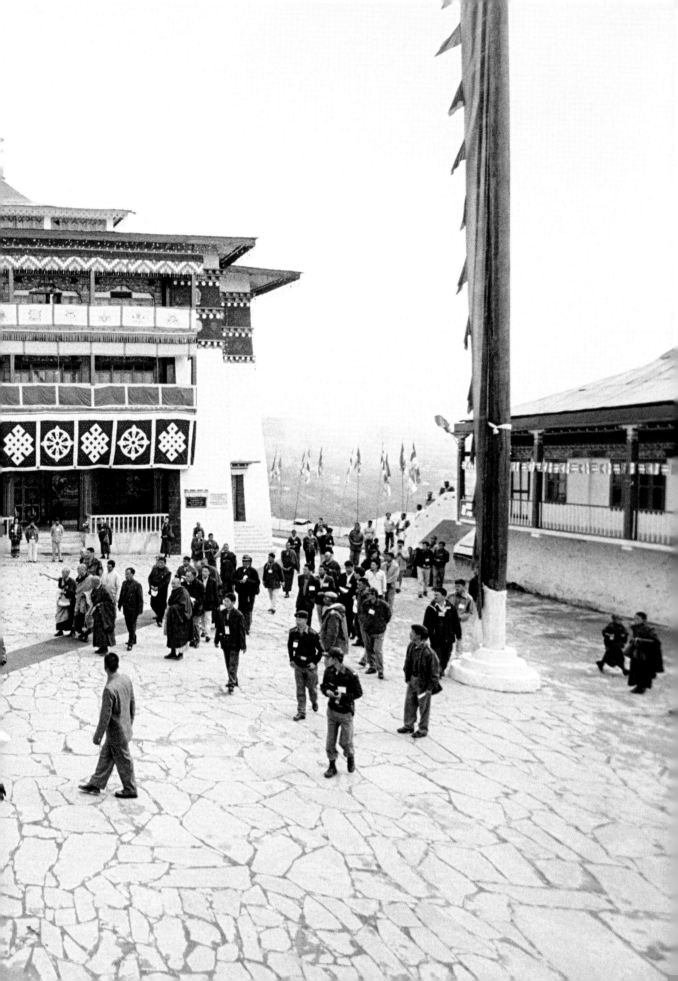

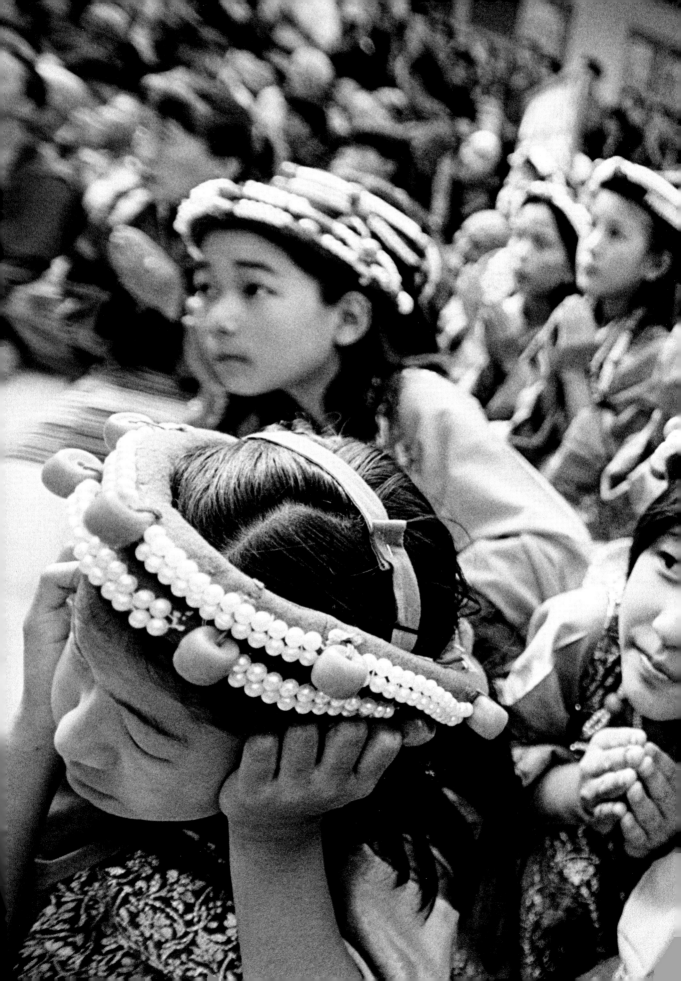

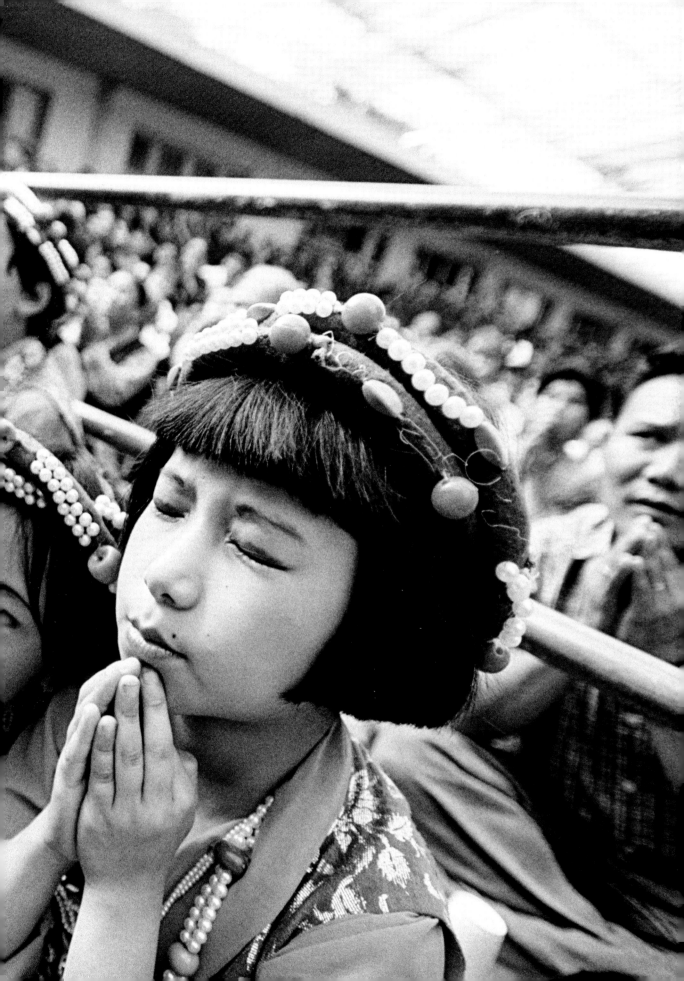

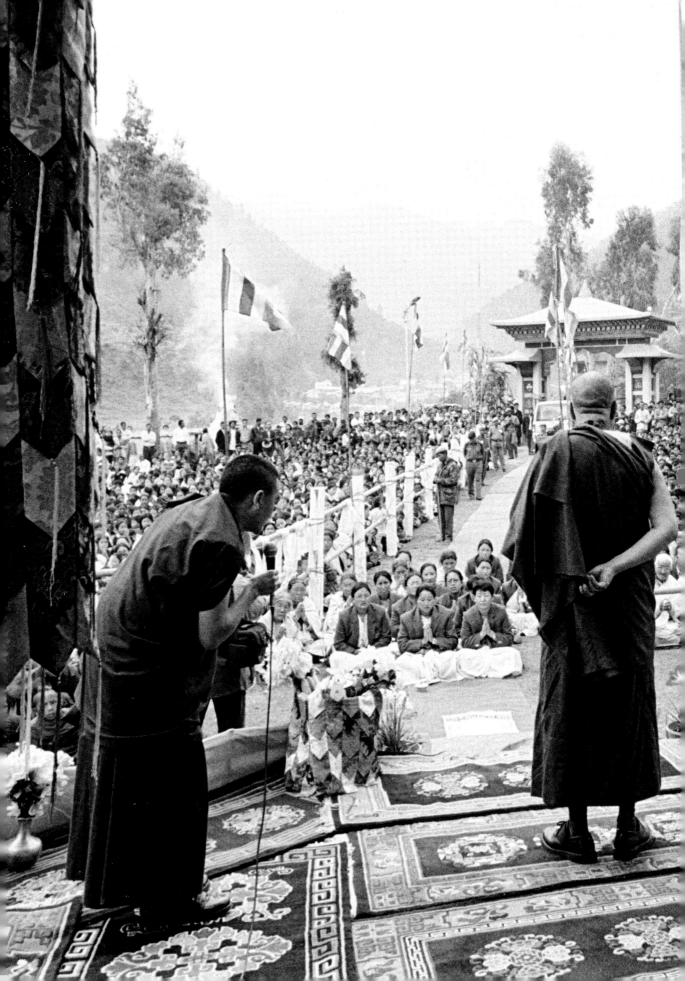

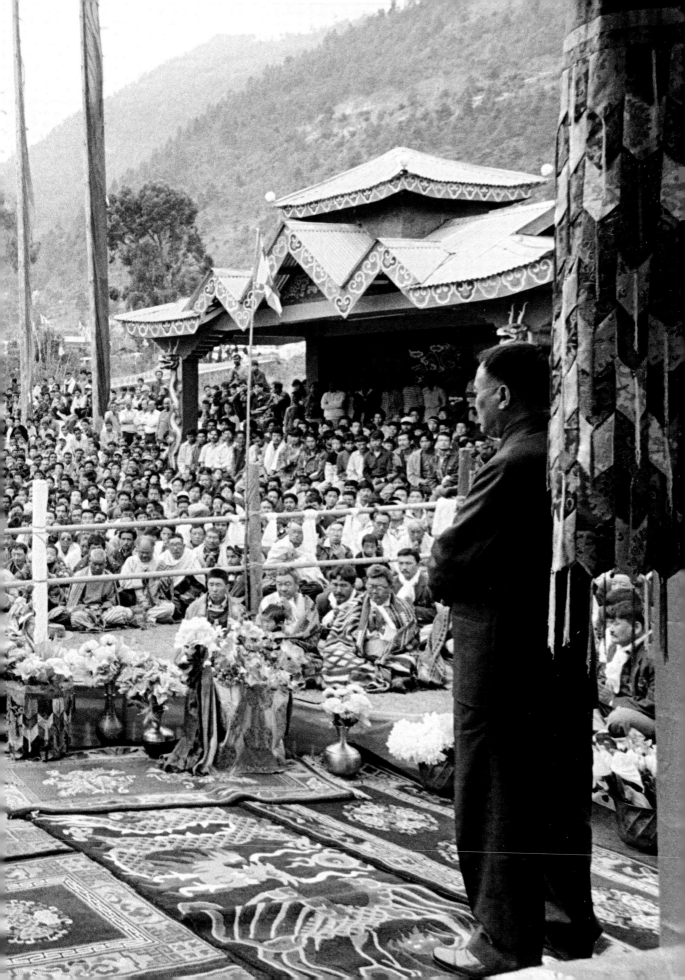

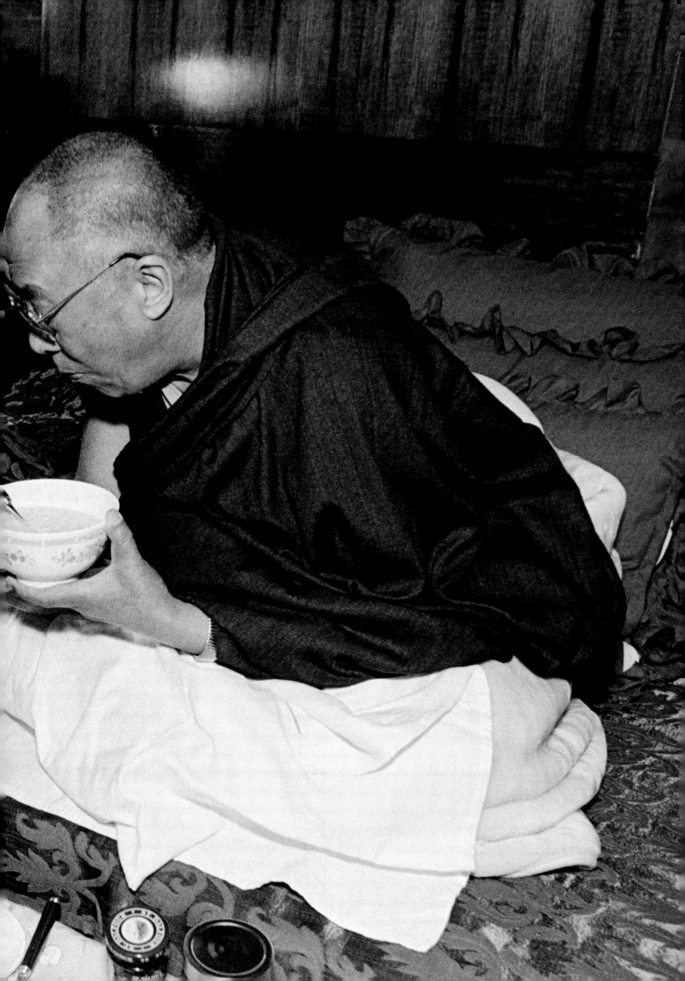

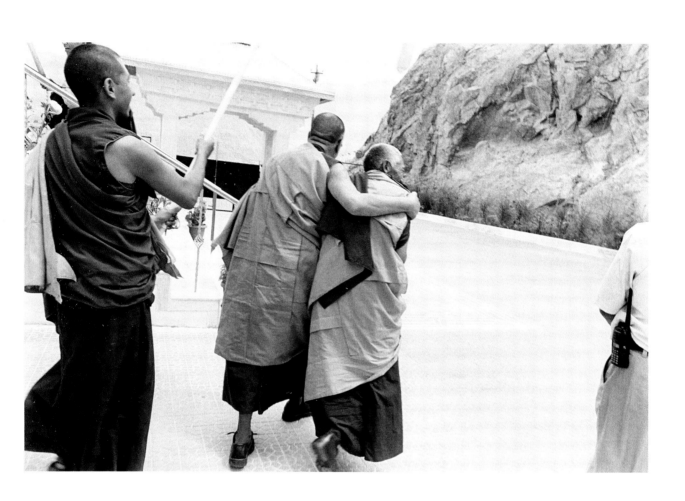

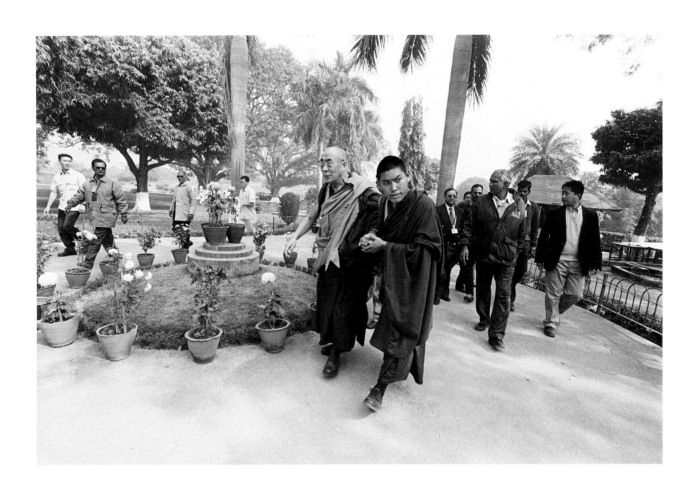

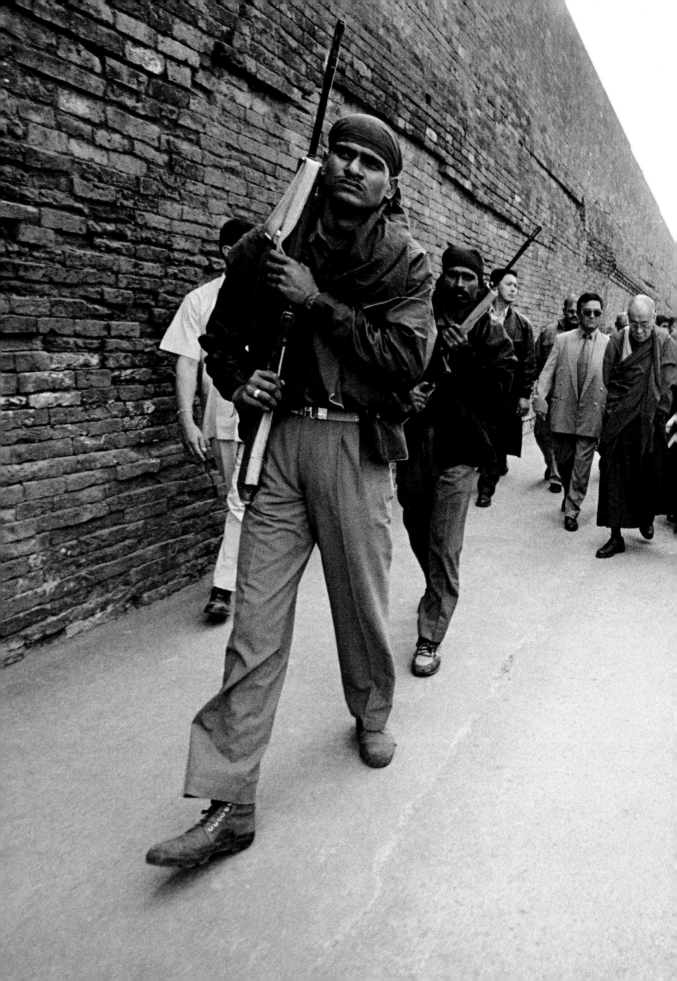

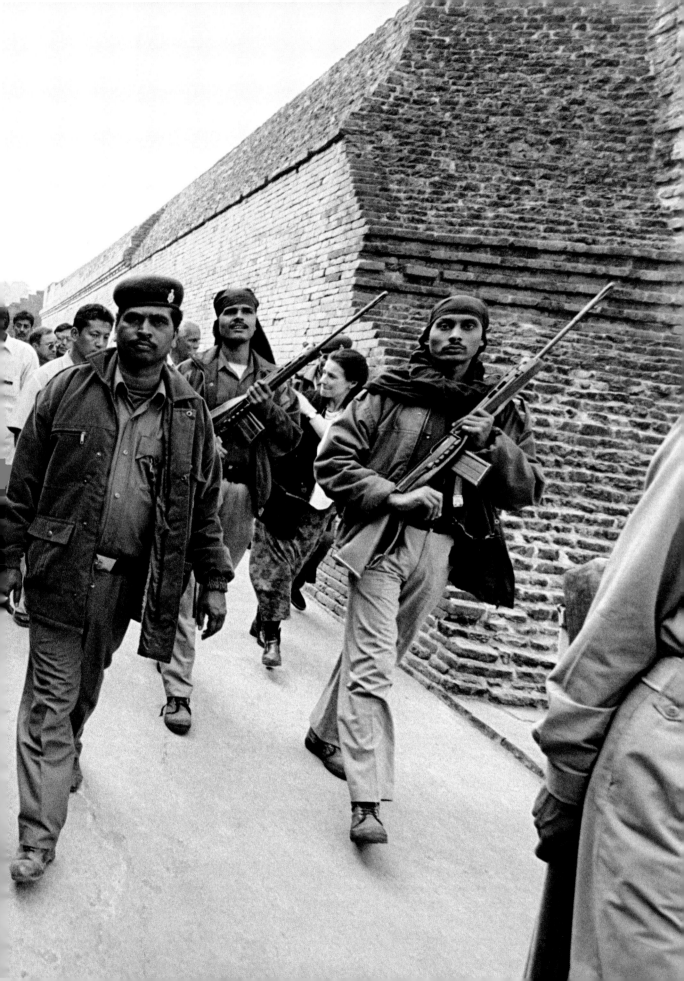

A SIMPLE BUDDHIST MONK

One of the lesser-known aspects of the Dalai Lama's life is his profound identification with the simple life of a monk, notwithstanding his elevated status as the spiritual leader of Tibetan Buddhism. Devout Tibetans, for example, revere him as the embodiment of the Buddha of Compassion. Yet when it comes to his own sense of self, what he cherishes most seems to be his identity as a monk. He often describes himself as a "simple Buddhist monk," and, when asked to autograph a book or document, likes to use the byline "a monk in the Buddha's order" (*shakyai gelong*). On several occasions, I have heard the Dalai Lama share how the thought "I am a monk" arises naturally, even in his dreams. It is an awareness that tends to surface whenever a mental affliction, such as envy or attachment, begins to make itself felt. "Only very rarely does the thought 'I am the Dalai Lama' arise in my dreams," he says. His monastic discipline is reflected in every aspect of his daily life. Rising at 3:30 a.m.,

he dedicates over three hours of every morning to meditation, prayer, and study. He observes the strict precept of not eating after lunch and wears the same robes as other Tibetan monks.

True to the principle of simplicity, the Dalai Lama's personal lifestyle exemplifies what Buddhist texts call "minimal desires and a sense of contentment." I remember visiting the Dalai Lama's private quarters while assisting him and Howard Cutler on their book, *The Art of Happiness.* His bedroom was strikingly bare. A narrow space that felt more like a passageway between two larger rooms, it held a single bed pushed against the wall, a small bedside table, and framed photographs of his spiritual teachers hanging on the wall above, most prominently Kyabje Ling Rinpoche and Kyabje Trijang Rinpoche. Attached to this modest bedroom was a small bathroom with a shower cubicle and a single pair of rubber flip-flops by its side. The bedroom opened into a large meditation and reading room, where a sofa faced a central altar adorned with sacred objects. Among them was a sandalwood replica of a famed Gandhara Buddha, depicting the emaciated figure of the Buddha during his ascetic phase. The figure's protruding ribs serve as a reminder of the Buddha's perseverance on the path to enlightenment. Asked why this image means so much to him, the Dalai Lama once explained that it symbolizes the diligence, persistence, and hardship required to pursue that path.

As his English translator for over three decades, I have accompanied the Dalai Lama on countless journeys all over the world. While he enjoys meeting people from all walks of life, I have observed him at his most joyful when sitting with fellow monastics. Their shared vision of the monastic life—a life dedicated to cultivating human potential through celibacy, simplicity, and discipline—continues to inspire him deeply, even if he would not recommend it for everyone. In Tibetan Buddhism, there is a saying that perfectly encapsulates the Dalai Lama's personal life: "For yourself, as few needs and chores as possible. For others, as many needs and chores as possible."

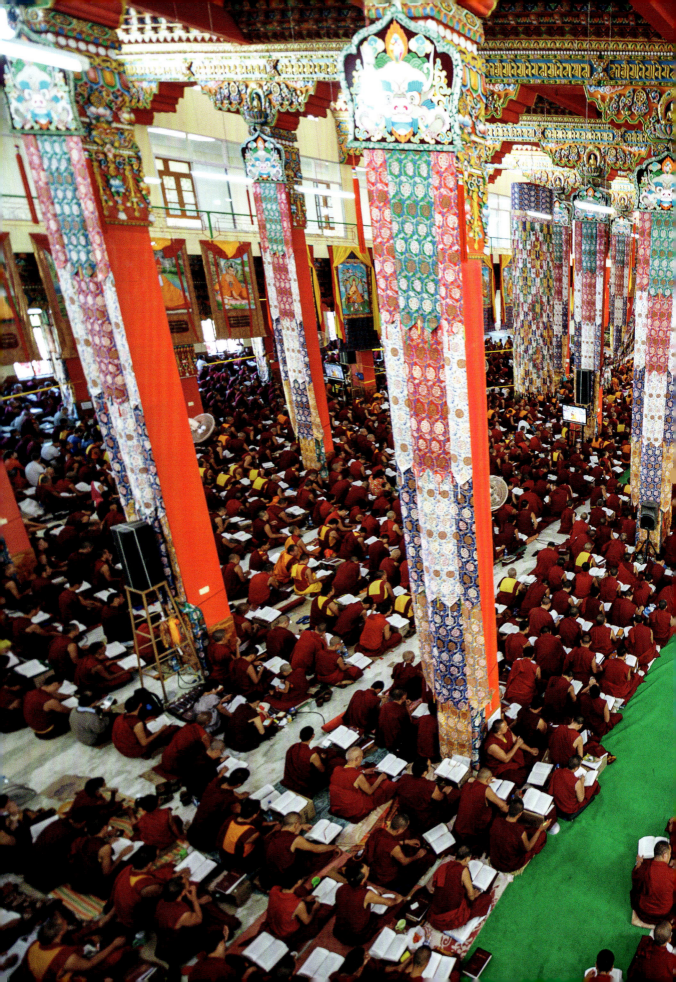

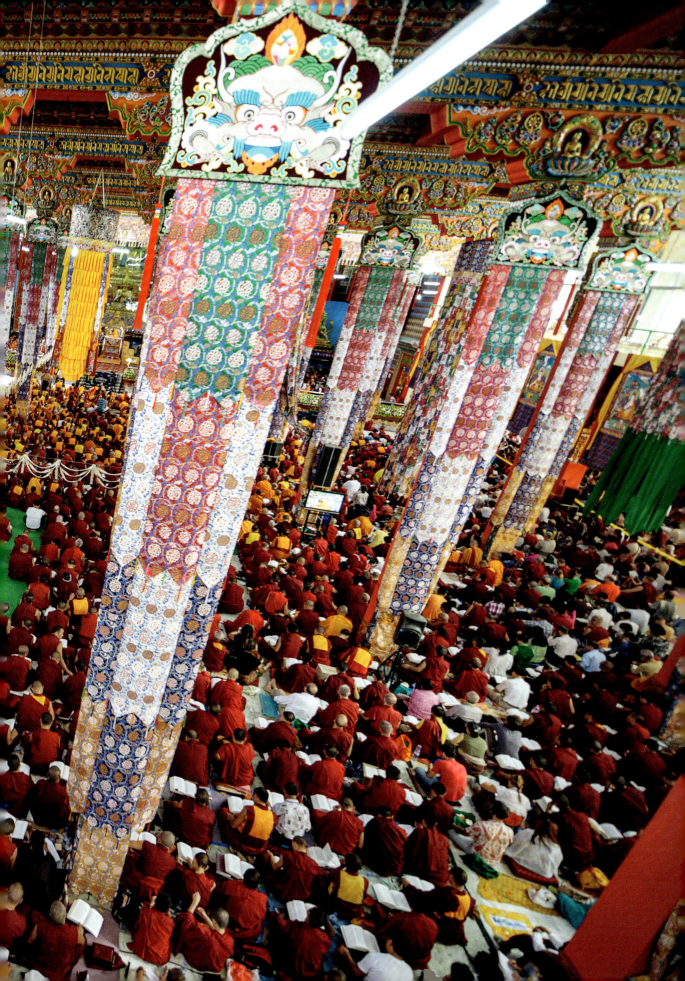

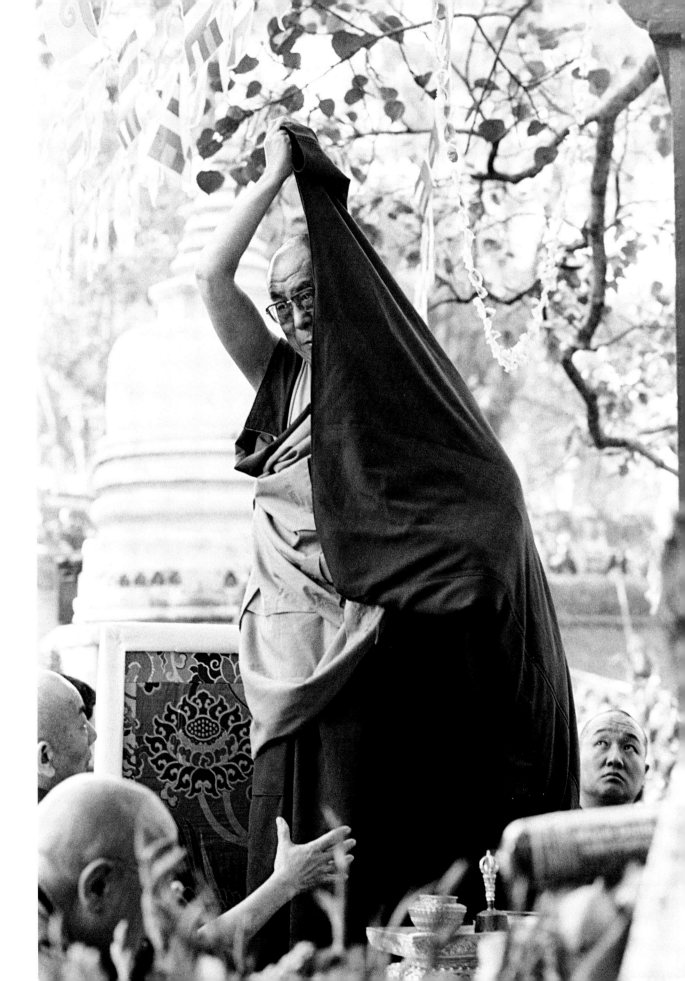

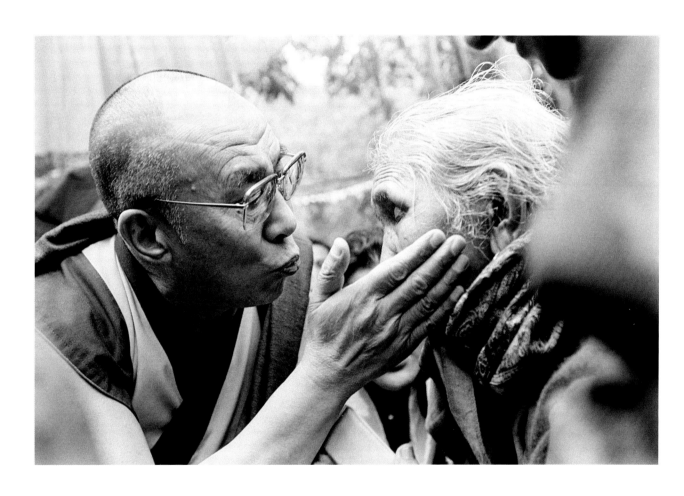

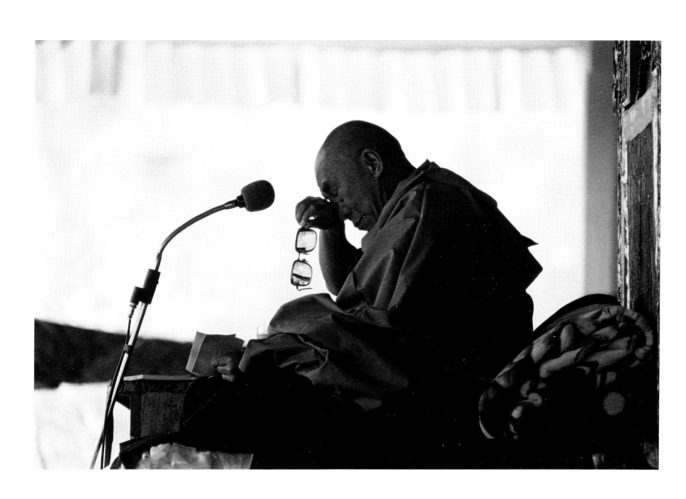

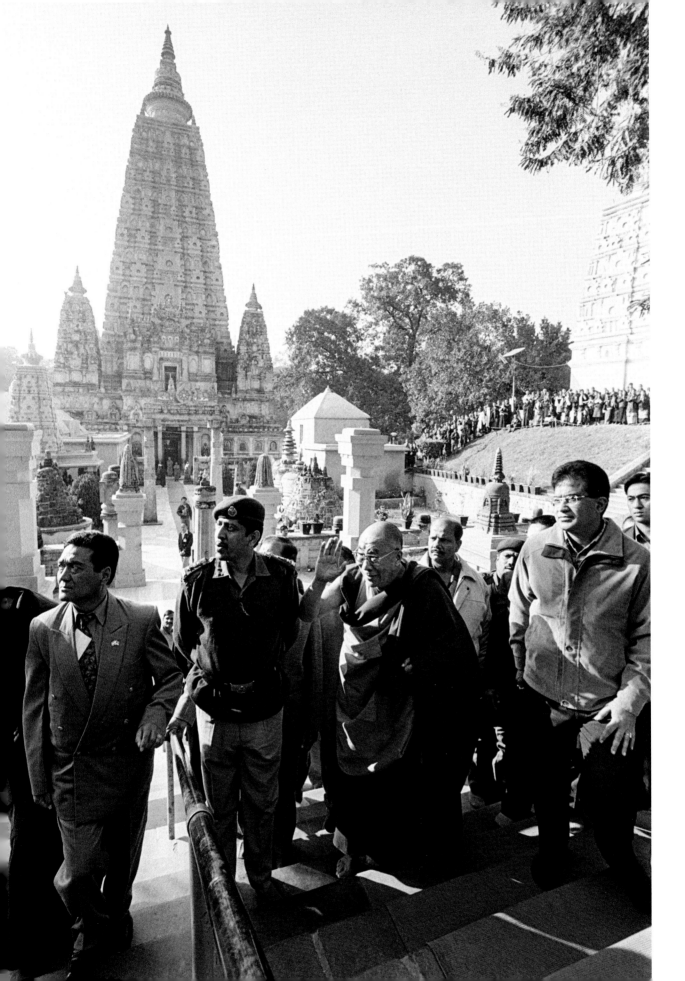

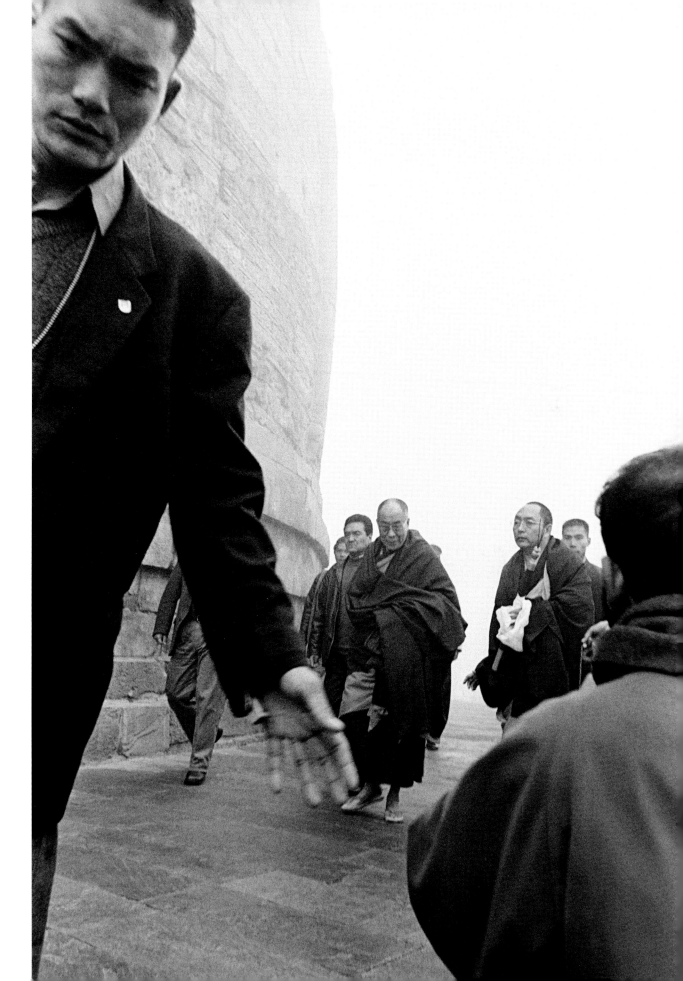

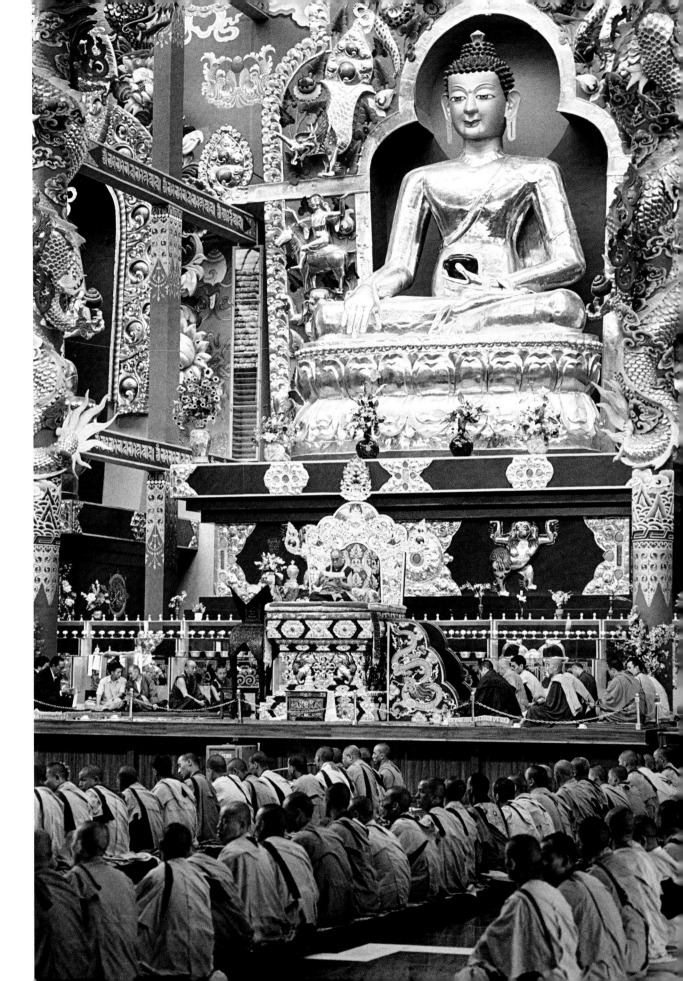

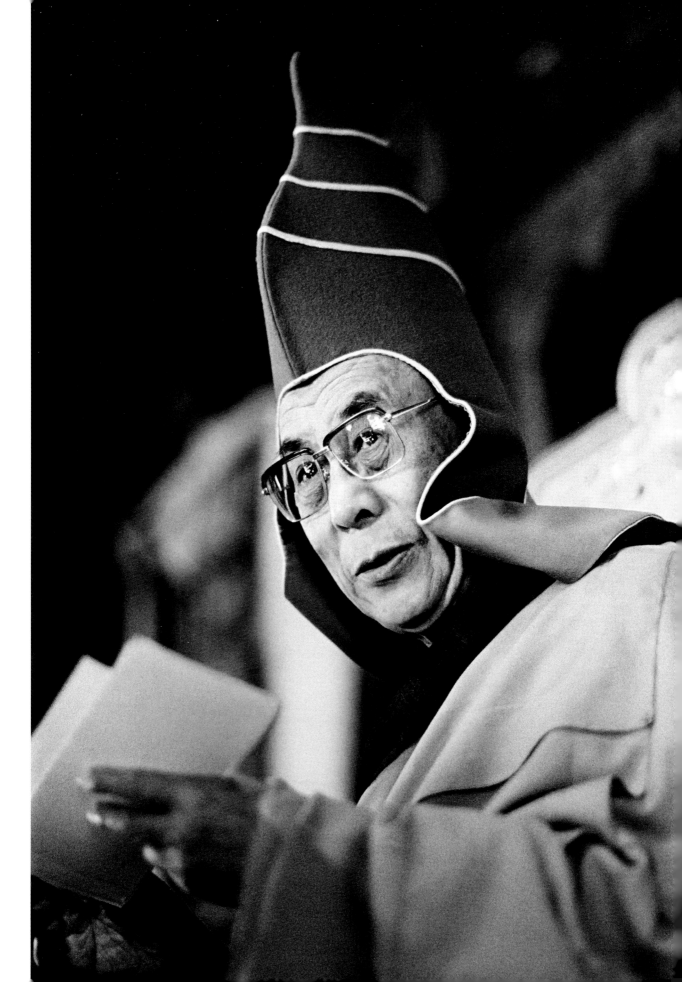

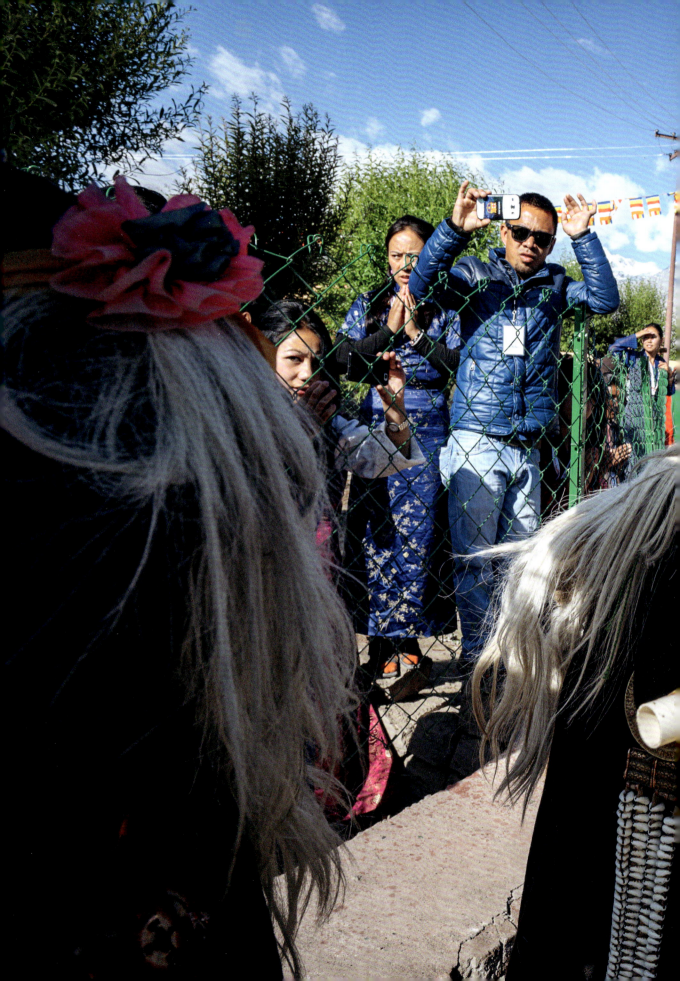

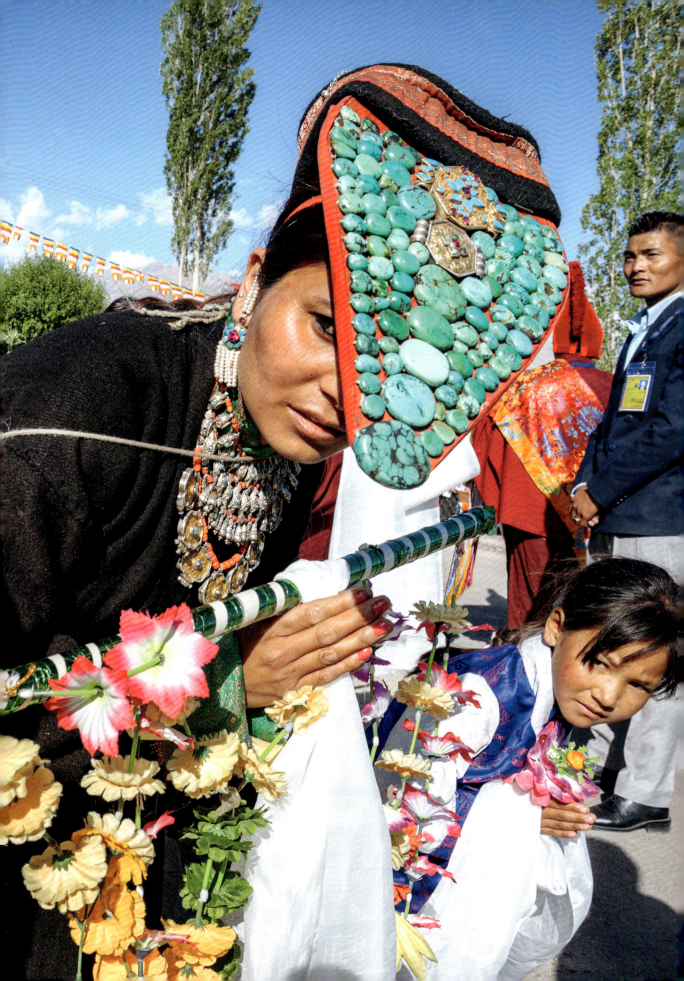

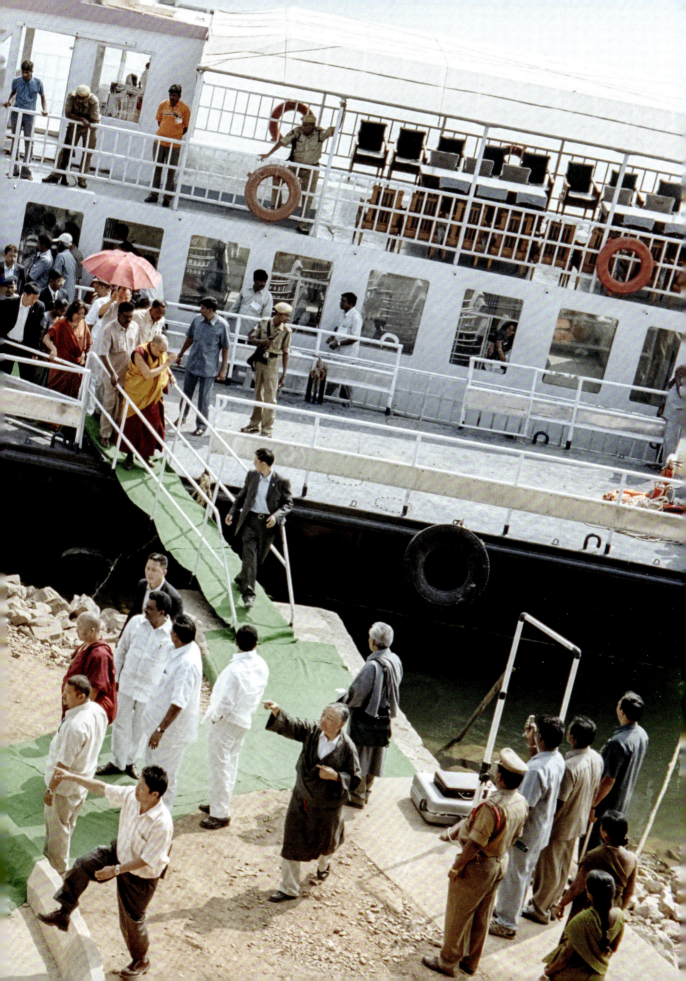

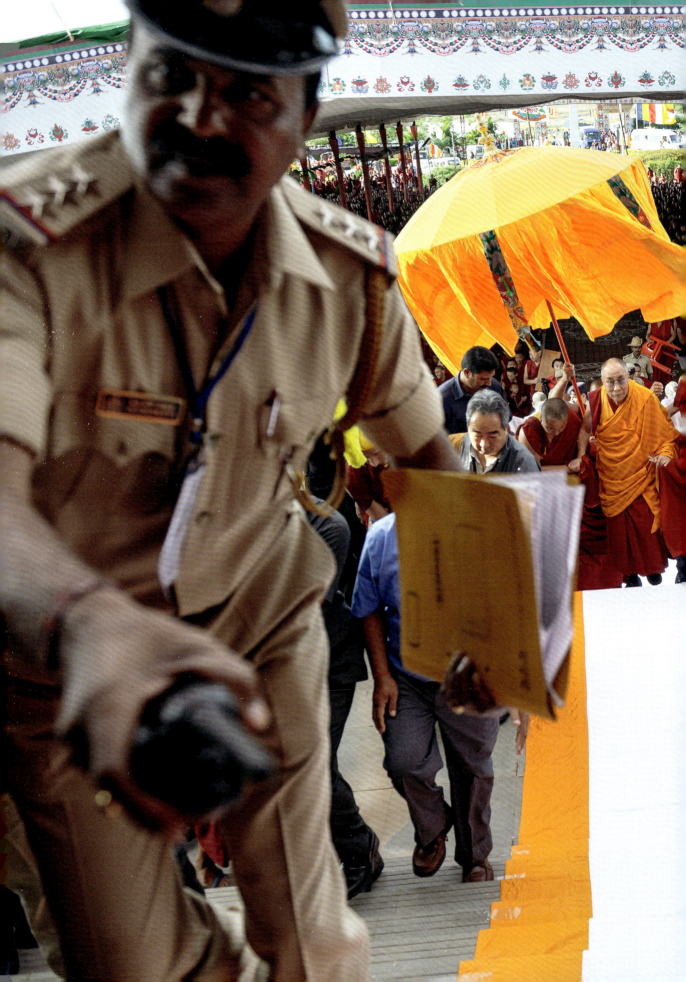

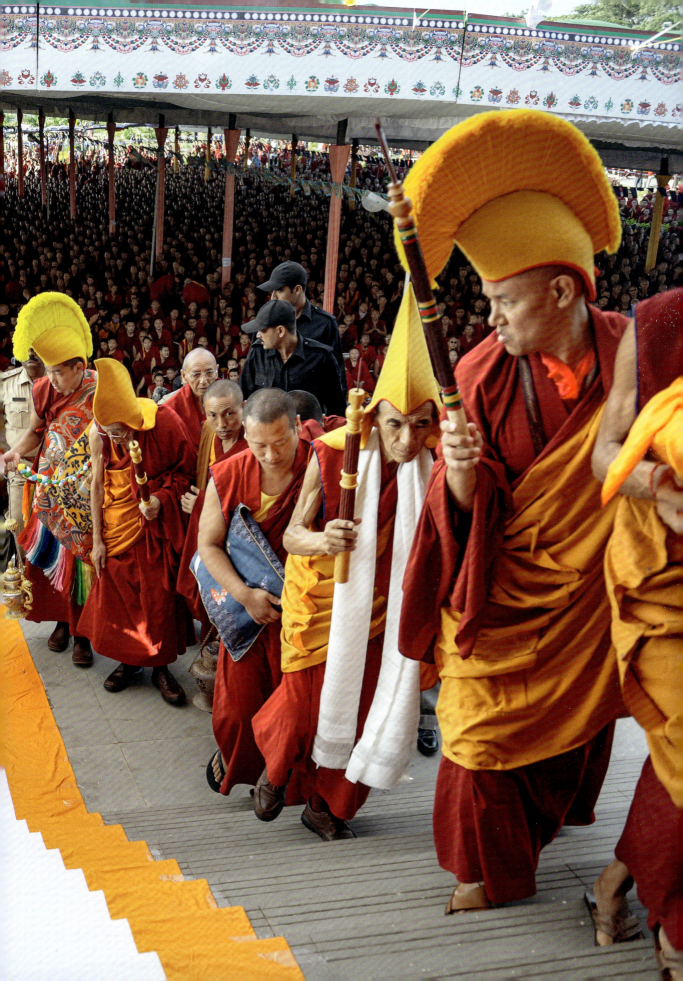

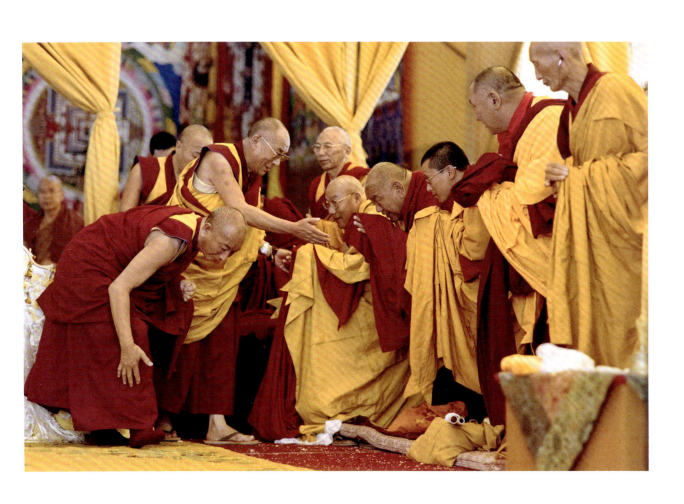

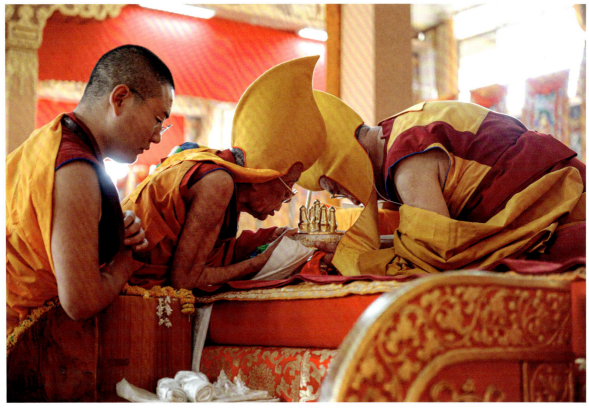

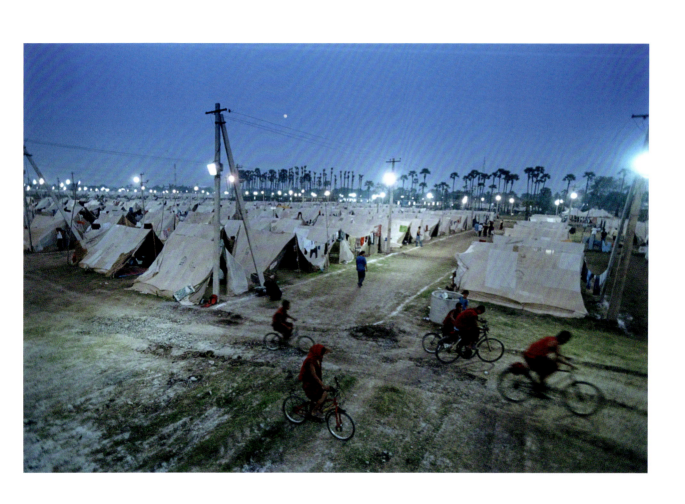

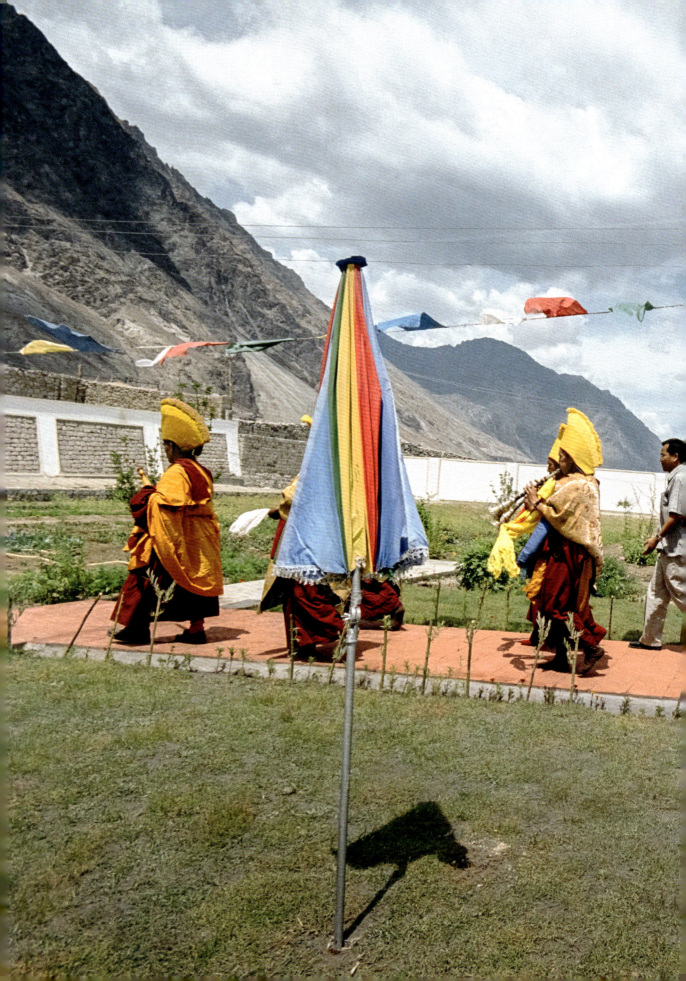

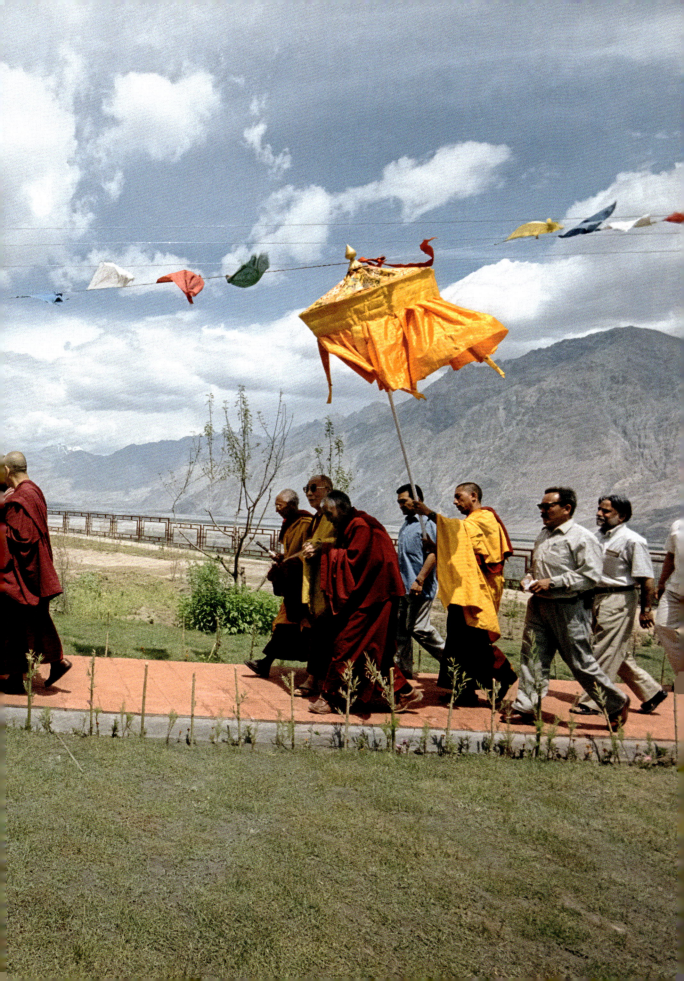

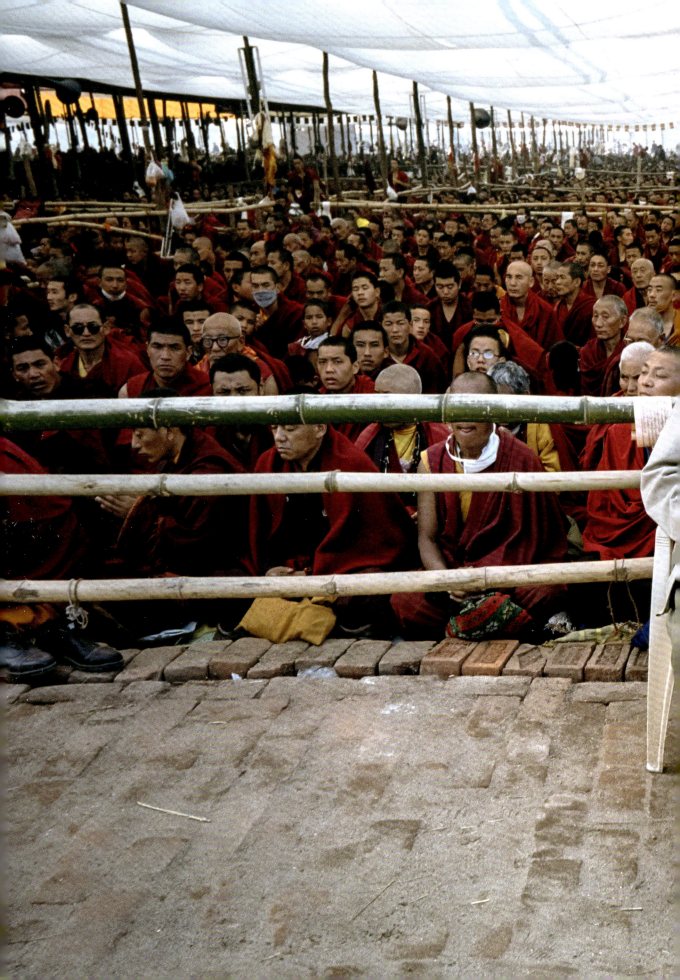

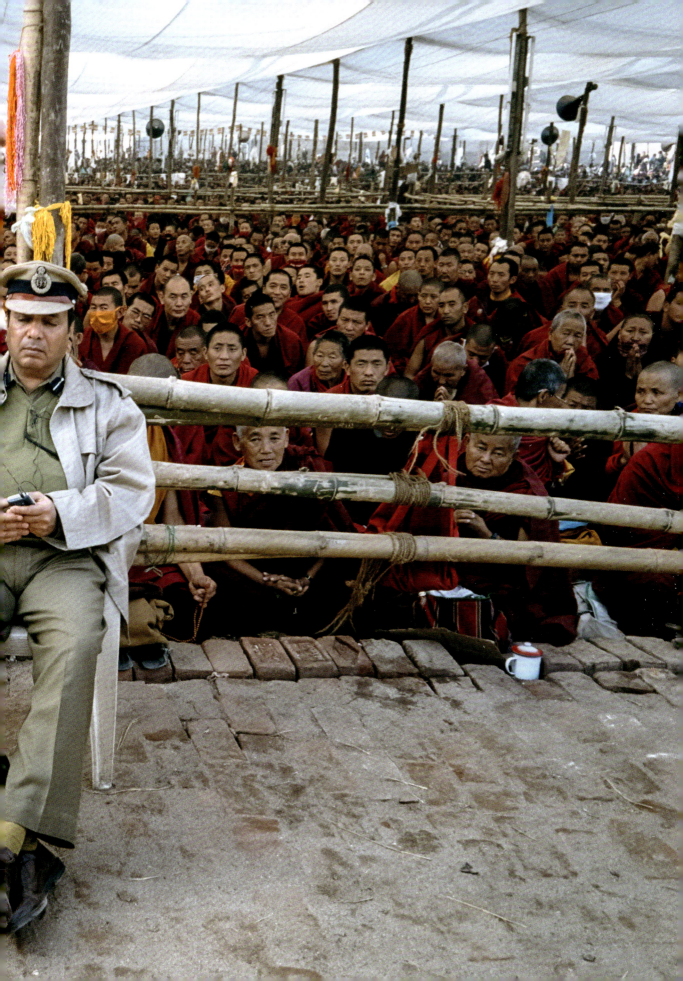

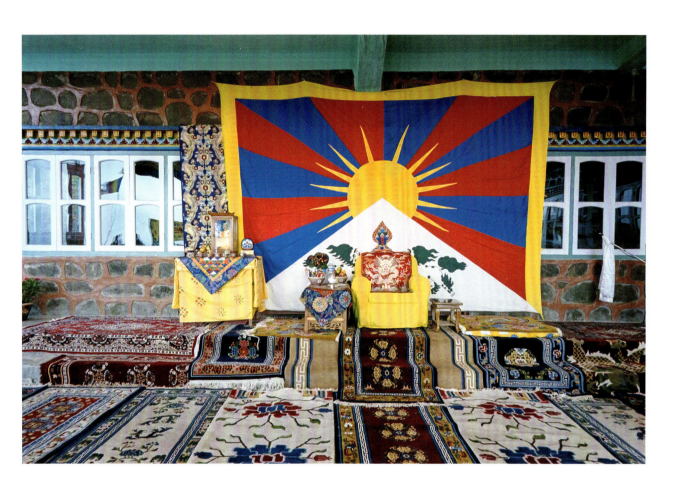

SPIRITUAL TEACHER TO THE WORLD

In his *New York Times* bestseller, *Ethics for the New Millennium,* the Dalai Lama reflects on the profound lessons humanity has learned from the momentous twentieth century. He observes that "a purely external approach" to the human quest for happiness is bound to be insufficient. "What I propose," he writes, "is a spiritual revolution."

The spiritual revolution envisioned by the Dalai Lama begins with the individual, with each of us recognizing that the key to happiness lies within, not outside, ourselves. While we are all predisposed to seek happiness, the Dalai Lama reminds us that true happiness transcends the fleeting sensation of physical pleasure. Genuine happiness is a deeper sense of fulfillment and satisfaction, which arises only when we succeed in living a life of meaning and purpose. "If the happiness we seek is more than physical," the Dalai Lama reasons, "then, logically, the path to finding it must transcend external material means." In

essence, he teaches us that not only is the destination of genuine happiness internal, but the path to it must also be found within ourselves. It is this deeper understanding of happiness that the Dalai Lama alludes to when he declares: "The purpose of life is to seek happiness." He was articulating this idea long before the rise of the popular "wellness" movement, as when, in *The Art of Happiness,* he wrote: "True happiness relates more to the mind and heart. Happiness that depends mainly on physical pleasure is unstable; one day it's there, the next day it may not be." For the Dalai Lama, any sincere quest for this deeper happiness will always be a quest for spirituality.

At the core of the Dalai Lama's vision of what I might call "universal spirituality" is his belief in the basic goodness within us and the benefits of cultivating greater self-awareness. Self-awareness enables us to harness the resources of our own mind to the spiritual endeavor of becoming a better human being. Cultivating a deeper appreciation of our innate capacity for empathy and compassion is an essential part of this journey. It teaches us to engage with others and the world around us from a place of connection with our better selves. It is through self-awareness and compassion—or what the Dalai Lama often refers to as "warm-heartedness"—that we develop the discernment needed to navigate our relationships and respond skillfully to life's inevitable challenges. Warm-heartedness becomes a touchstone that helps us stay grounded, even in the face of adversity.

Although the Dalai Lama is one of the world's most prominent religious figures, he has never advocated religion as the sole path to spirituality—or even to ethics. Instead, he is widely known for promoting a "secular," or universal, approach to ethics, grounded in our shared human condition, common sense, and scientific insights into human behavior. Like many contemporary scholars of religion, he sees the world's religious traditions as human creations designed to provide ethical guidance within specific cultural and doctrinal contexts. The Dalai Lama acknowledges that these religious traditions continue to offer profound guidance and spiritual solace to millions of faithful the world over. Yet beyond the particularities of individual faiths, he points to a more universal dimension of spirituality. This dimension lies in humanity's shared quest for meaning, our search for connection with something greater than ourselves, and the fundamental quality of the human heart: compassion.

Reflecting on the centrality of compassion to spirituality, the Dalai Lama once wrote: "This, then, is my true religion, my simple faith. In this sense, there is no need for temple or church or synagogue, no need for complicated philosophy, doctrine, or dogma. Our own heart, our own mind, is the temple. The doctrine is compassion."

With these words, the Dalai Lama reminds us that the ultimate spiritual practice is not found in ritual or belief but in the cultivation of kindness, understanding, and concern for others.

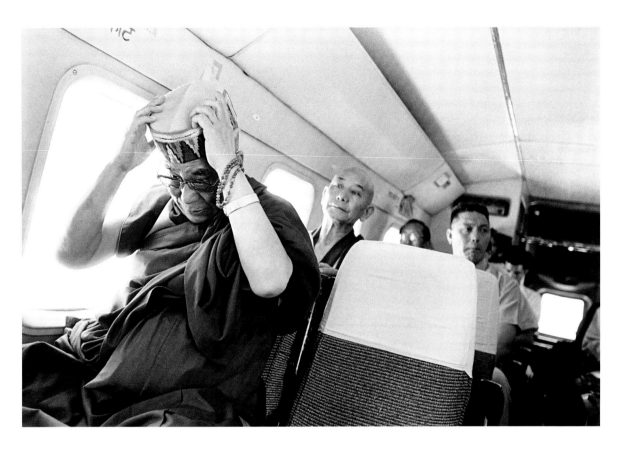
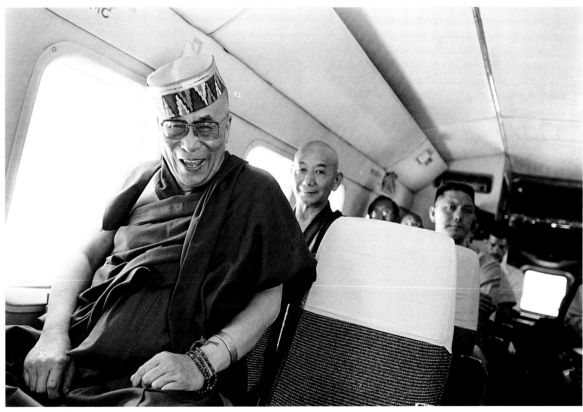

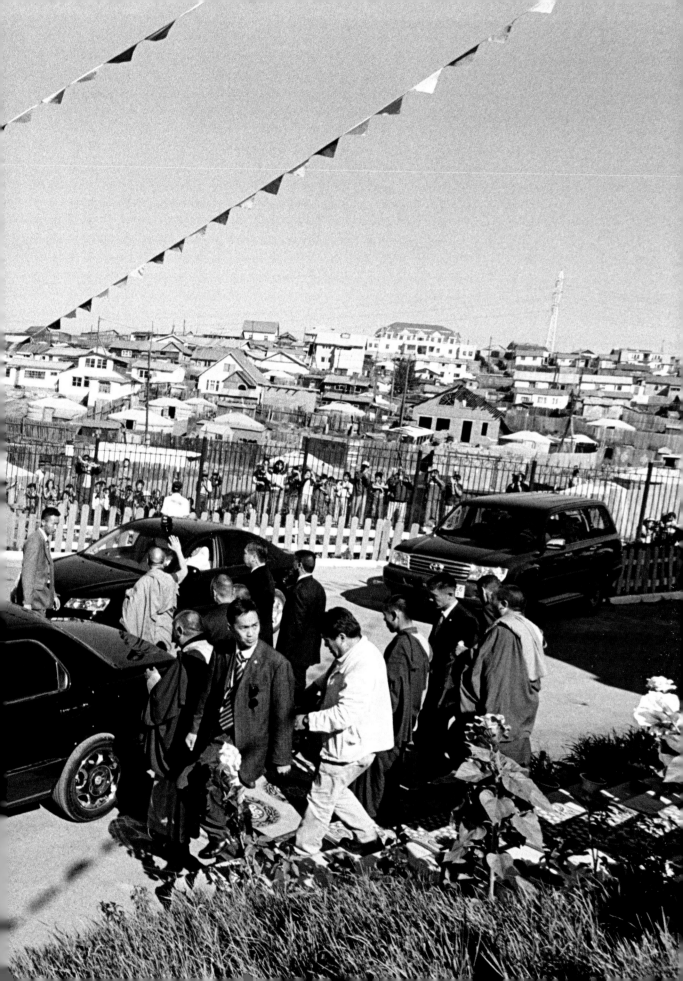

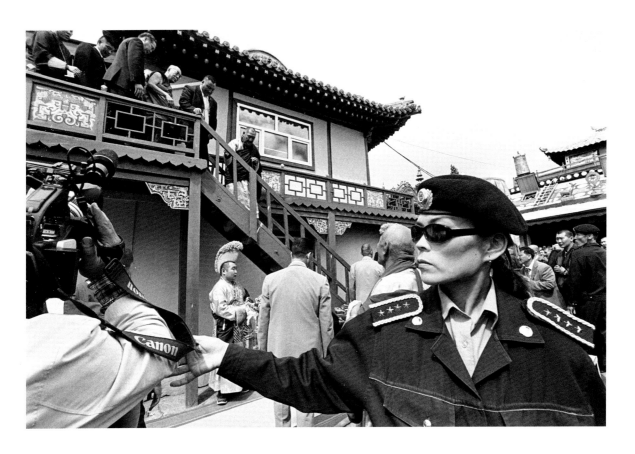
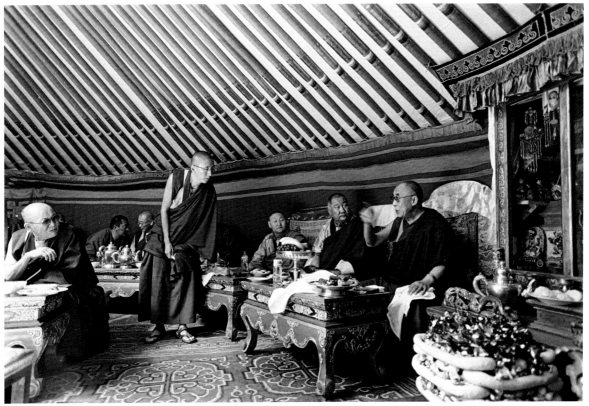

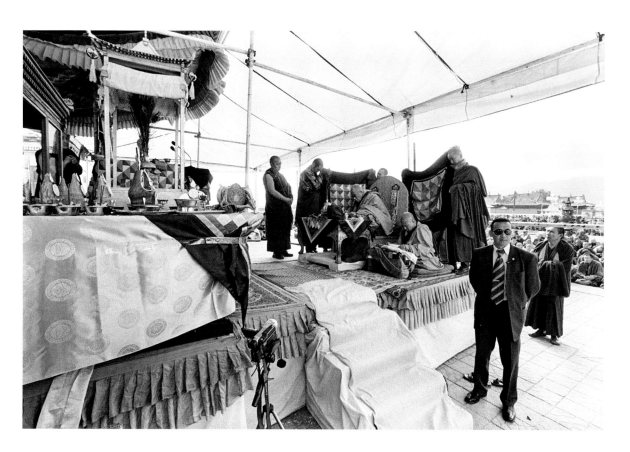
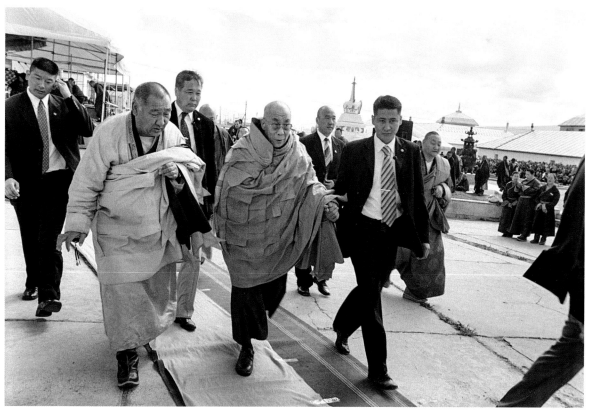

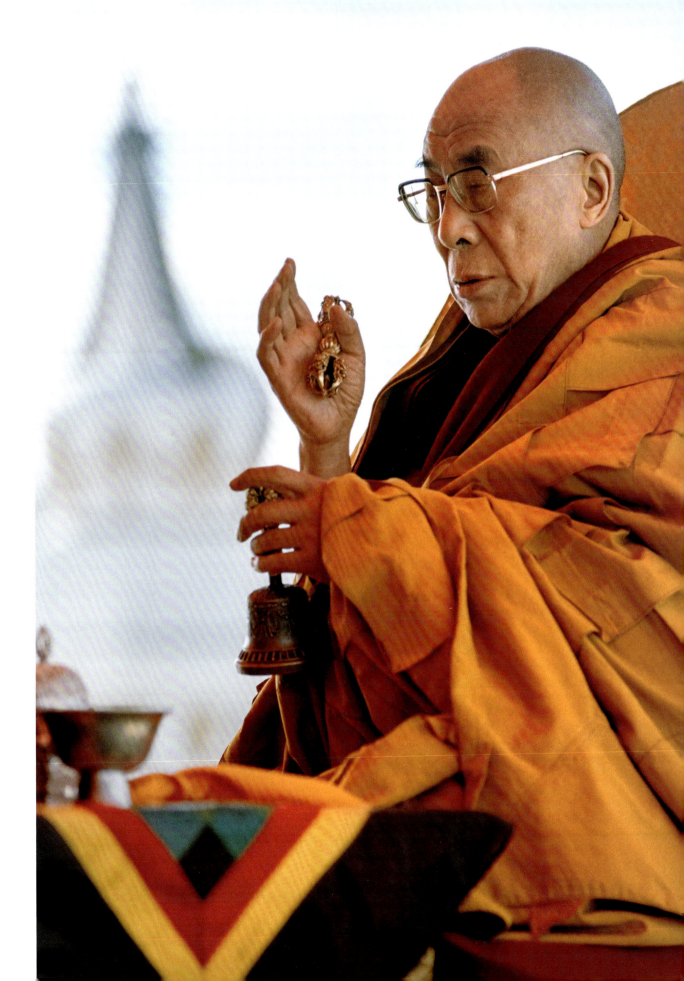

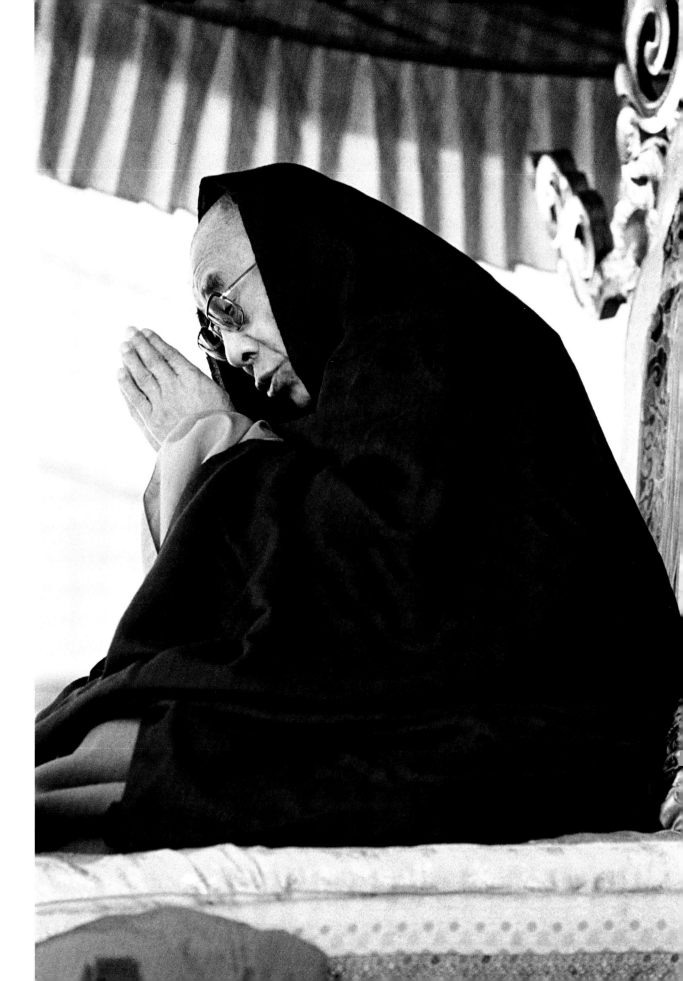

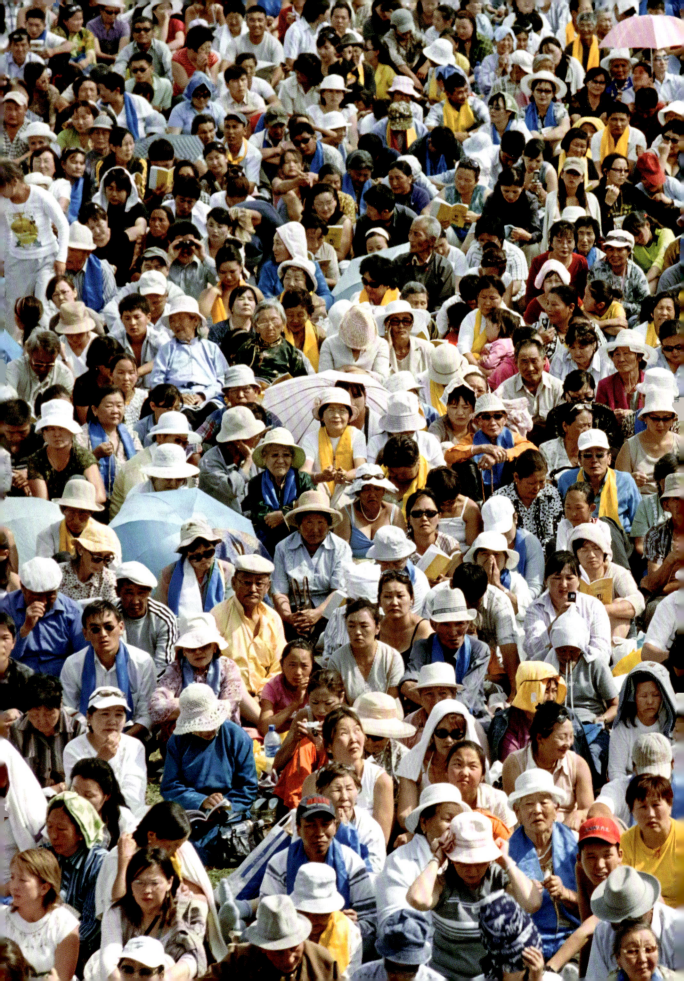

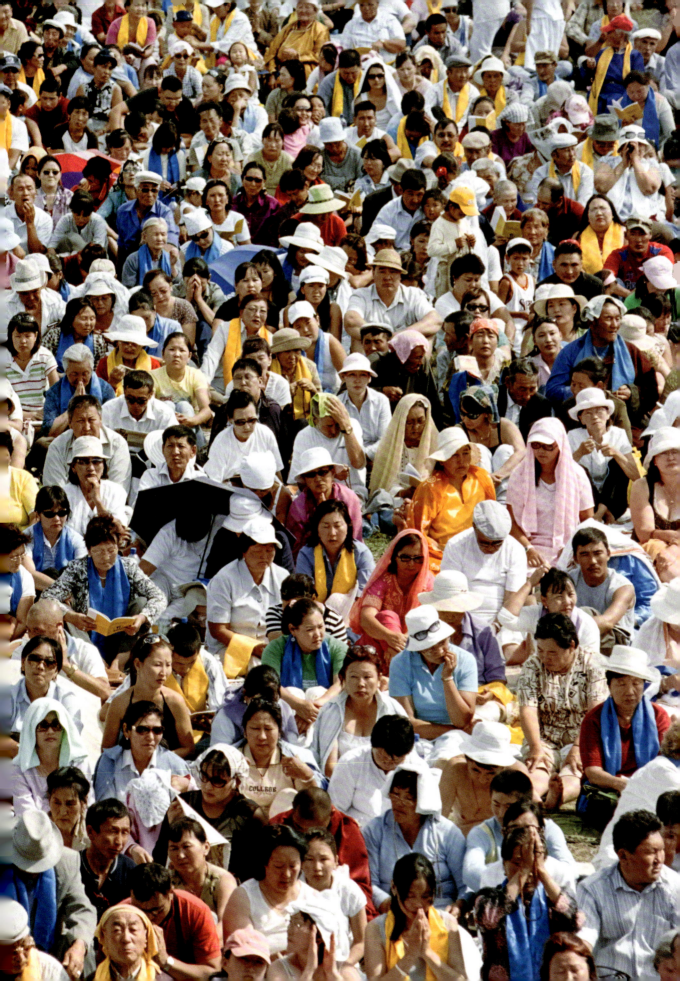

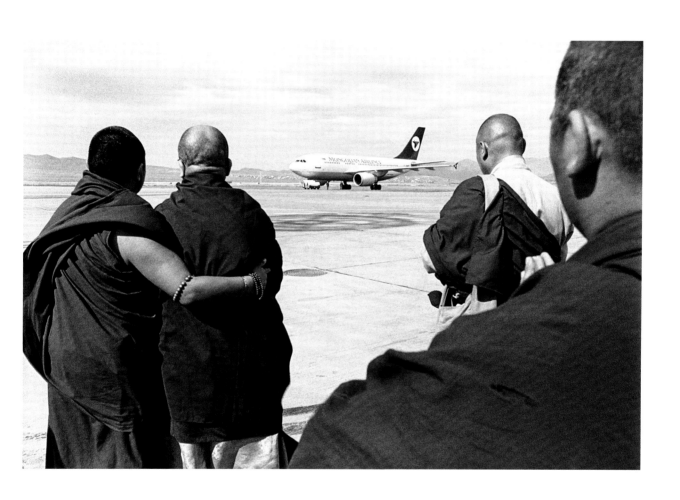

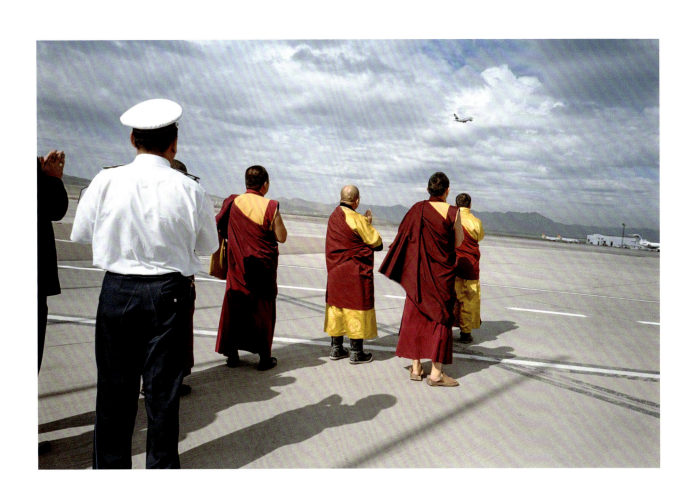

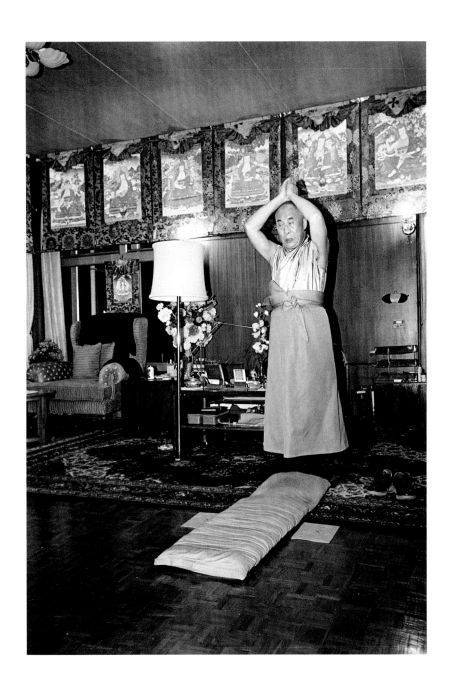

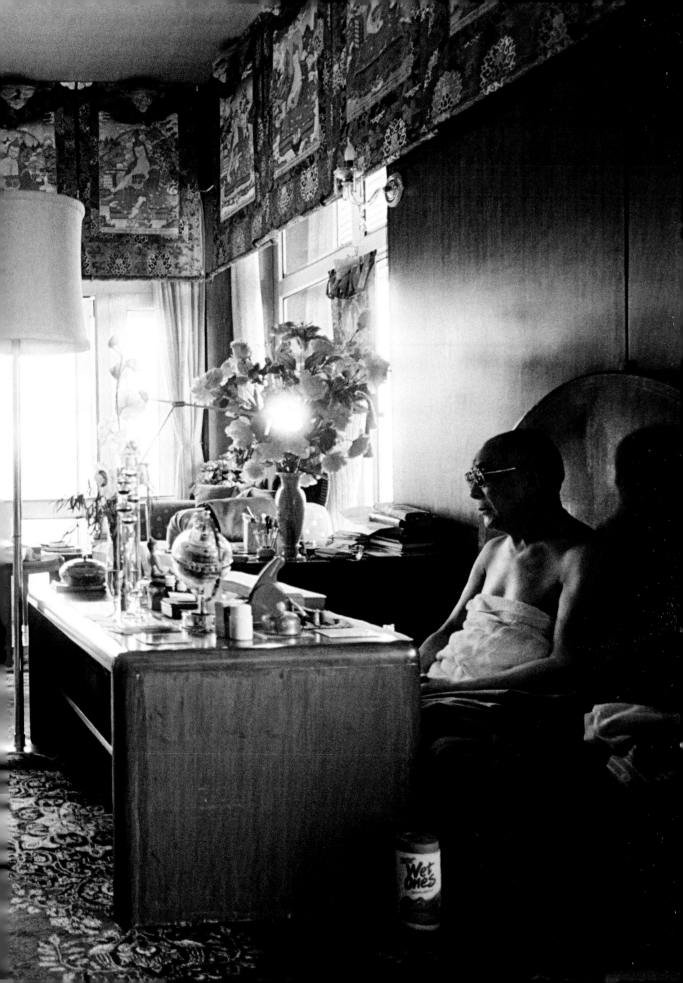

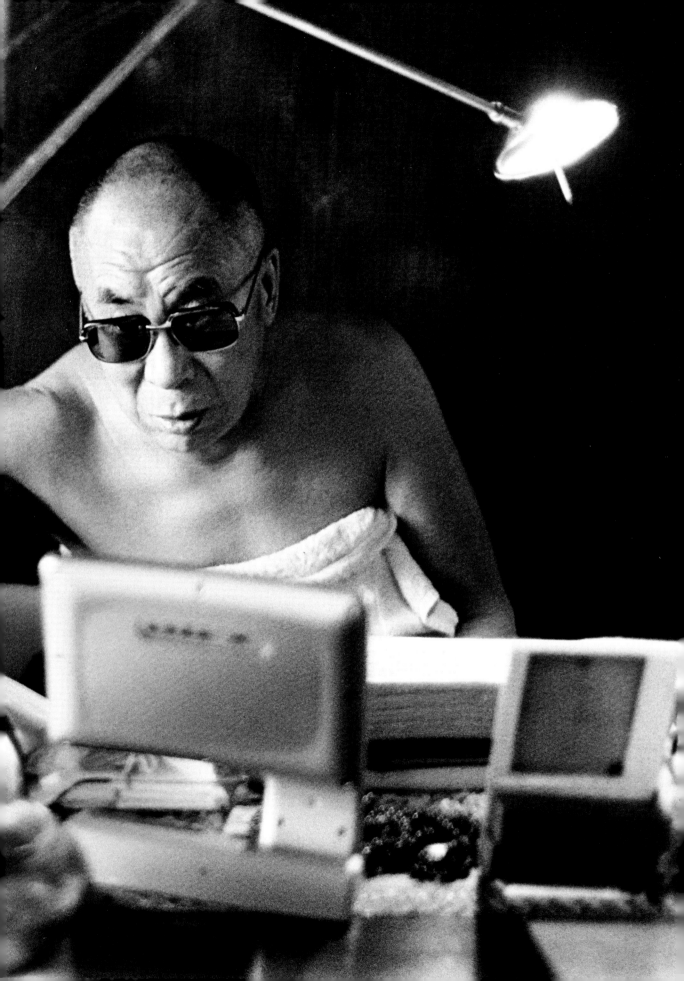

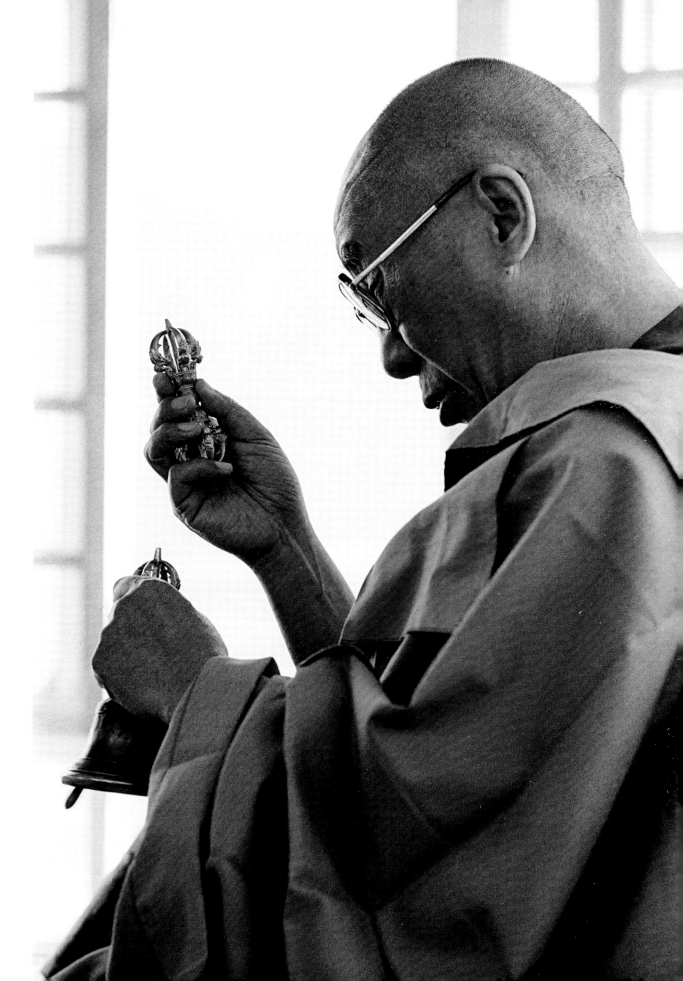

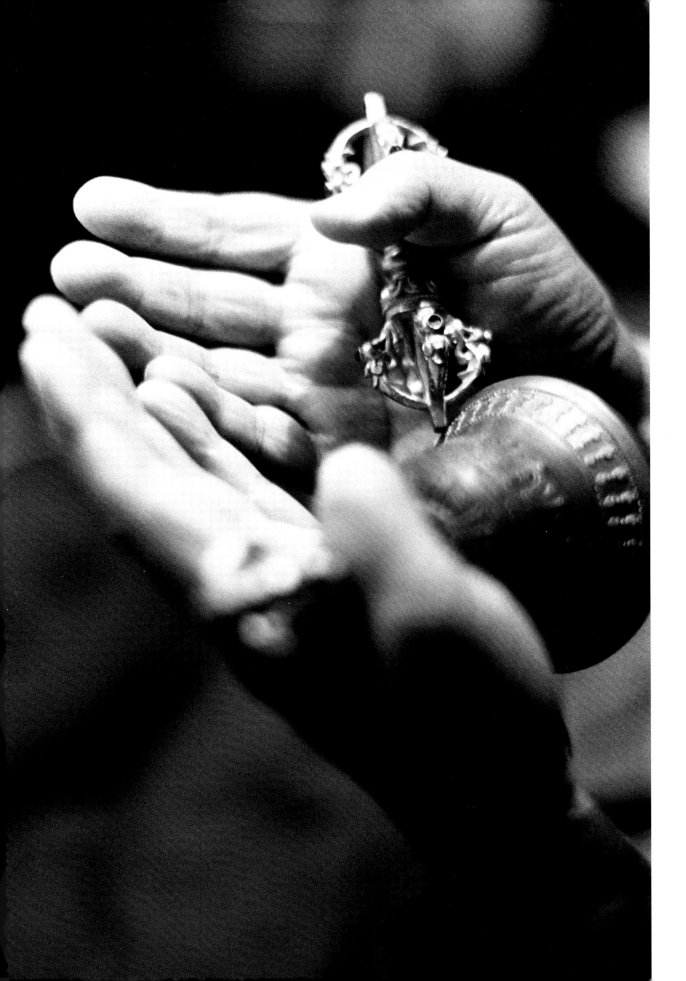

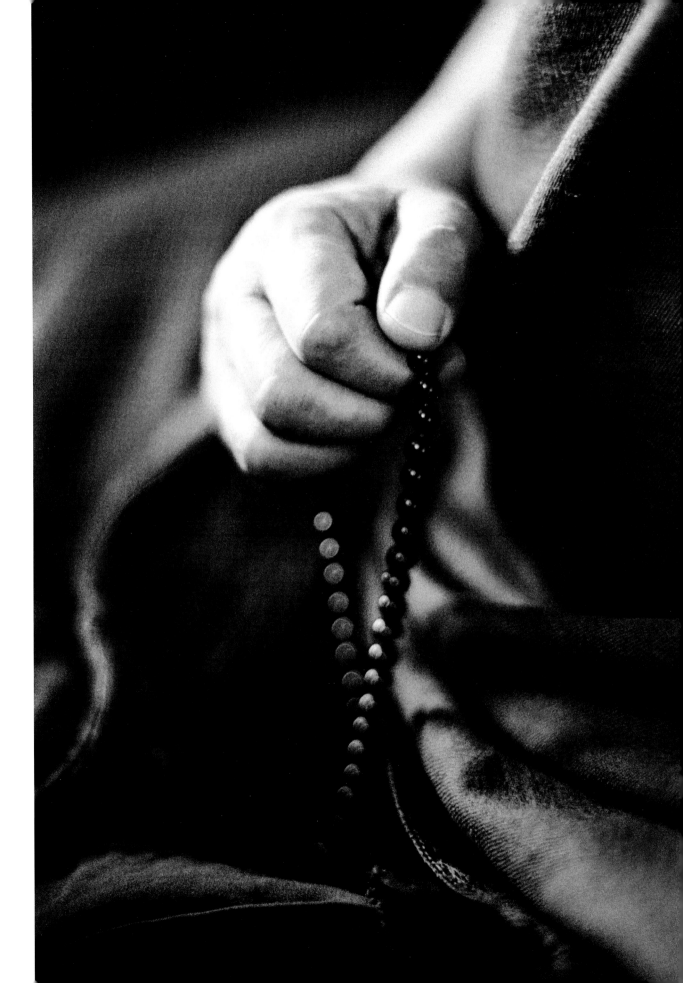

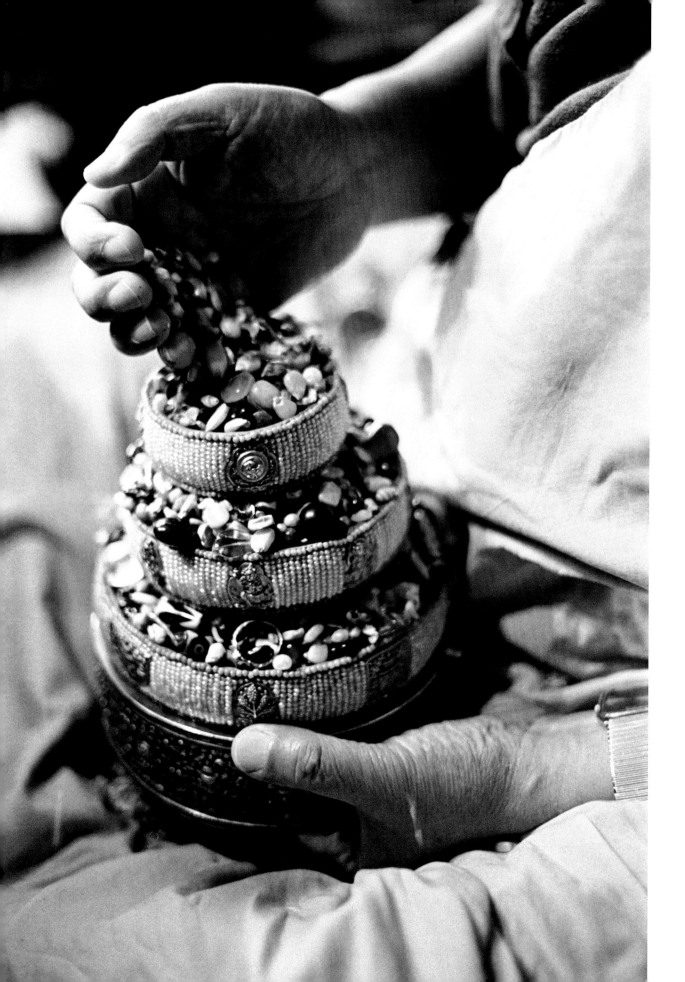

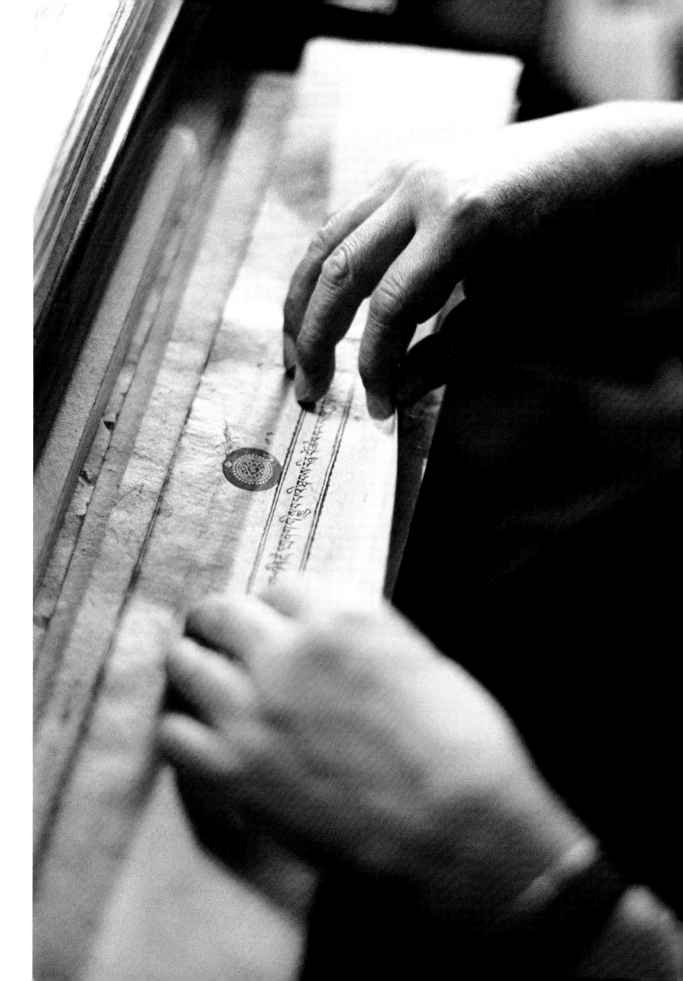

THE KALACHAKRA CEREMONY

A Tibetan Buddhist Rite for World Peace

His Holiness the Dalai Lama conducted his first Kalachakra Empowerment in Lhasa, Tibet, in 1954, when he was just twenty (according to the Tibetan system). Two years later, in 1956, he performed another Kalachakra Ceremony in Lhasa. Both ceremonies were attended by around 200,000 devotees. Since then, he has bestowed his empowerment thirty-two times, for the most part in India, including at Amravati, a site associated with the emergence of the Kalachakra teachings. Beyond India, he has conducted the ceremony in Switzerland (Rikon, 1985), Spain (Barcelona, 1994), Mongolia (Ulaanbaatar, 1995), Australia (Sydney, 1996), Austria (Graz, 2002), and North America, including in Madison (1981),

Los Angeles (1989), Bloomington (1999), Toronto (2004), and Washington, D. C. (2011). His Holiness's most recent Kalachakra Empowerment, the 34th and his last, was held in Bodh Gaya, the sacred site of the Buddha's enlightenment. All the images of the Kalachakra ceremony in this book are from the Dalai Lama's 33rd Kalachakra, which was conducted in Leh, India, in 2014, and attended by over 150,000 devotees.

Kalachakra Empowerment is an intensive, multi-day ritual requiring the Dalai Lama, as the *Vajra* Master, to oversee every stage of the process from start to finish. He is assisted by the monks of Namgyal Monastery, who are historically responsible for supporting the Dalai Lama in all major ceremonies. Their tasks include preparing the ground for the mandala, invoking the deities of the mandala, consecrating the site, and, finally, dismantling the mandala once the empowerment is over. Throughout, the Dalai Lama and the monks perform meditation and rituals to invoke the enlightened beings associated with the Kalachakra mandala, thus ensuring their presence throughout the ceremony.

The key stages of the ceremony include:

– Blessing the site for the mandala's creation

– Performing the *saghar,* a ritual dance by monks around the mandala platform

– Consecrating water in ritual vases for use during the ceremony

– Drawing the sand mandala and coloring it with colored sands

– Consecrating the mandala by inviting "wisdom beings" to inhabit its form

– Conducting the preparatory initiation, followed, over several days, by the actual empowerment

– Concluding the ceremony with the dismantling of the mandala

"Kalachakra," meaning "Wheel of Time," is an important teaching and practice in Tibetan Buddhism, originating from Indian Buddhism. It belongs to the Vajrayana, or "Adamantine Vehicle," an advanced class of Mahayana teachings. Vajrayana emphasizes complex visualization practices and yogic techniques involving breathwork and the body's energy centers (*chakras*), all grounded in the union of compassion and wisdom. It views the body as a microcosm of the universe, integrating body, mind, emotions, and the natural environment in the path to enlightenment.

In Kalachakra, this interplay is explicit. The cosmos is called the "outer Kalachakra," while the human body is the "inner Kalachakra." Their transformation into enlightened forms is facilitated by meditative practices known as the "alternative Kalachakra." The teachings include a detailed cosmological system and an intricate understanding of the body's elements, such as its stationary channels, moving winds, and subtle energy points (drops). This union of external and internal purification underscores the traditional Tibetan view of the Kalachakra Empowerment as profoundly transformative, not only for individuals but for the world as well. This explains why performance of the ceremony is often associated with promoting world peace. Formally, the Kalachakra belongs to the more

advanced Vajrayana system. As part of preparing the attendees, therefore, His Holiness typically discourses on Buddhism more generally prior to the actual empowerment, focusing especially on the cultivation of the twin virtues of compassion and wisdom.

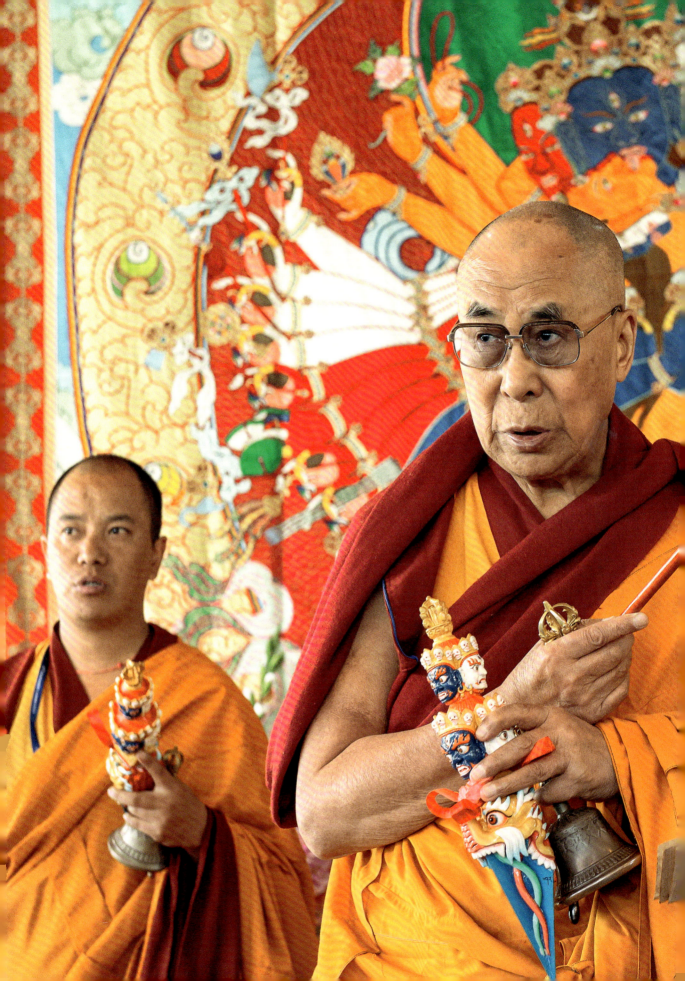

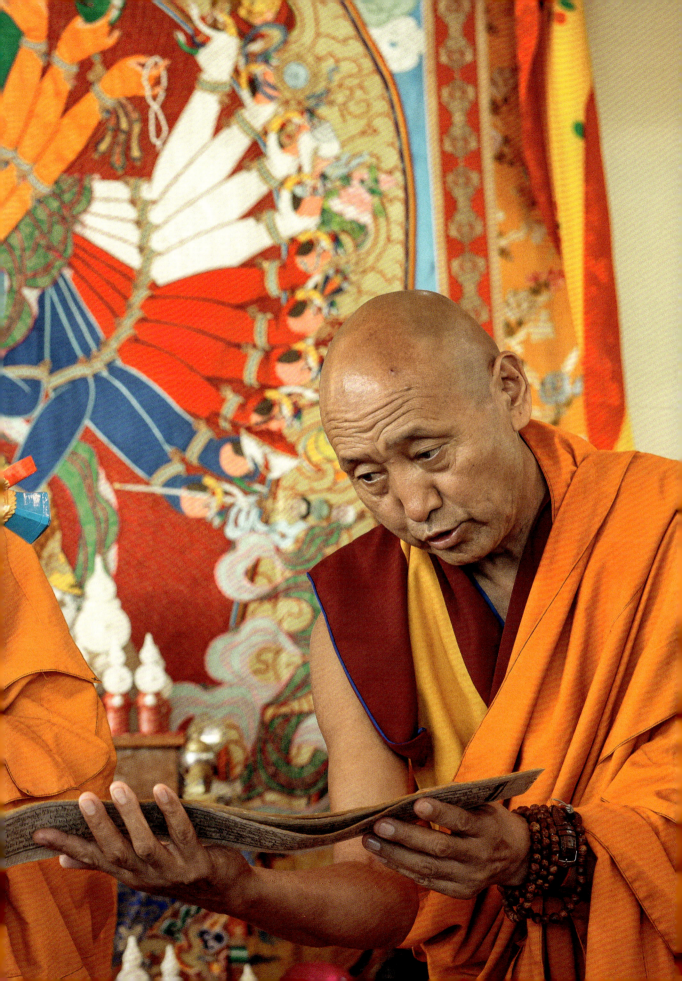

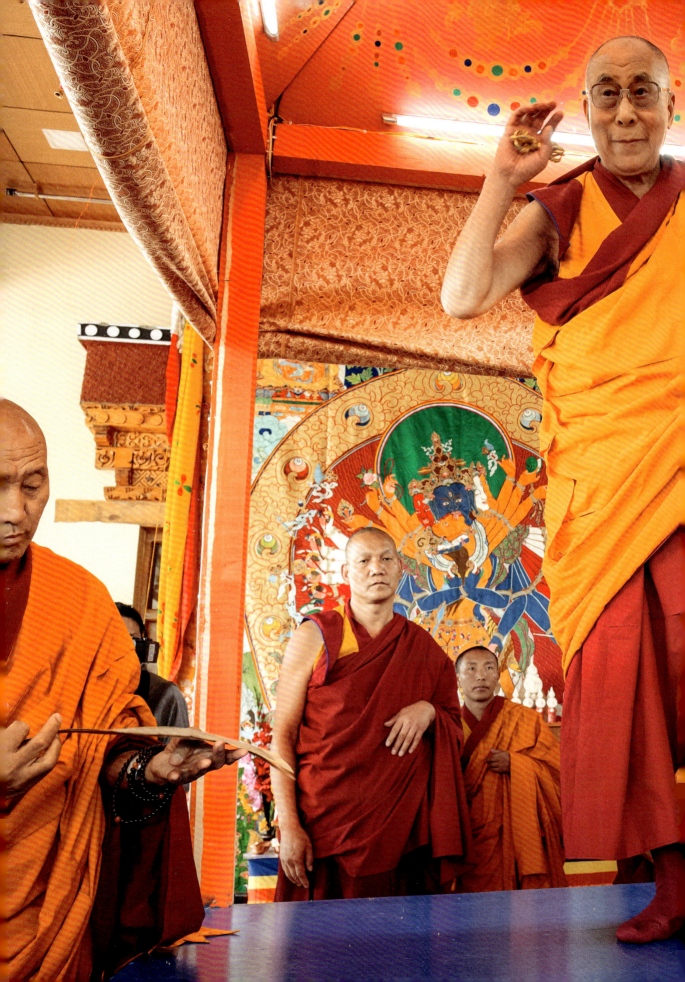

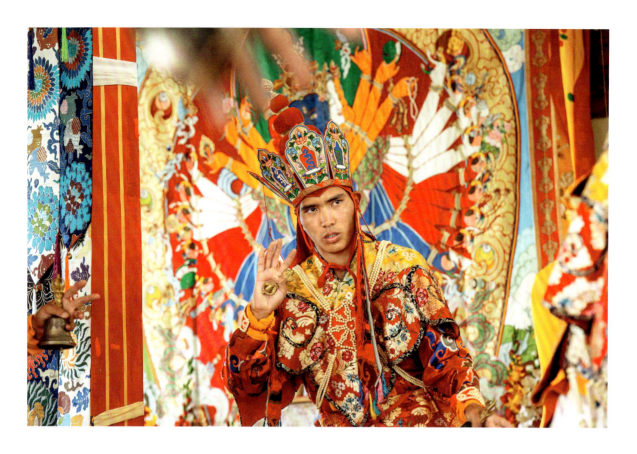
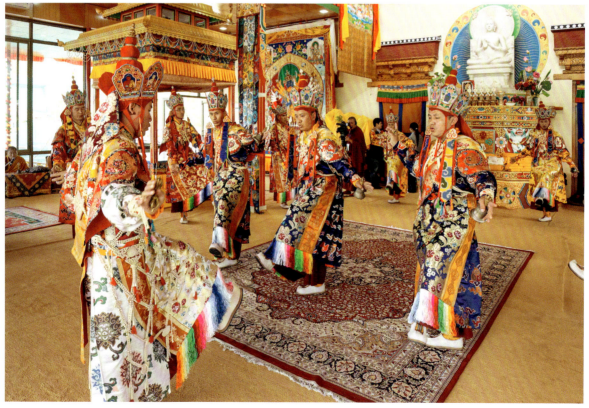

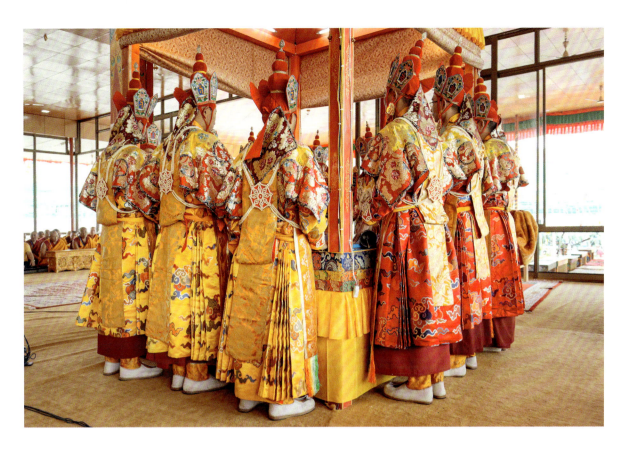

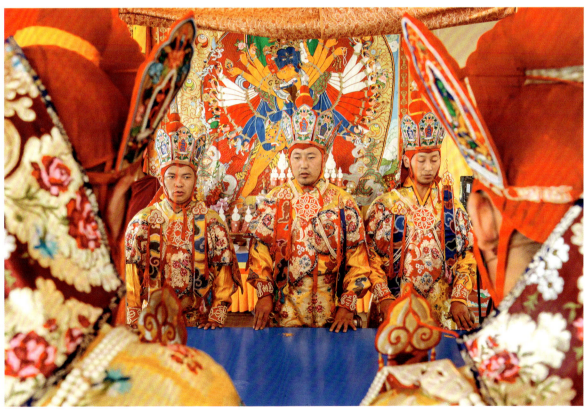

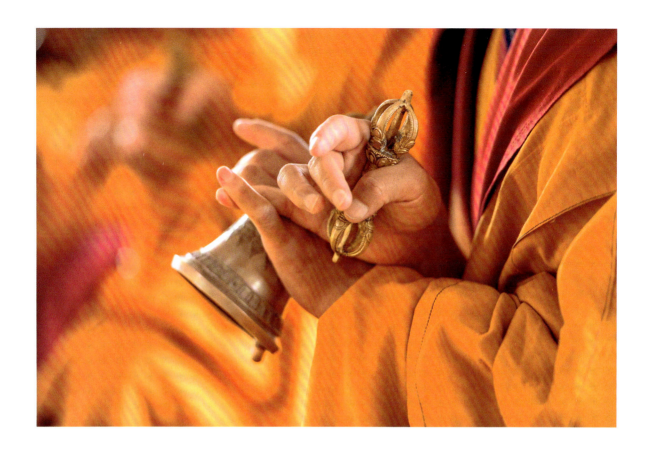

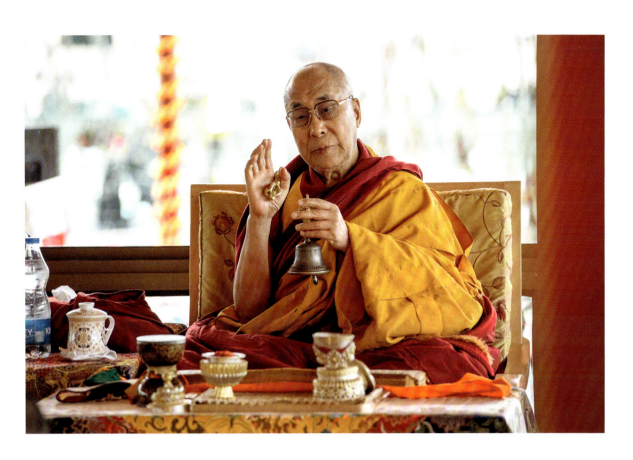

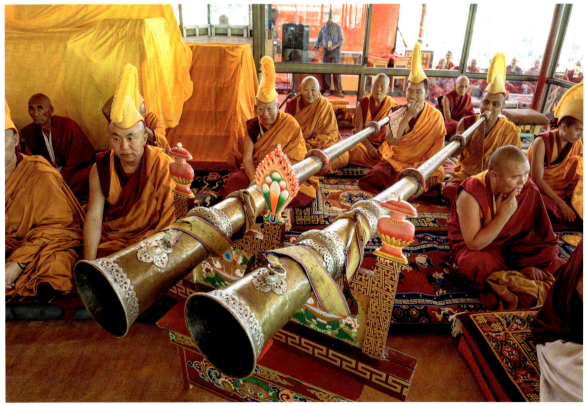

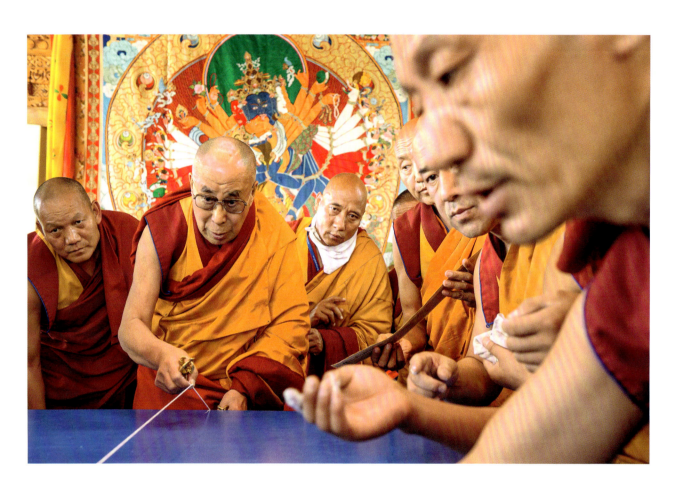

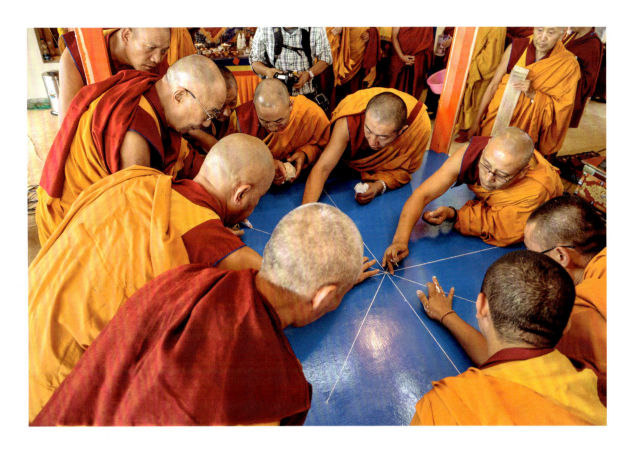

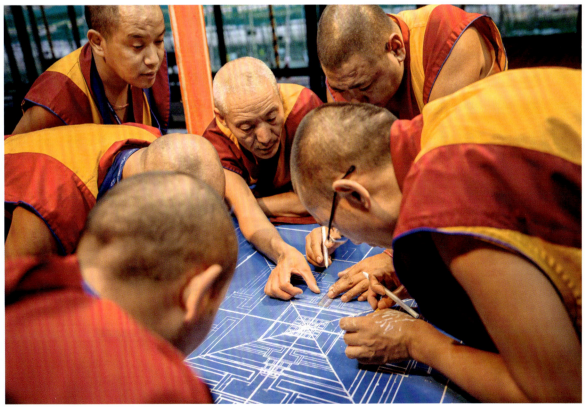

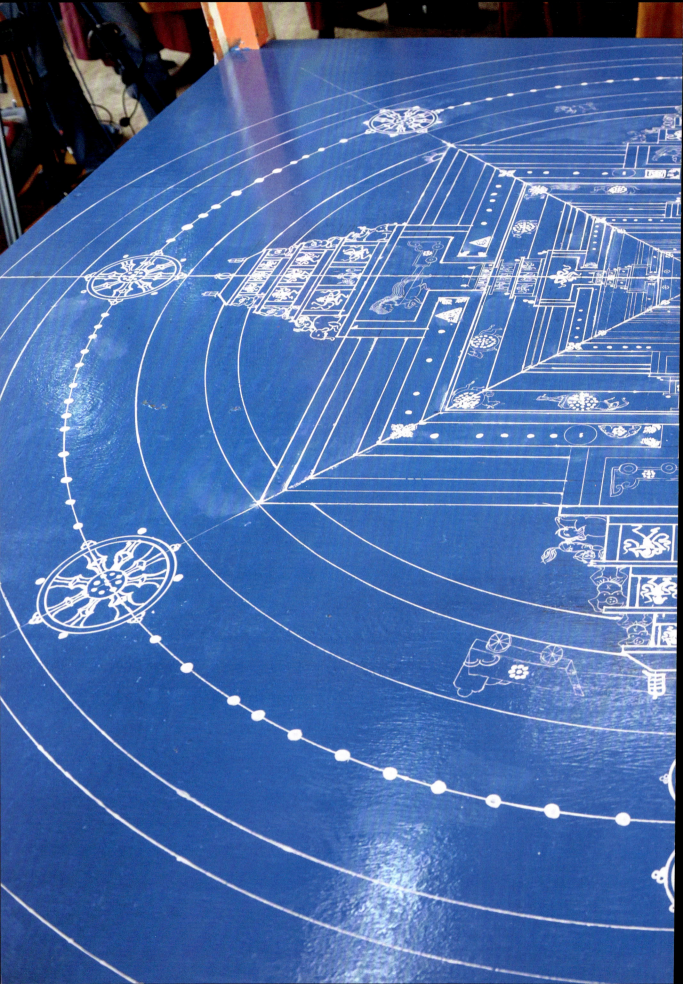

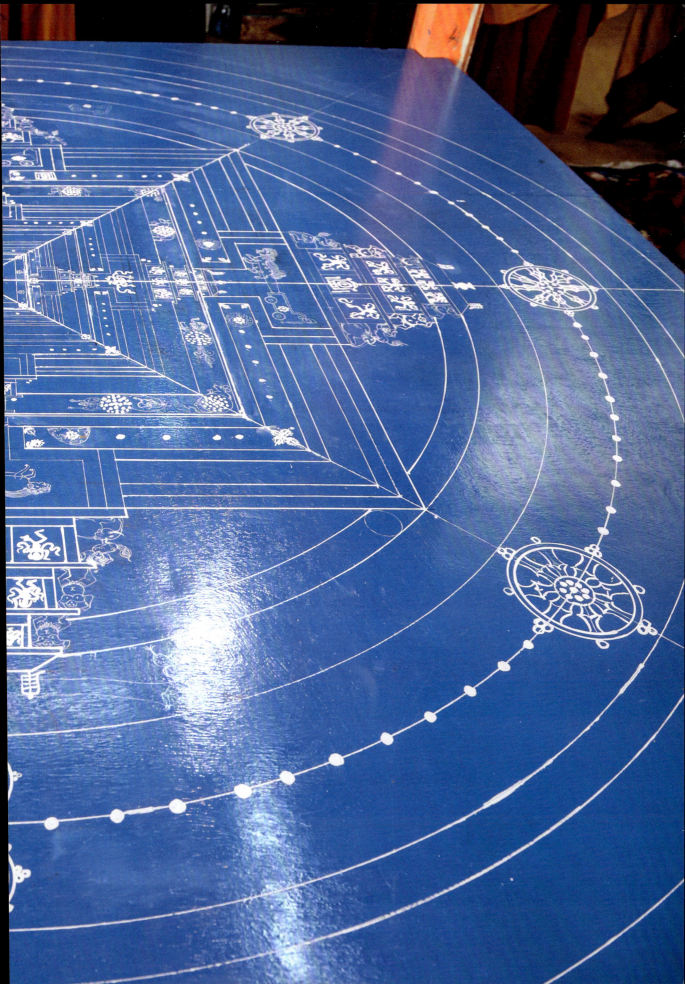

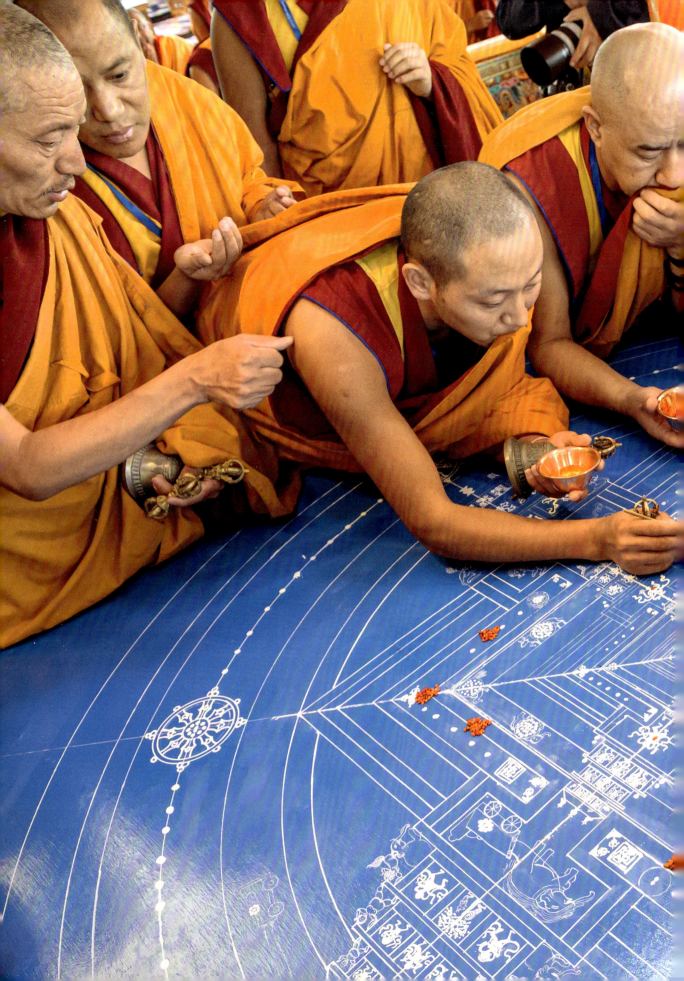

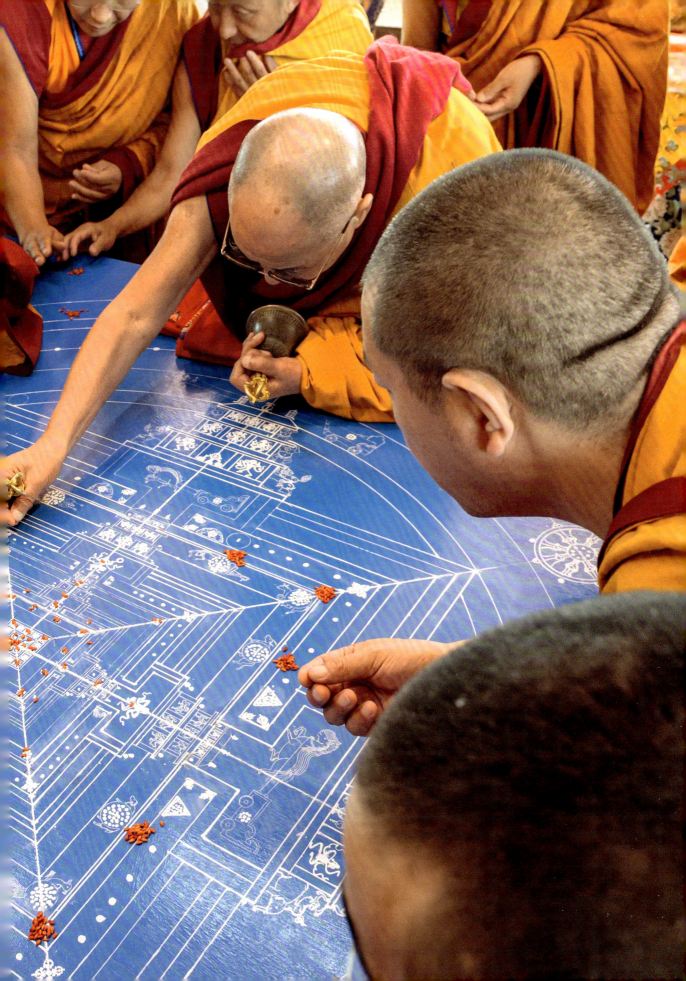

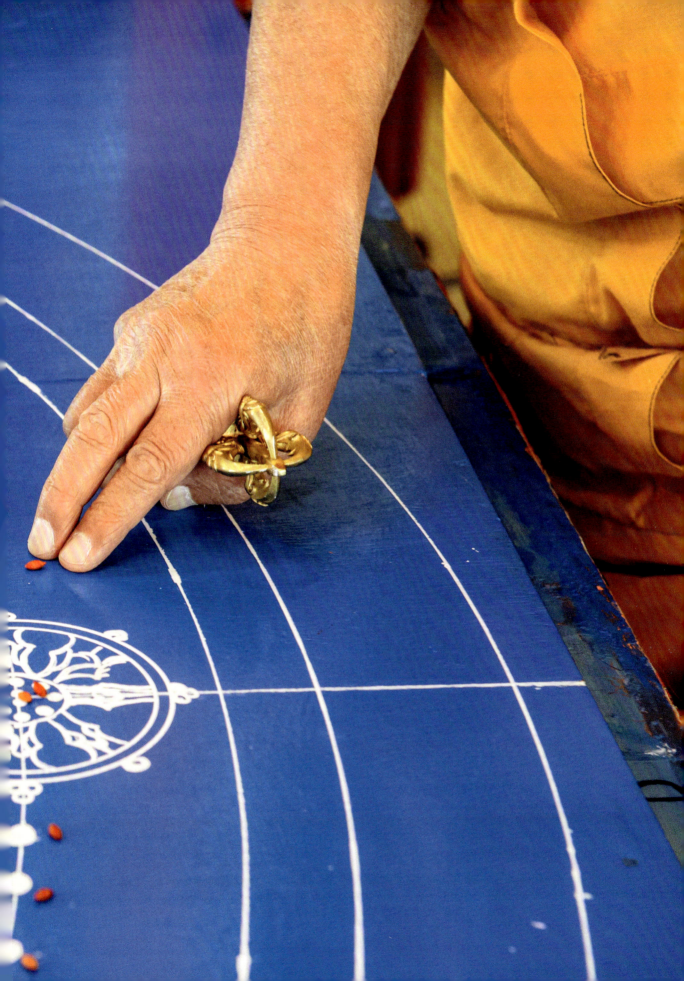

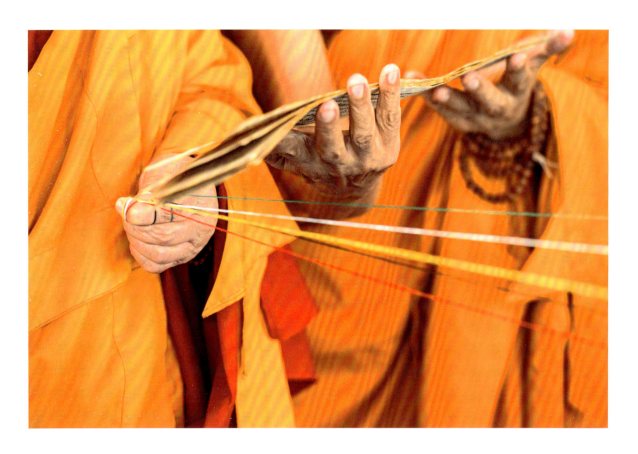

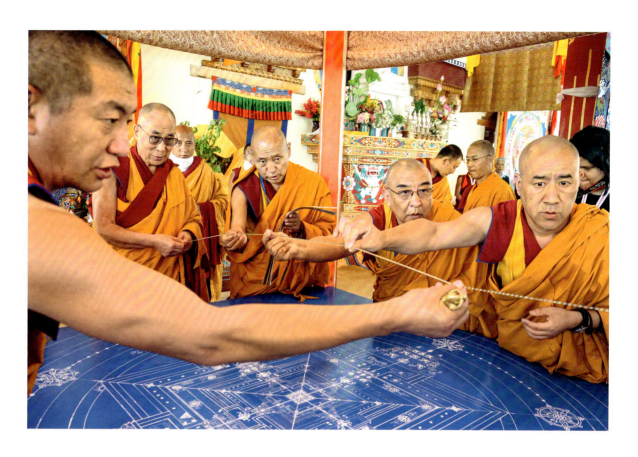

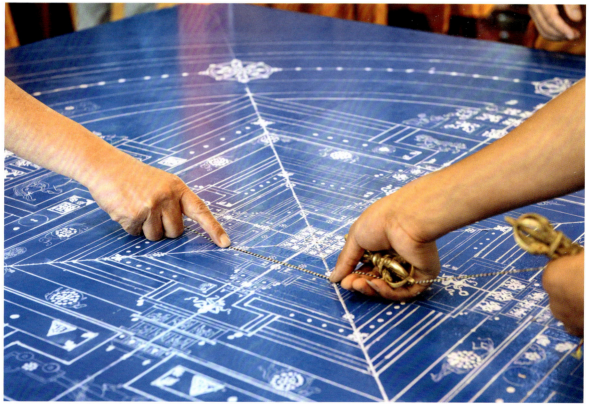

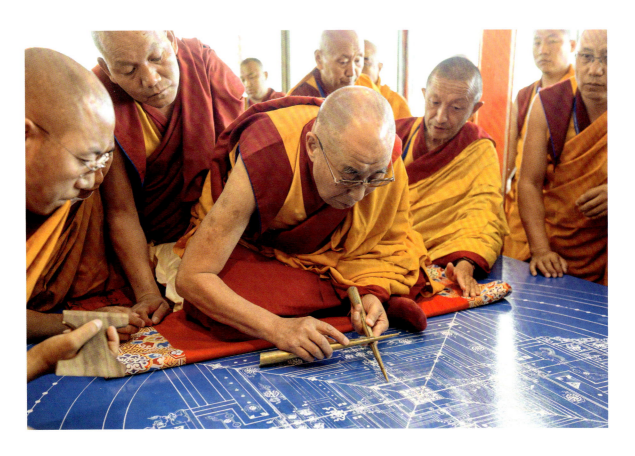

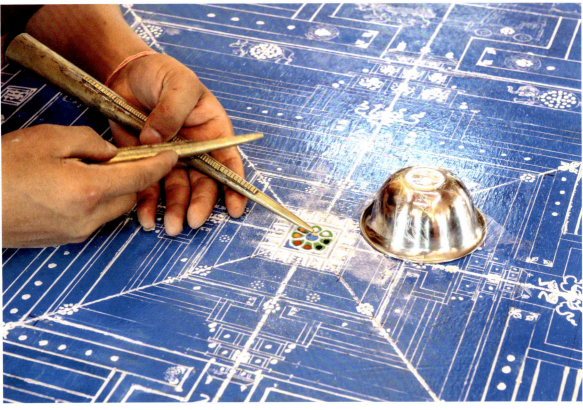

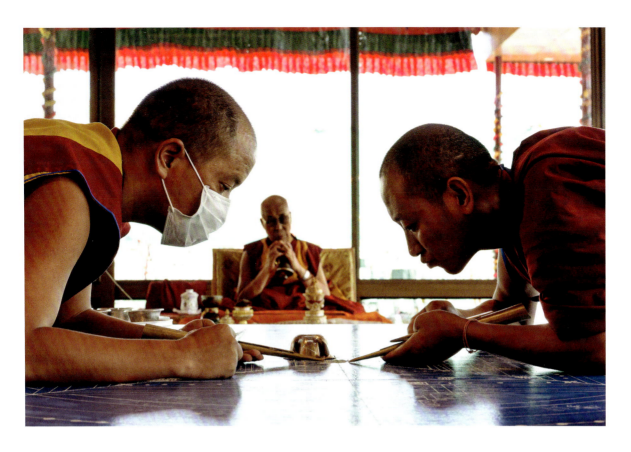

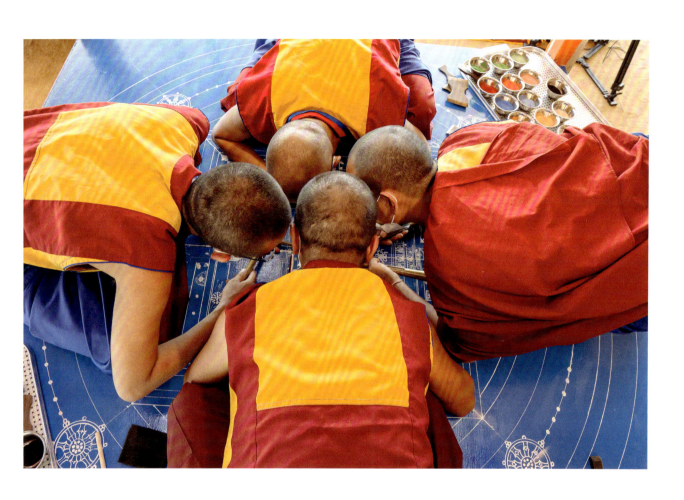

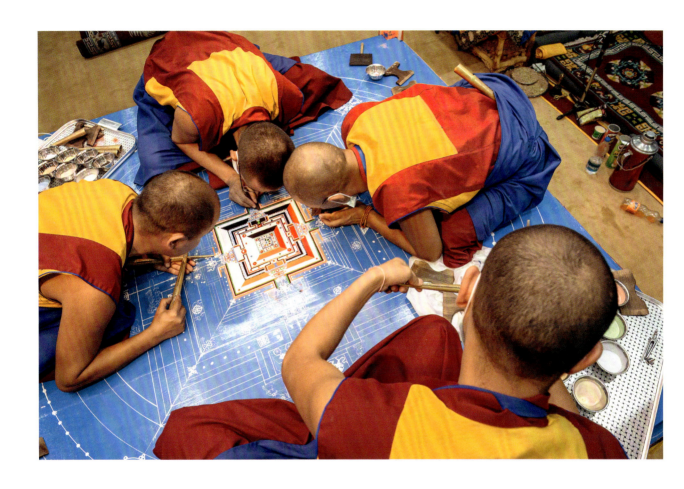

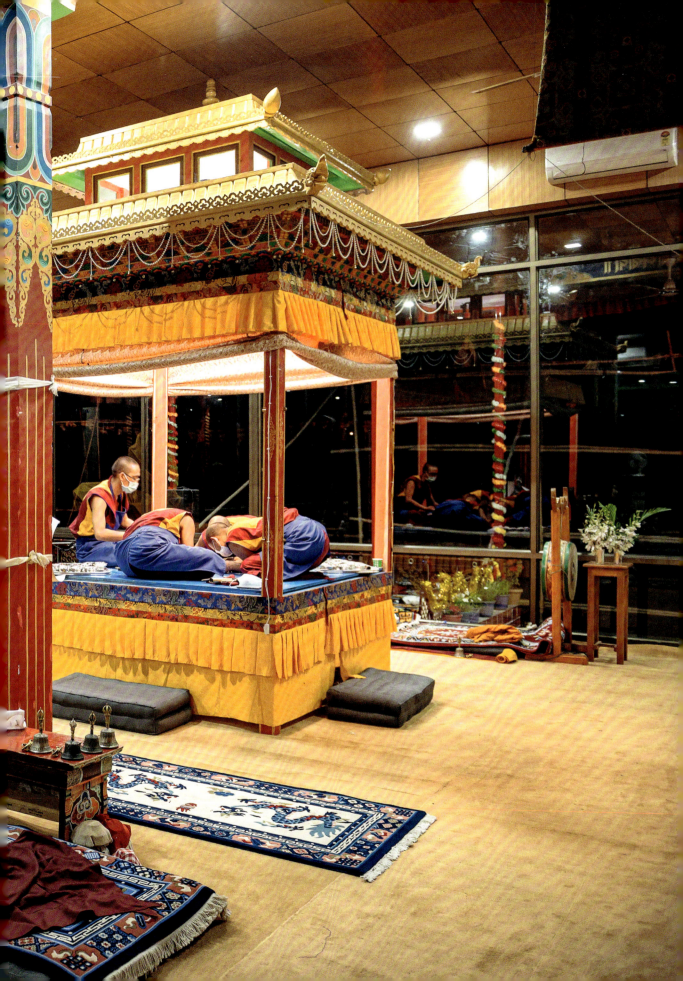

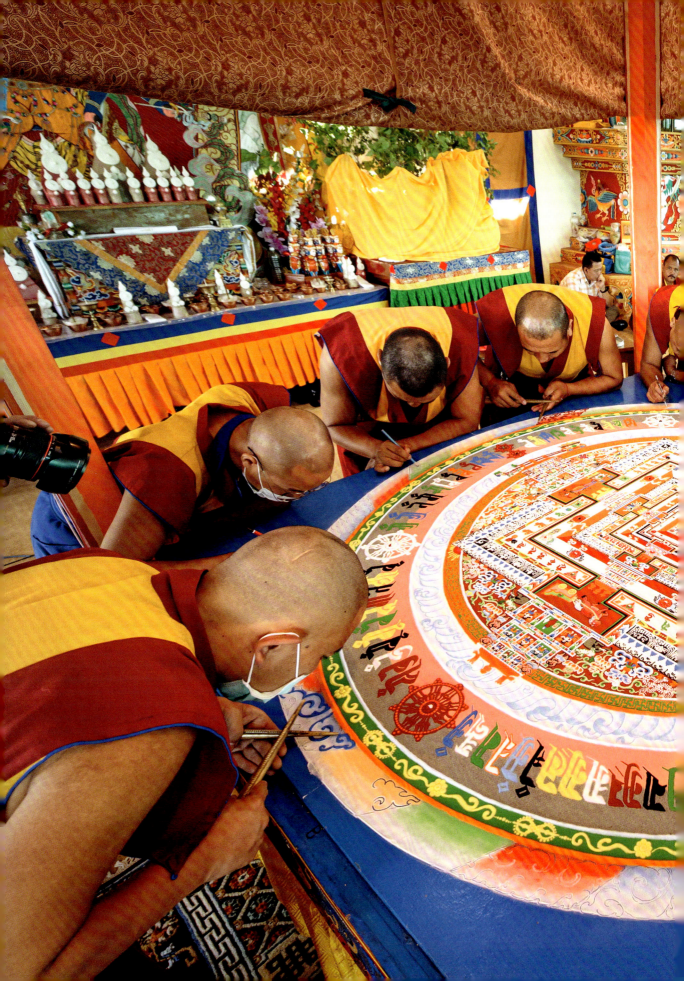

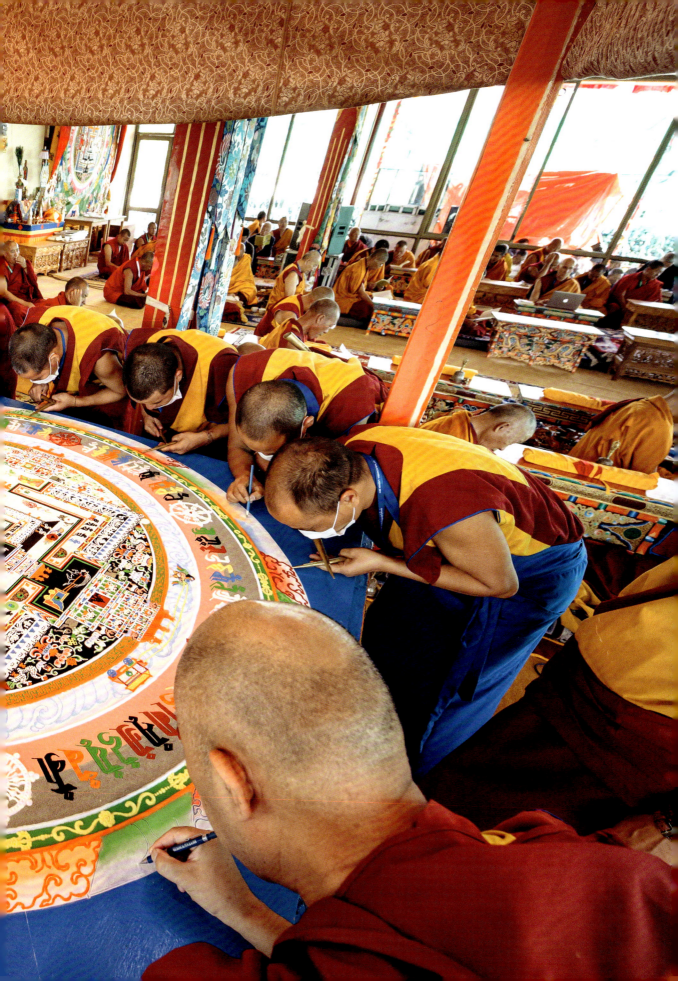

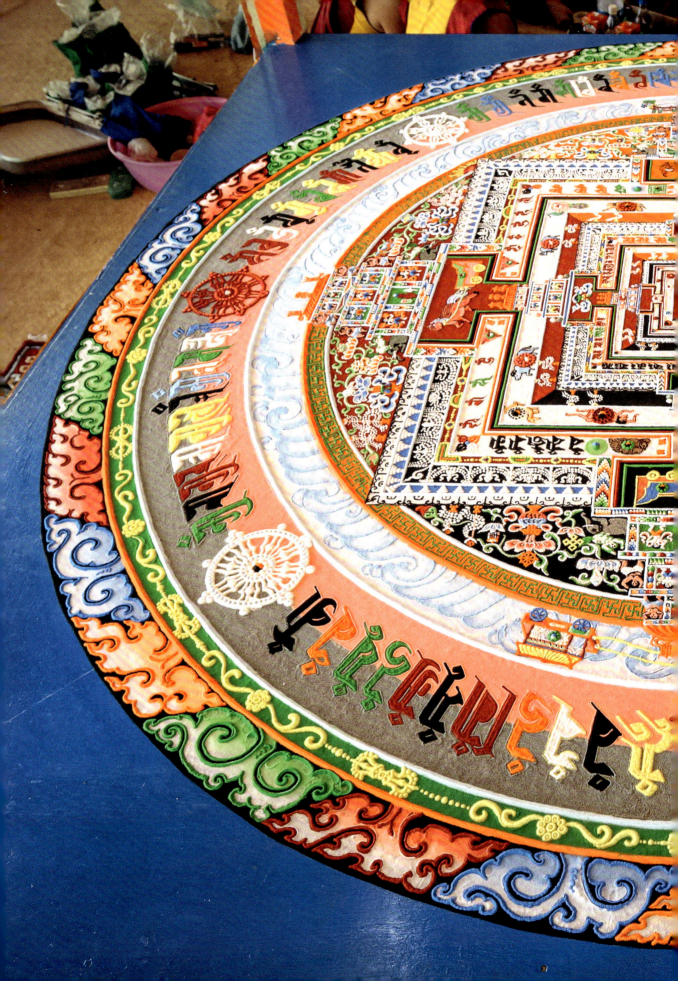

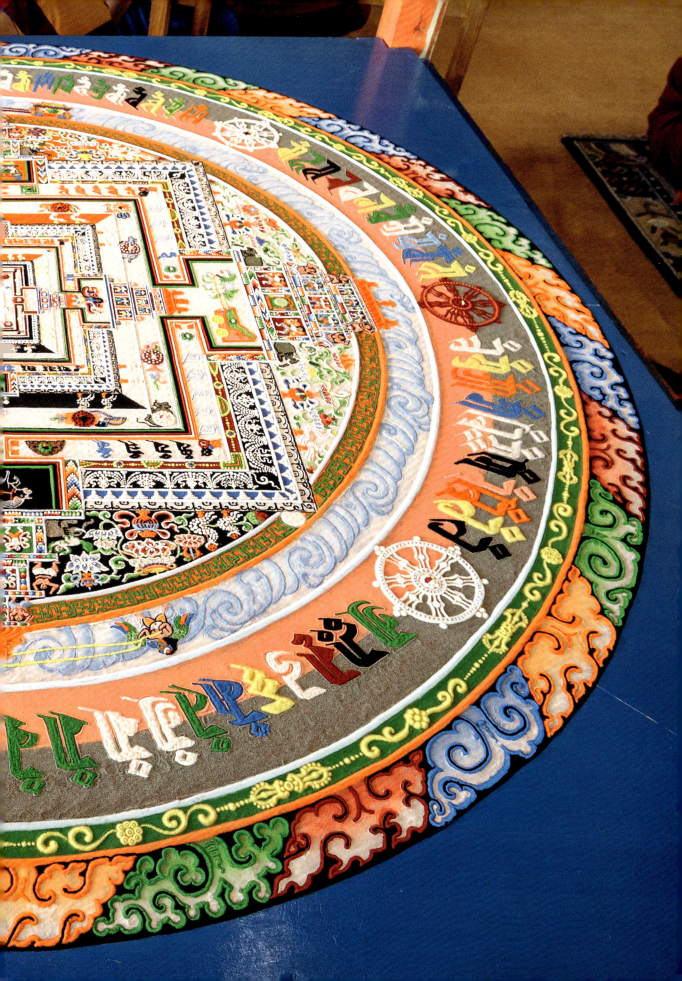

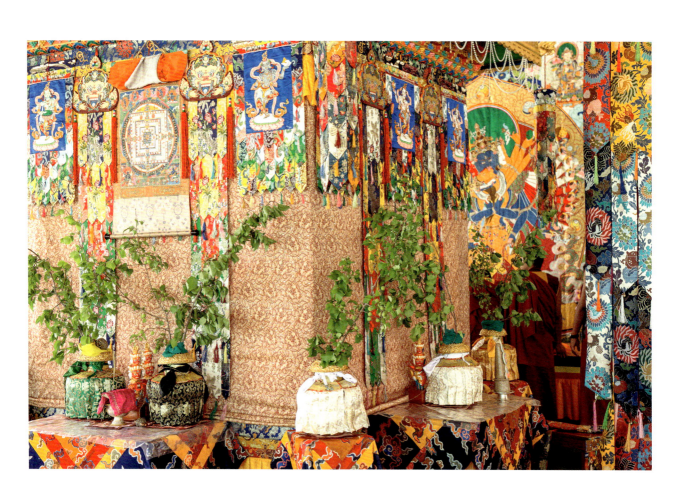

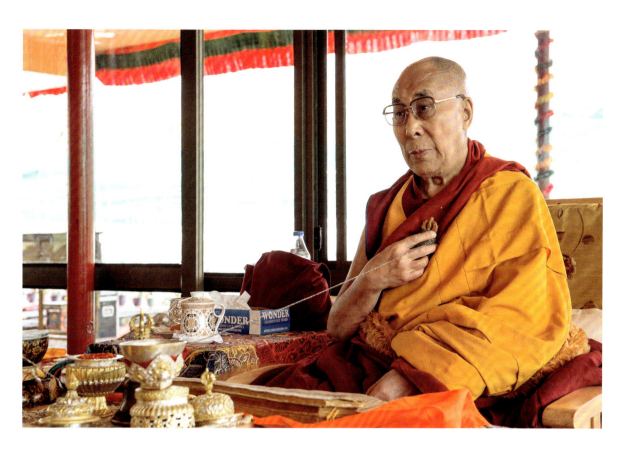

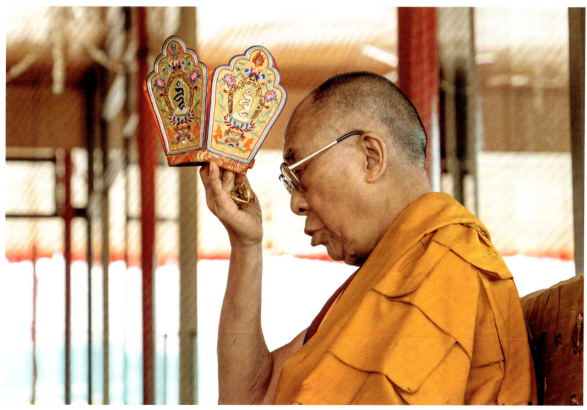

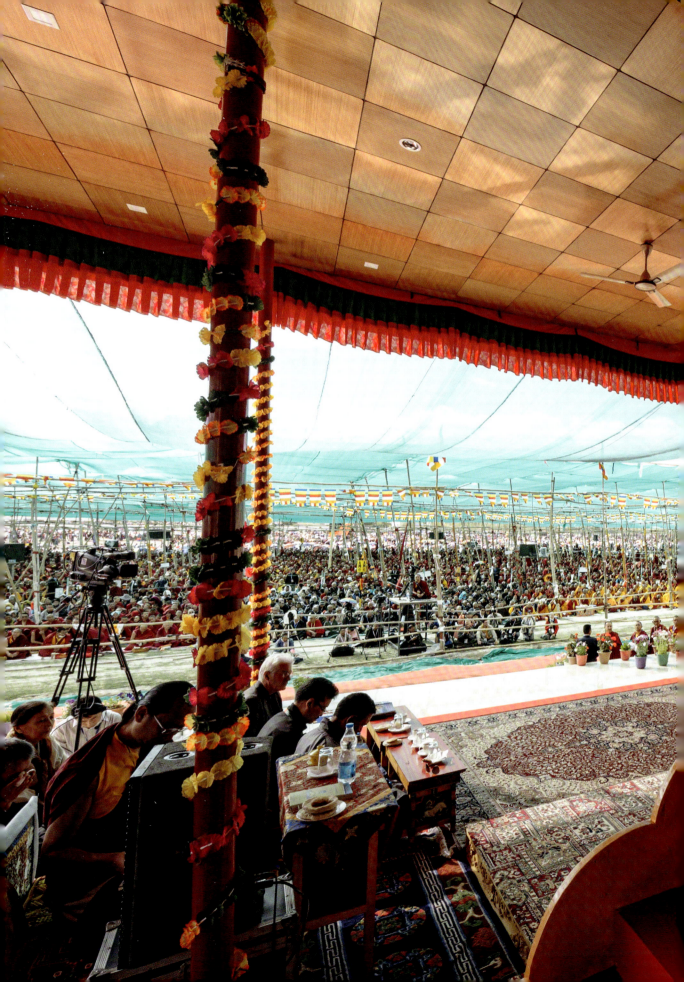

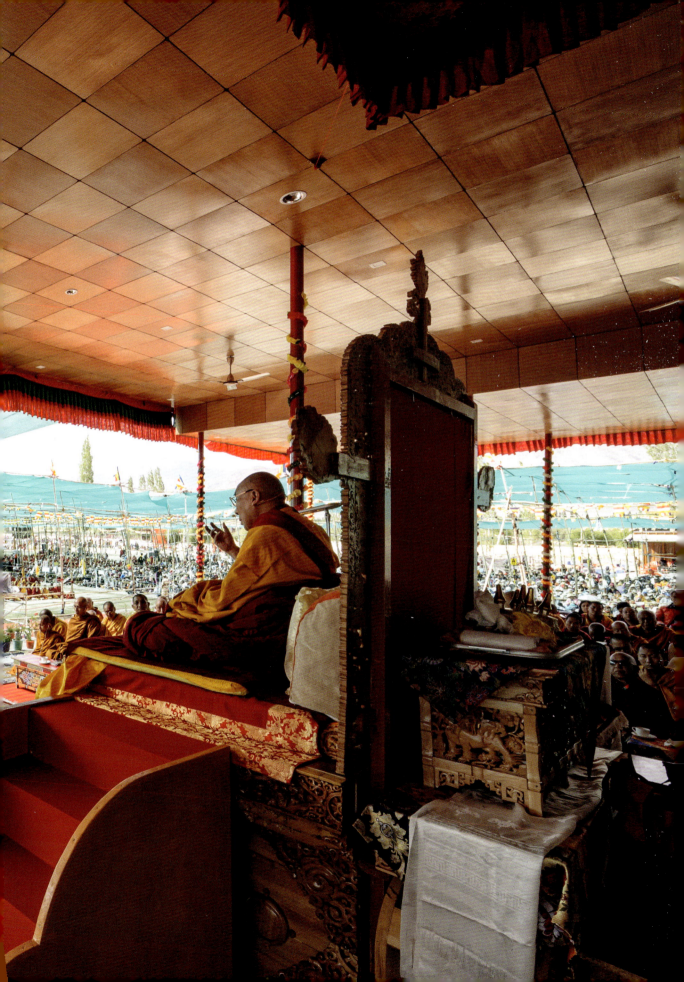

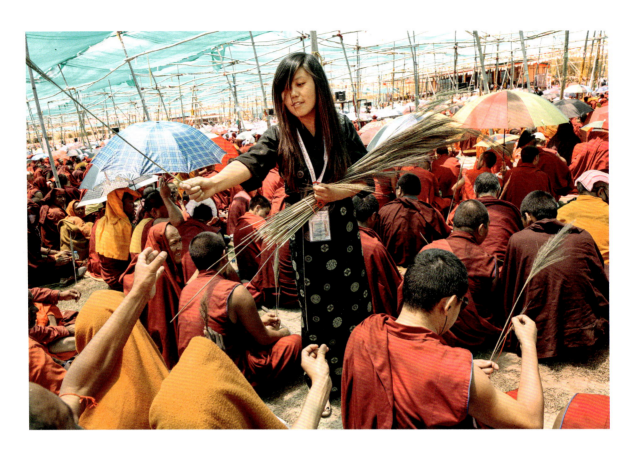

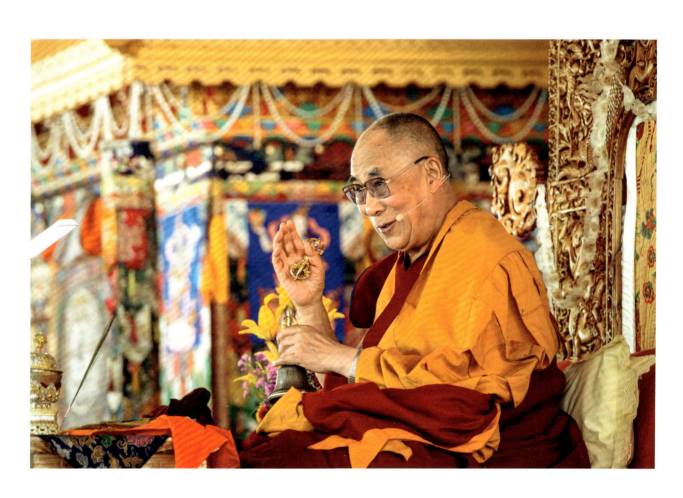

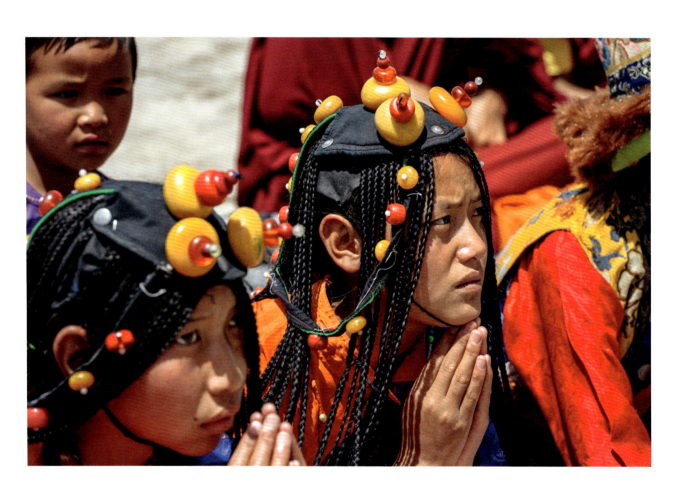

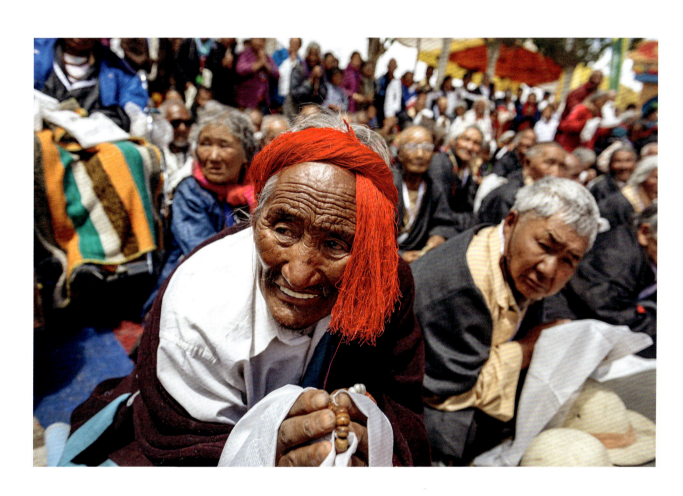

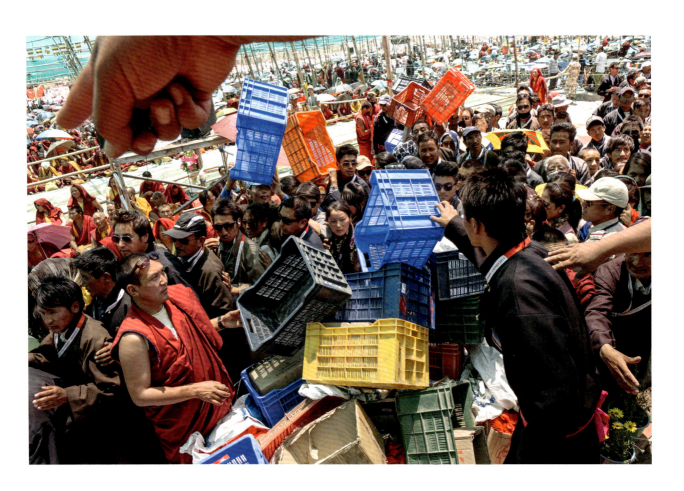

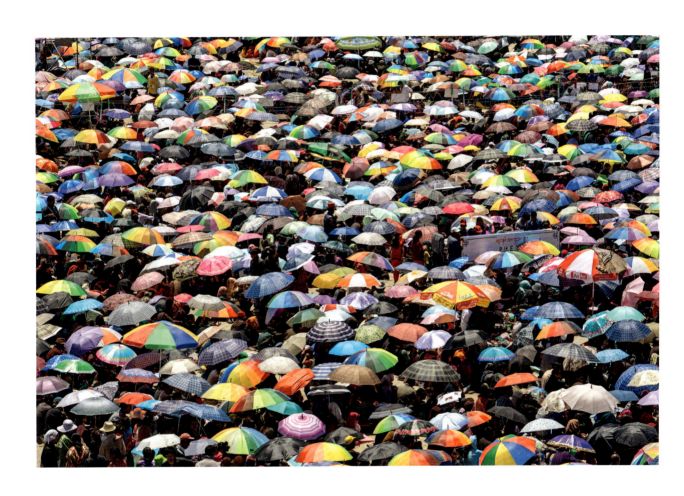

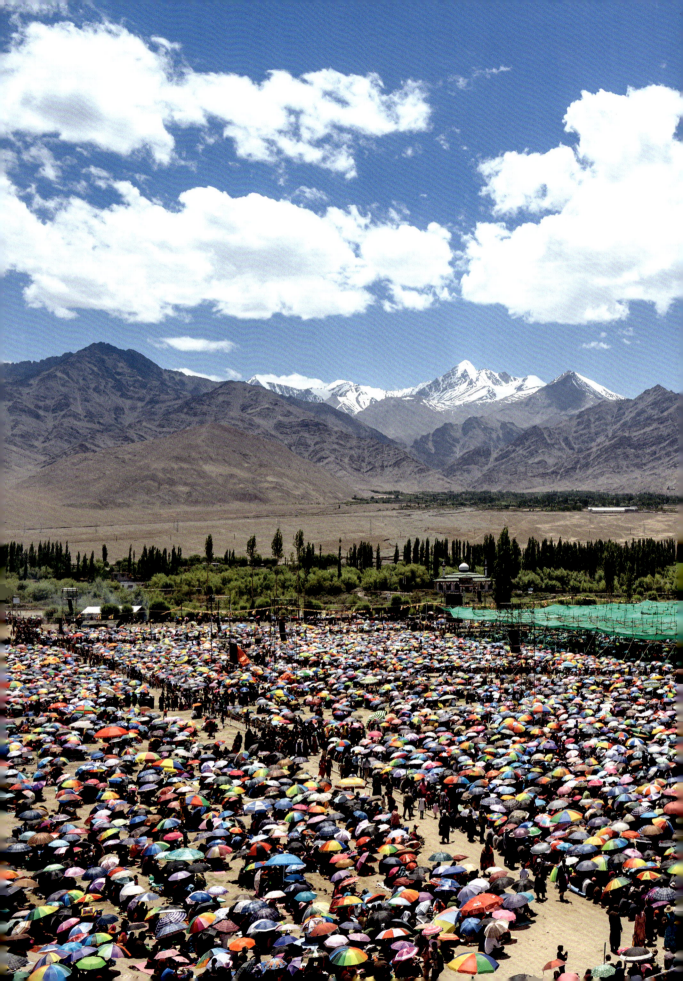

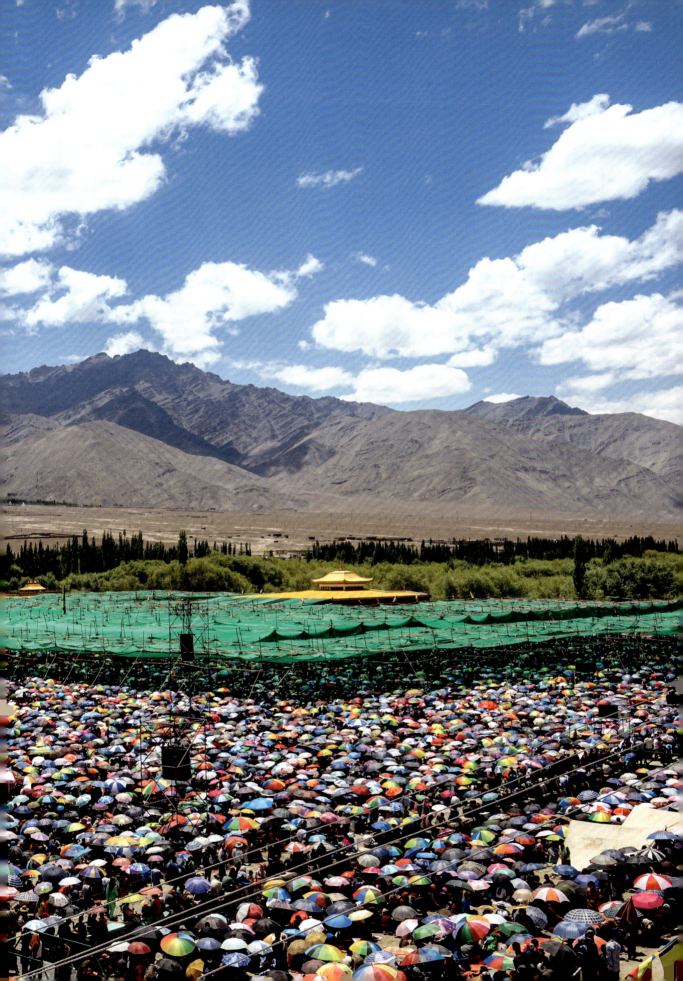

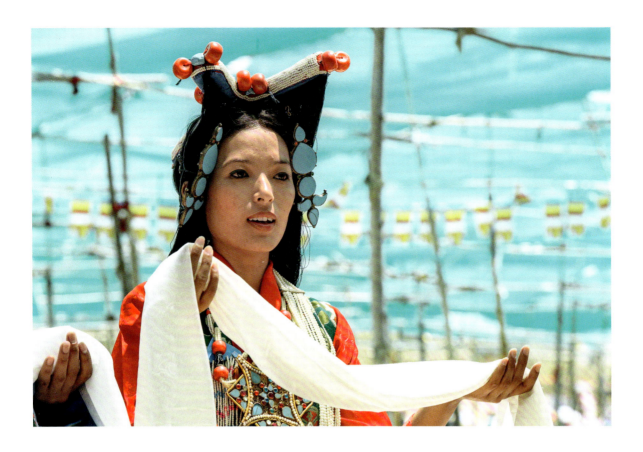

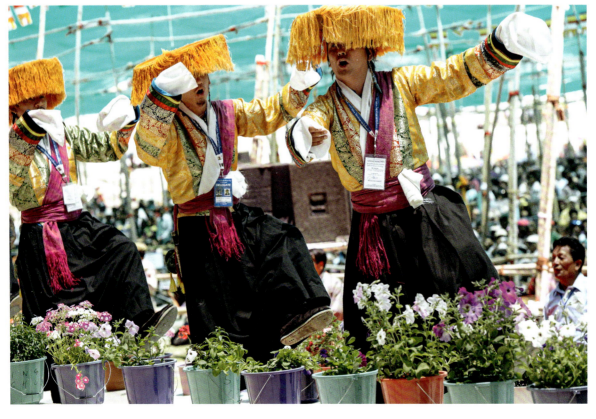

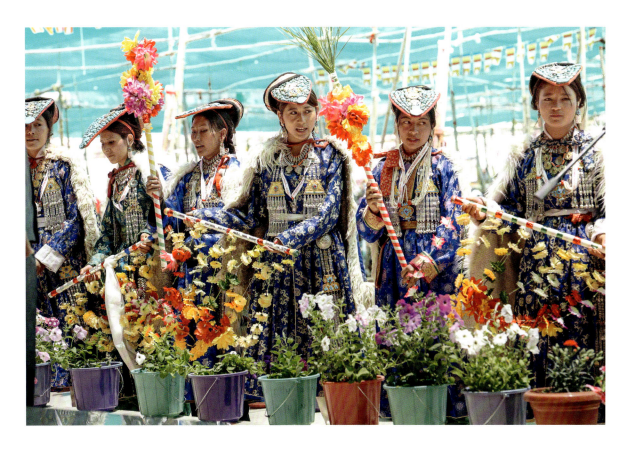

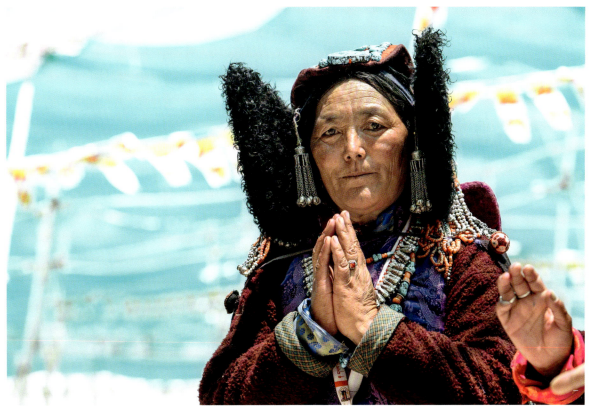

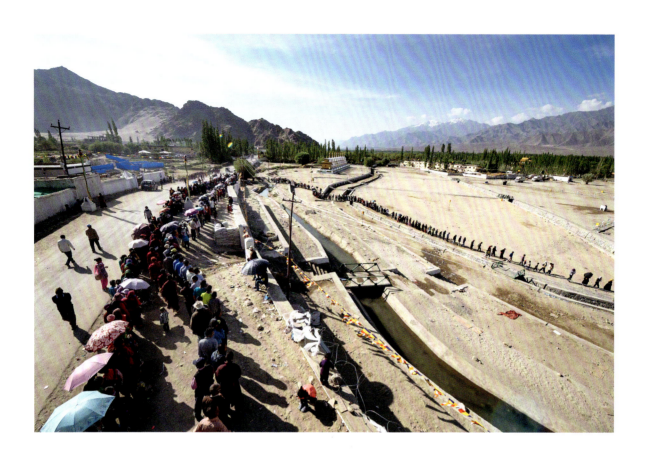

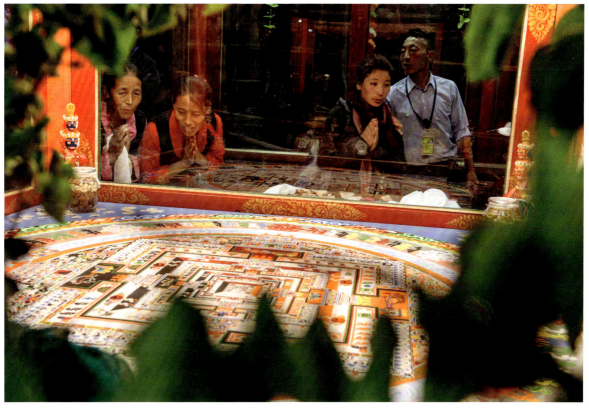

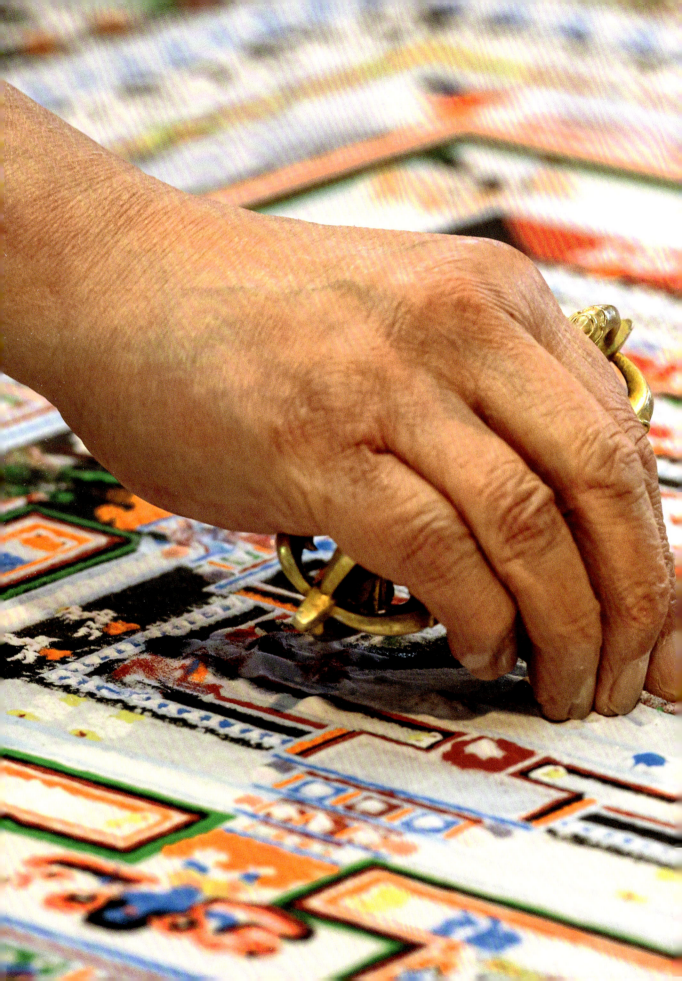

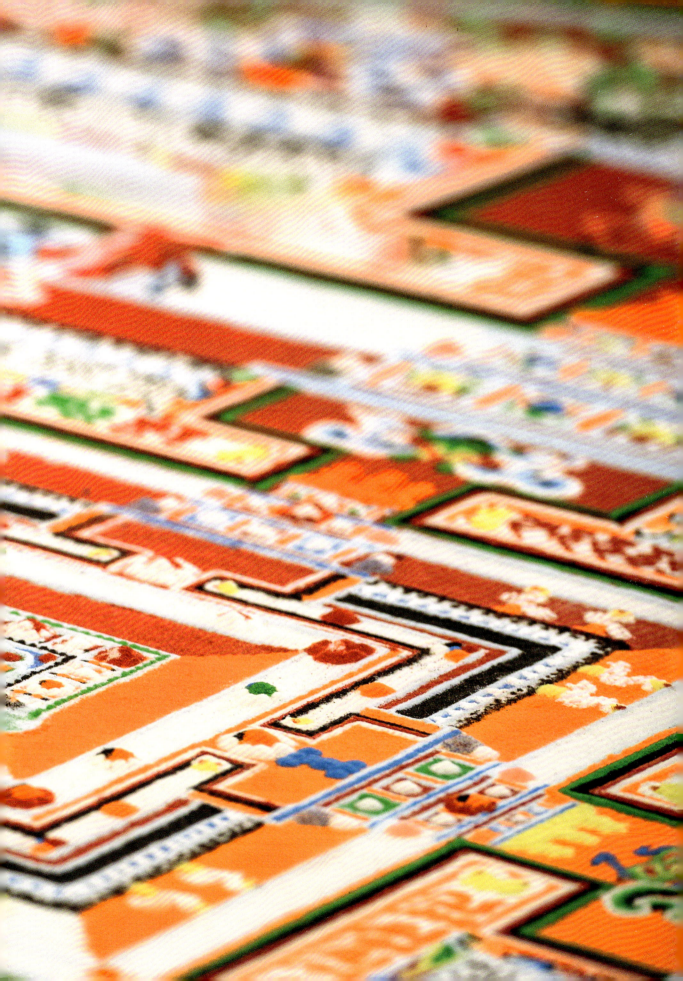

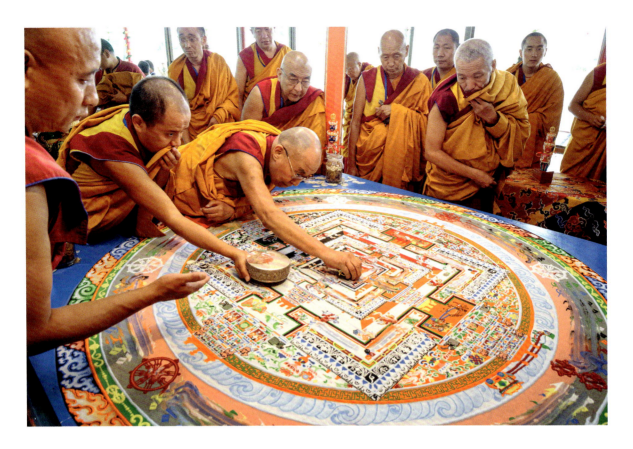

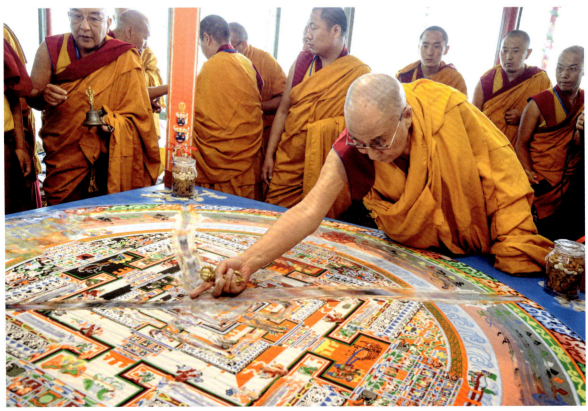

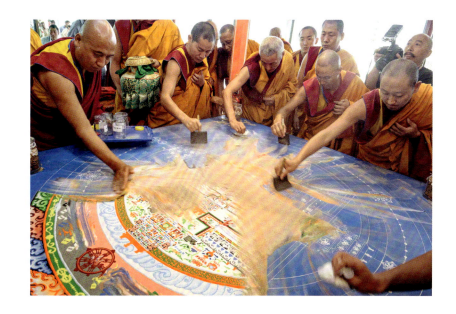

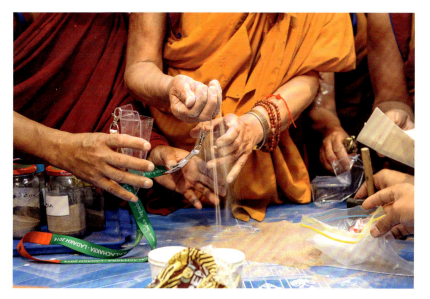

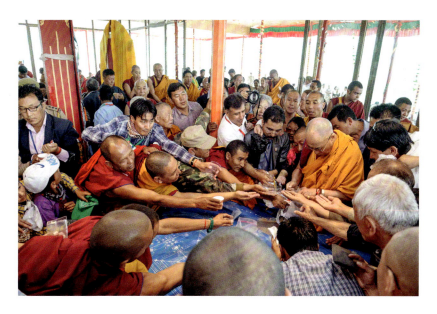

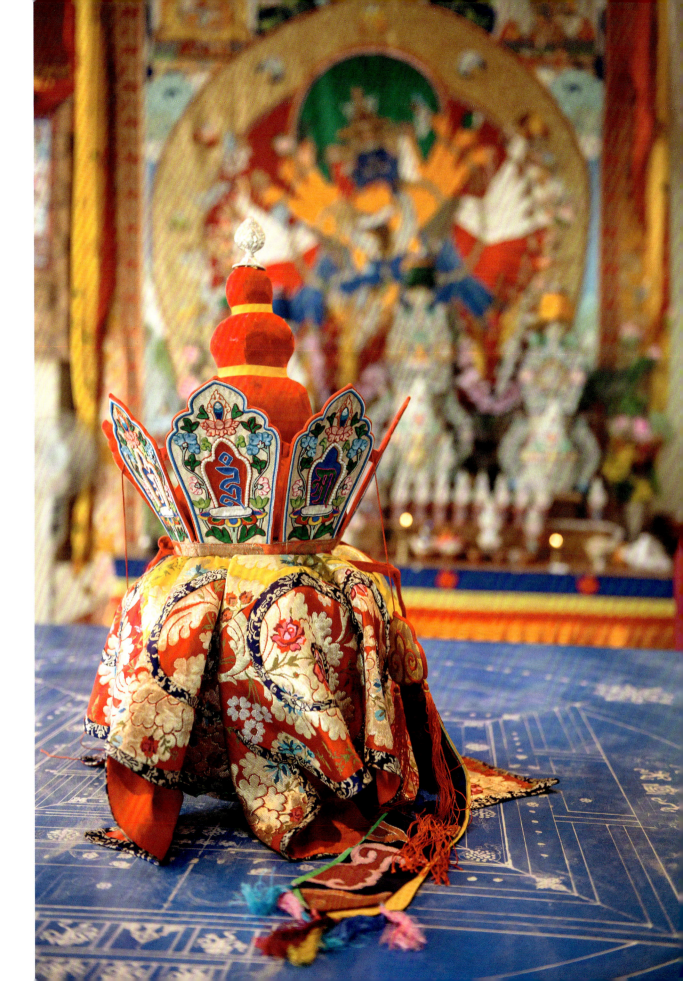

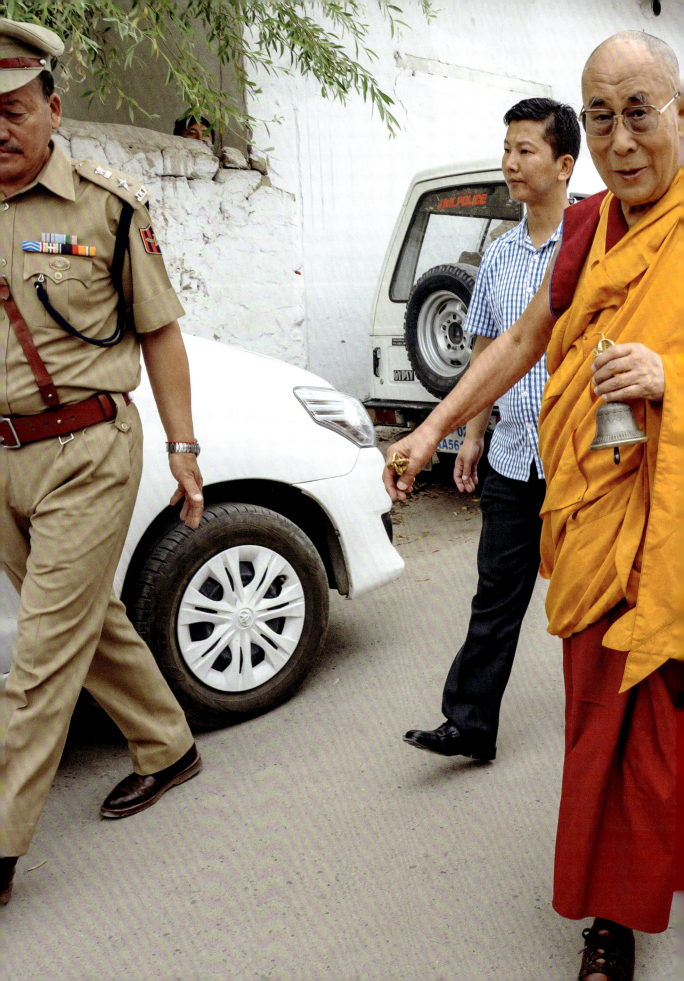

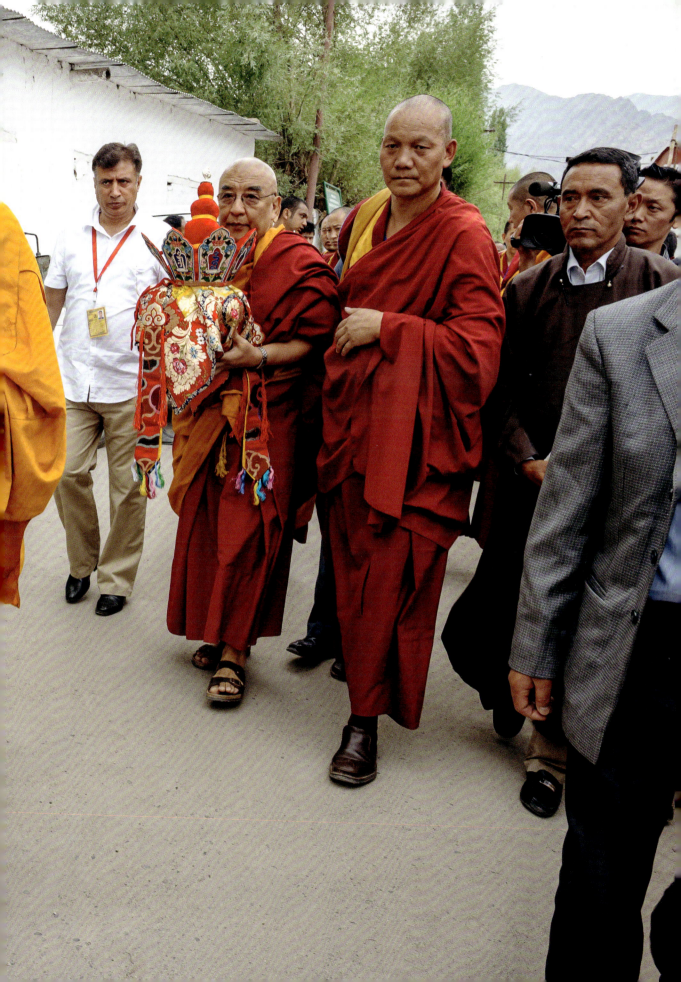

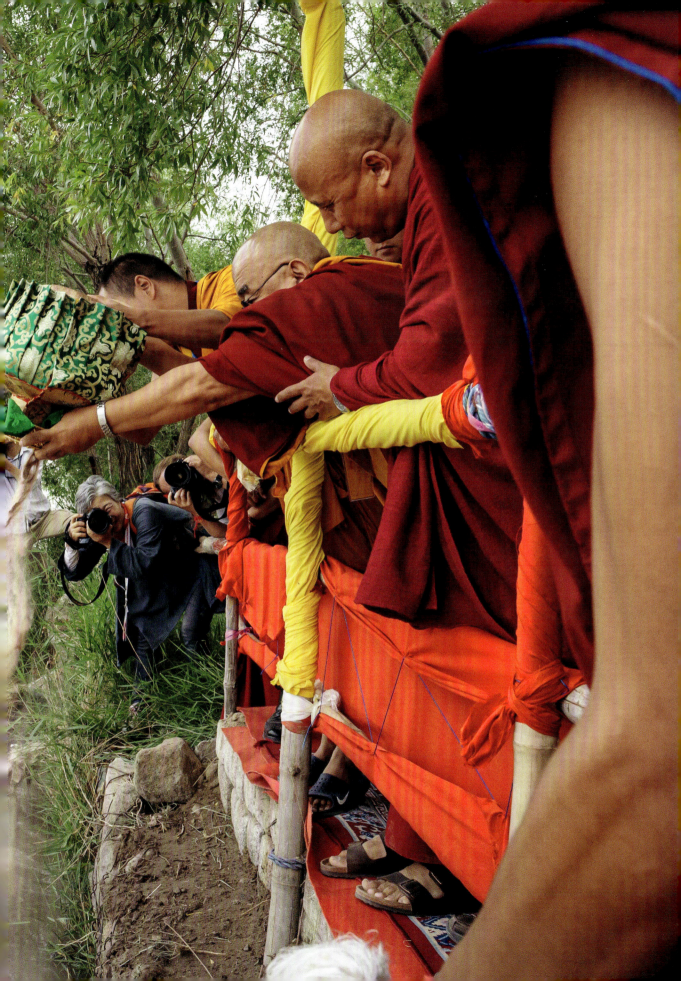

Thupten Jinpa

LEADER OF THE TIBETAN PEOPLE

The Dalai Lama was called upon to assume the temporal leadership of his nation in November 1950, shortly after Communist China's invasion of Tibet from the east. Barely sixteen and charged with guiding a country in mortal danger, he faced a steep and perilous learning curve. In 1954–55, he traveled to Beijing to meet China's communist leaders, including Mao Zedong and Zhou Enlai. Later, during a visit to India in 1956, when he was an official guest at the celebration of the 2500th anniversary of the Buddha's Nirvana, the Dalai Lama sought counsel from Prime Minister Jawaharlal Nehru on how best to address the mounting threat to Tibet's survival. In the end, after more than eight years of attempting to find a mutually workable accommodation with Beijing, the task turned out to be impossible. The Dalai Lama therefore fled his homeland and after a popular uprising of the Tibetan people in Lhasa in March 1959 crossed into India in search of refuge and a place from which to continue the struggle for his people.

Upon his arrival in India in April 1959, the Dalai Lama immediately drew global attention to Tibet's plight. His appeals led to three United Nations resolutions urging China to respect the Tibetan people's right to freedom and dignity. After settling in the northern Indian hill station of Dharamsala, he established the Central Tibetan Secretariat—later renamed the Central Tibetan Administration (CTA)—which essentially became the Tibetan government-in-exile. In other parts of India, especially in the south, specially designed Tibetan settlements were created so that Tibetans could live together as communities and preserve Tibetan culture. Anxious to rebuild Tibet's religious and cultural heritage, the Dalai Lama also oversaw the establishment of vital institutions in Dharamsala, including the Thekchen Choling Temple, Namgyal and Nechung Monasteries, the Library of Tibetan Works & Archives, the Tibetan Medical Institute, and the Tibetan Institute of Performing Arts. Other historically important Tibetan monasteries were re-established in India, while the Central Schools for Tibetans provided Tibetan youth with a modern education that would also ensure that they remain connected to their cultural roots.

The Dalai Lama initiated the democratization of Tibetan governance as early as 1963. A democratic charter for a future Tibet was drafted and Tibetan People's Deputies elected to serve as a Tibetan parliament in exile. Recognizing the changing global landscape—marked by China's admission to the United

Nations and its growing international presence—the Dalai Lama proposed what he called the "Middle Way" approach. This framework, developed in consultation with exiled Tibetan leaders, called not for independence of Tibet but for meaningful autonomy to help guarantee the survival of Tibet's distinct language, culture, and religion, as well as the fragile environment of the Tibetan plateau. The "Middle Way" approach garnered widespread international support and was seen by many as a pragmatic and visionary path. And even if two series of dialogues between the Dalai Lama's envoys and Beijing have yet to yield significant progress, the "Middle Way" approach remains a well-articulated and enduring framework for resolving the long-standing issue of Tibet and the Tibetan people's struggle for freedom and dignity.

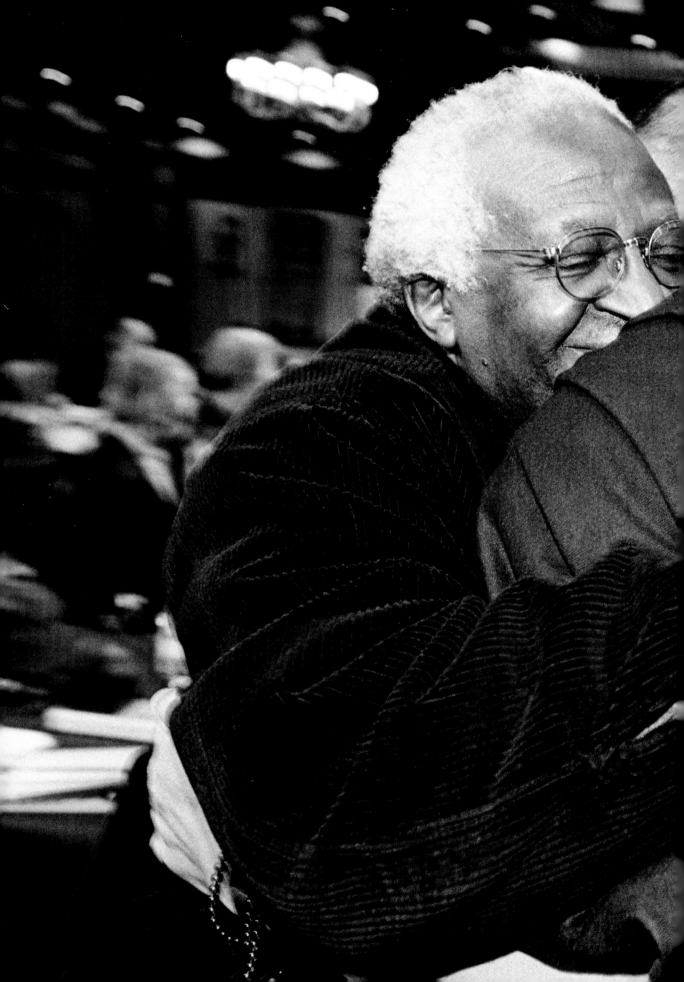

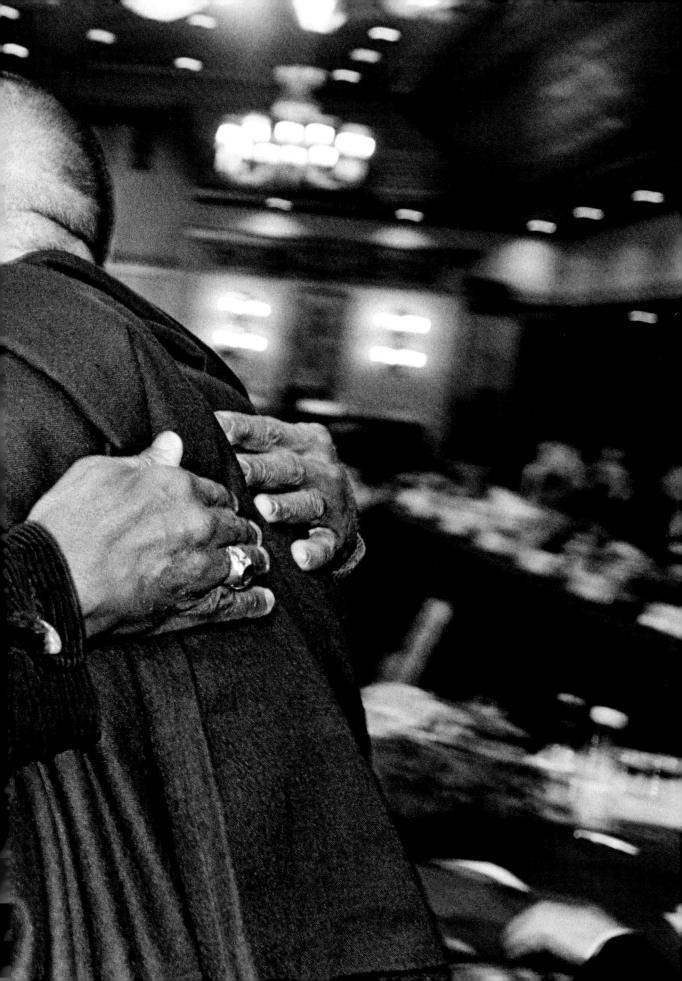

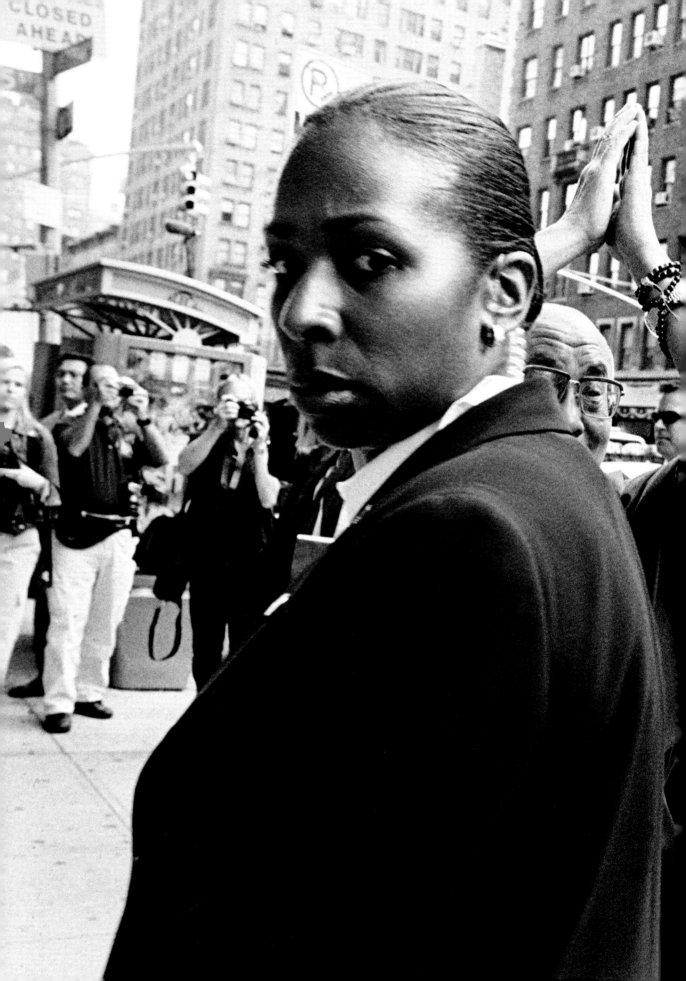

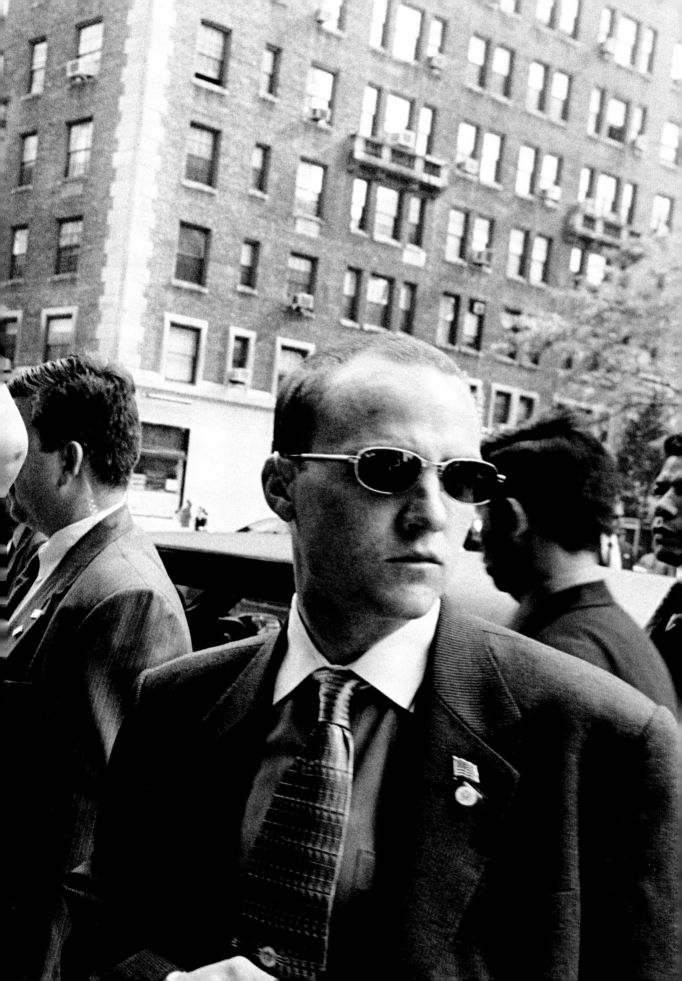

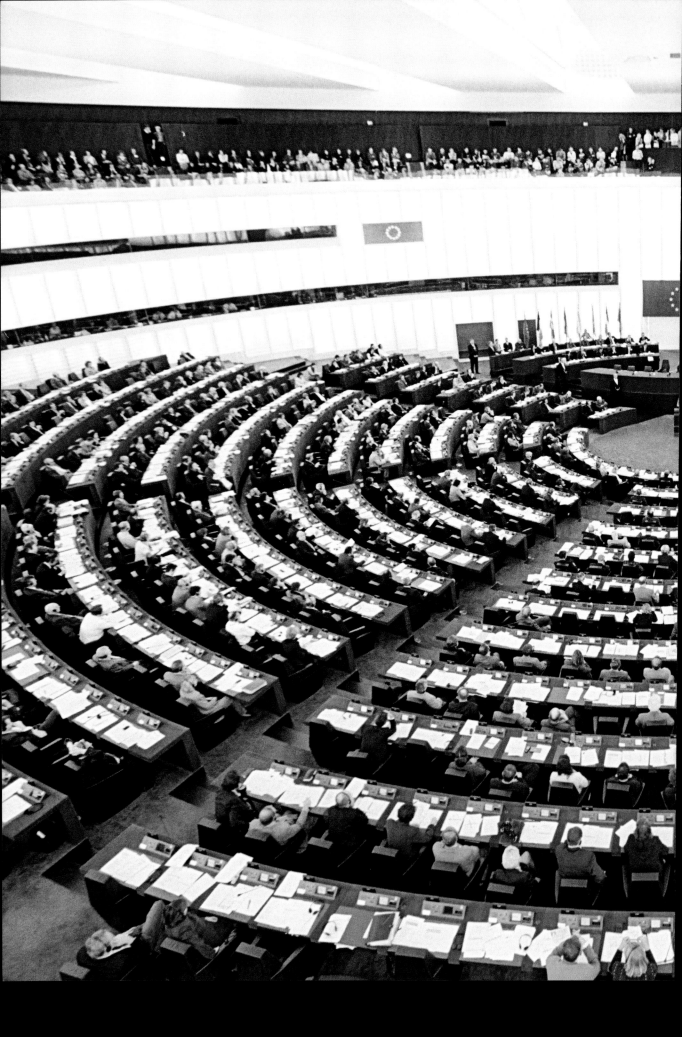

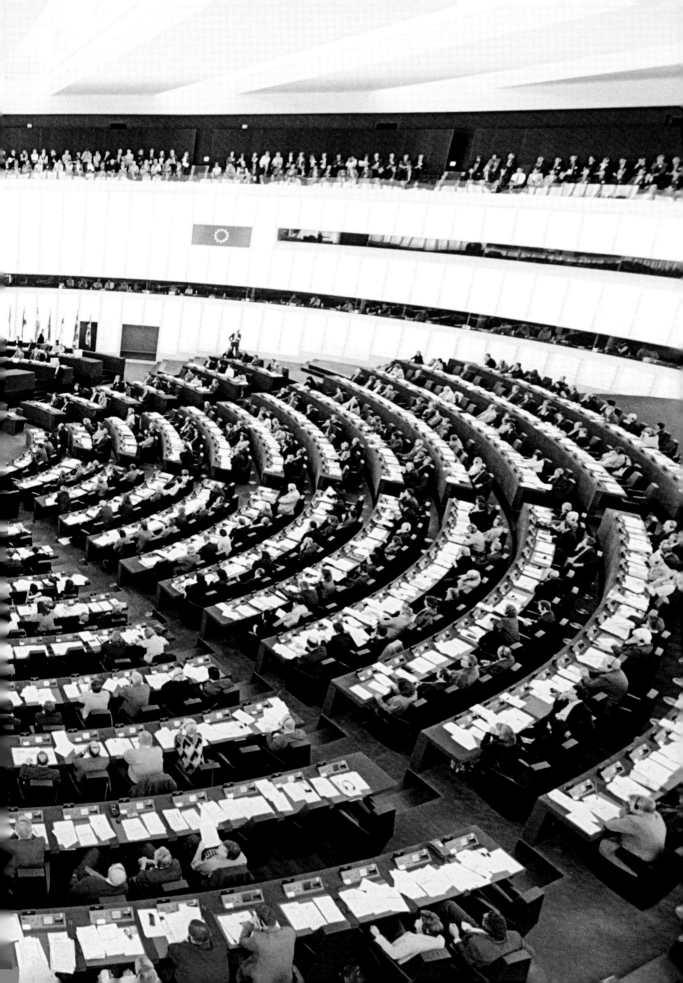

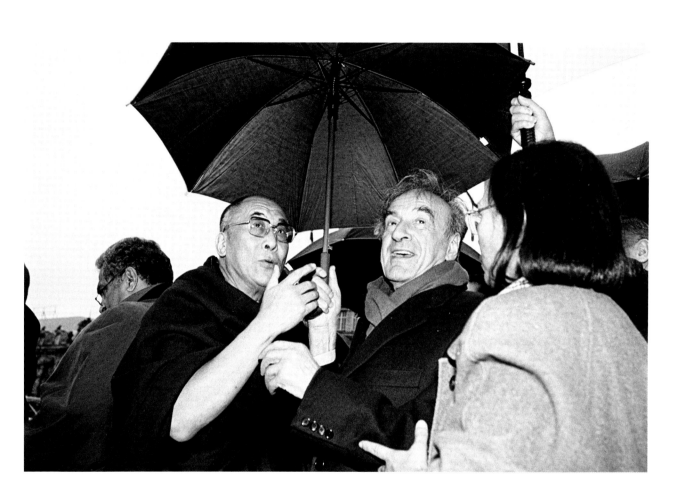

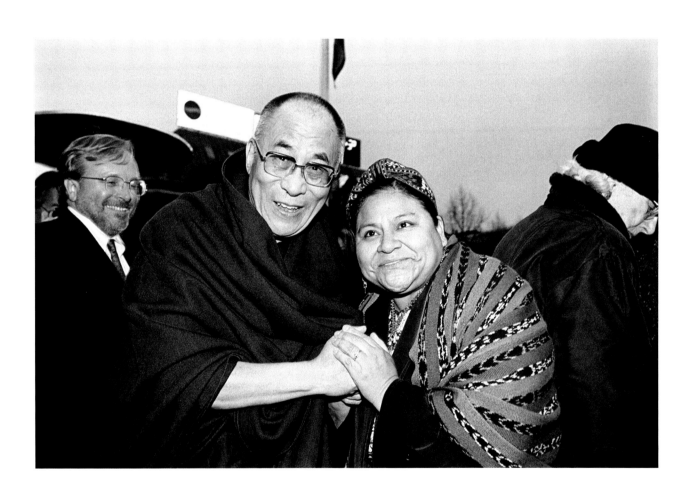

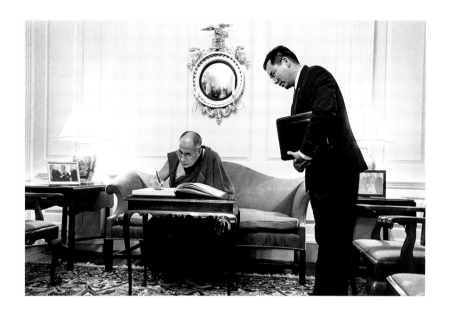
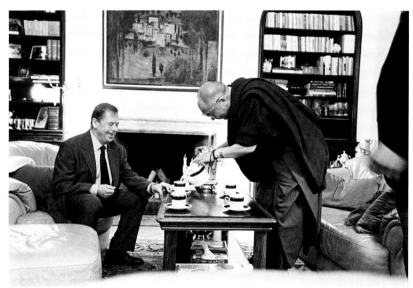
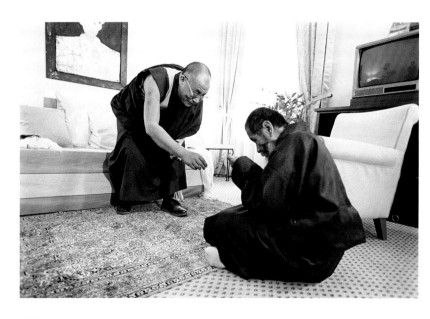

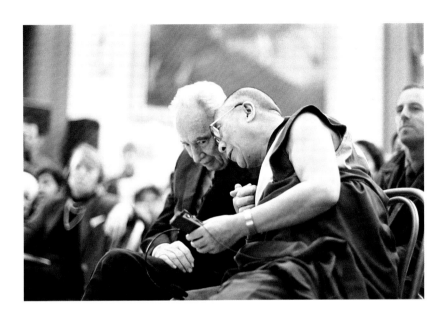
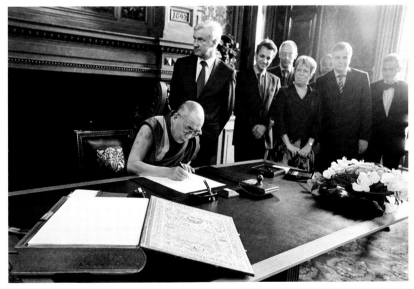

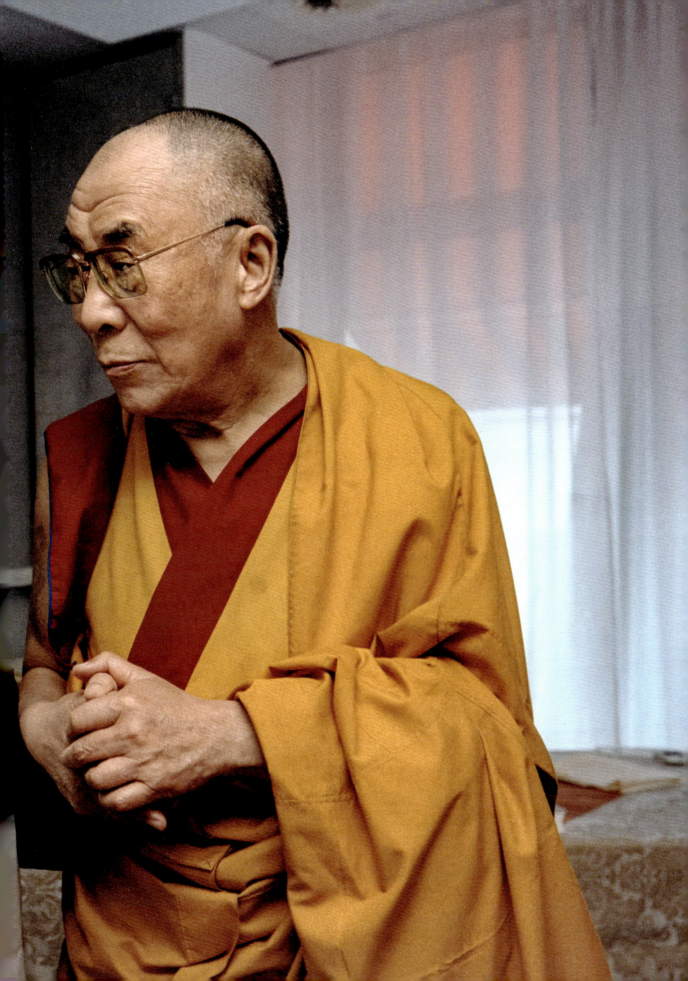

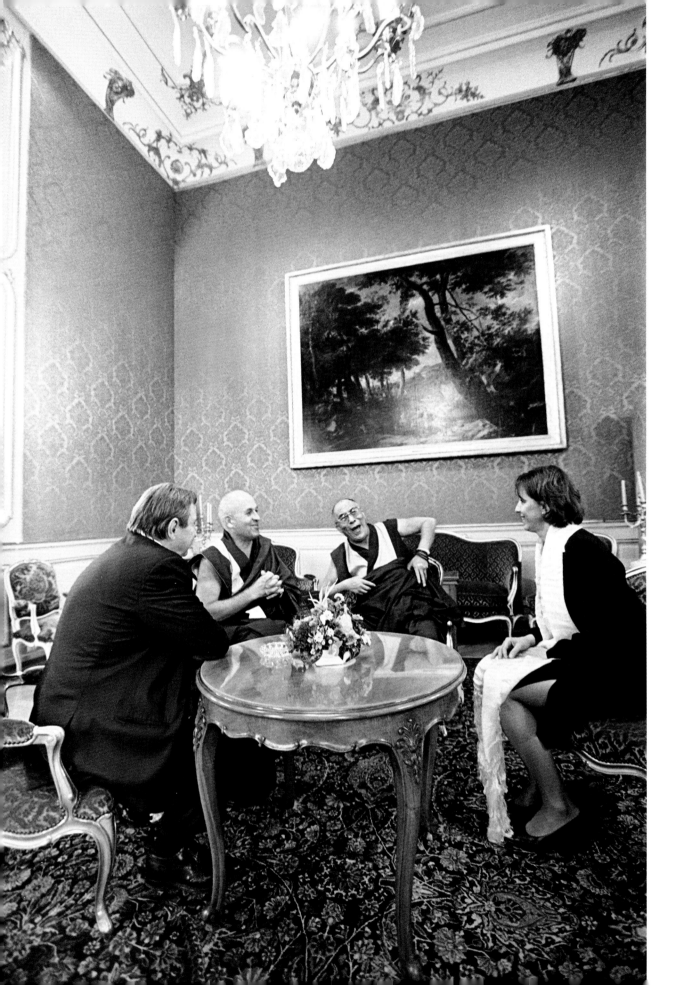

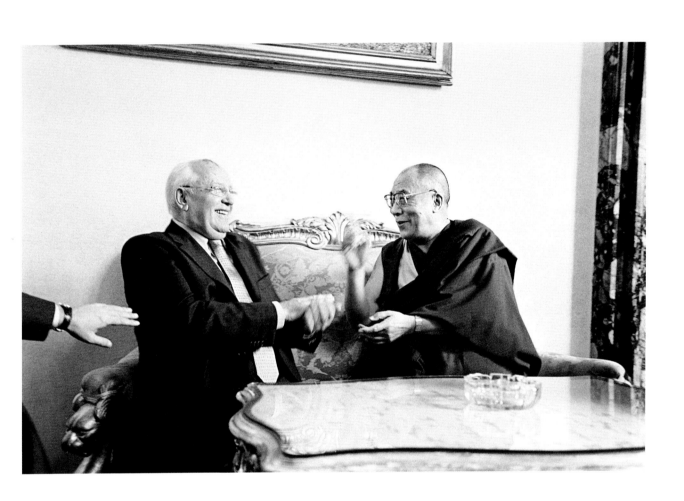

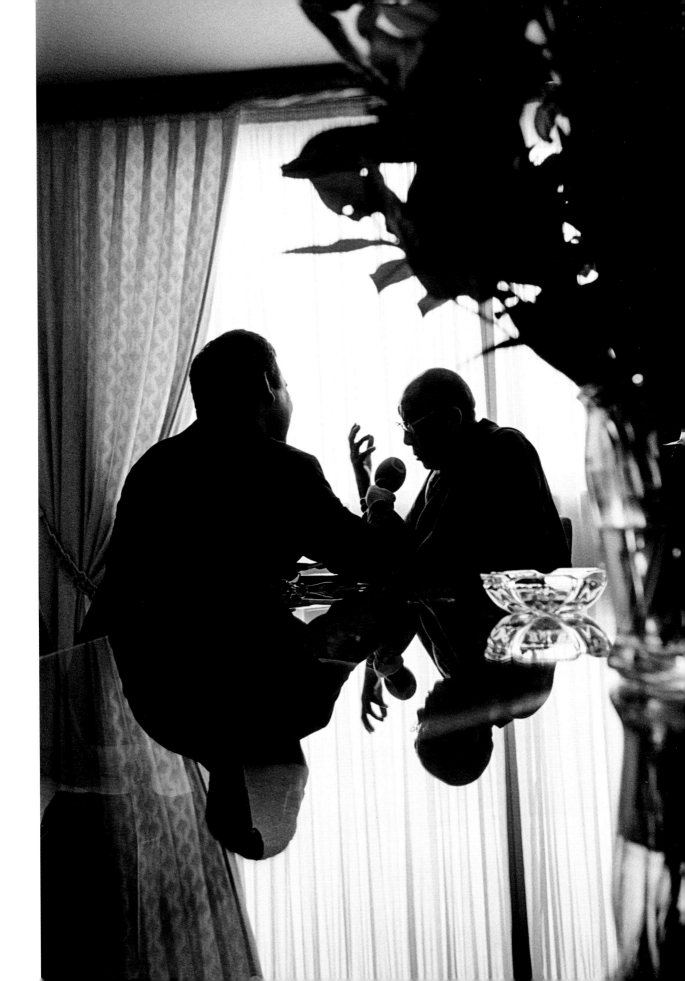

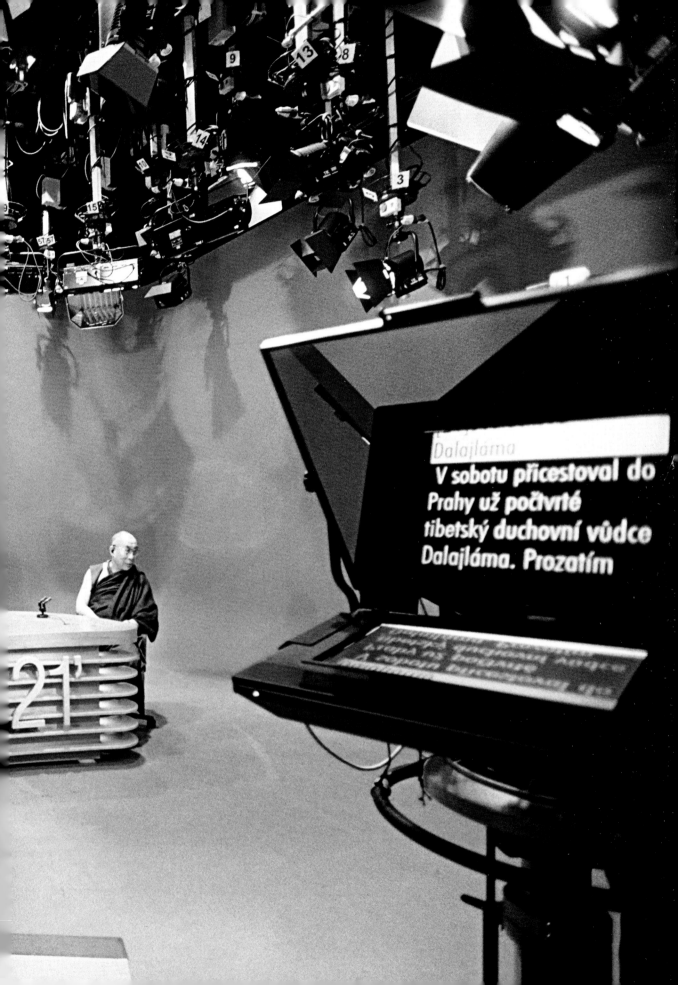

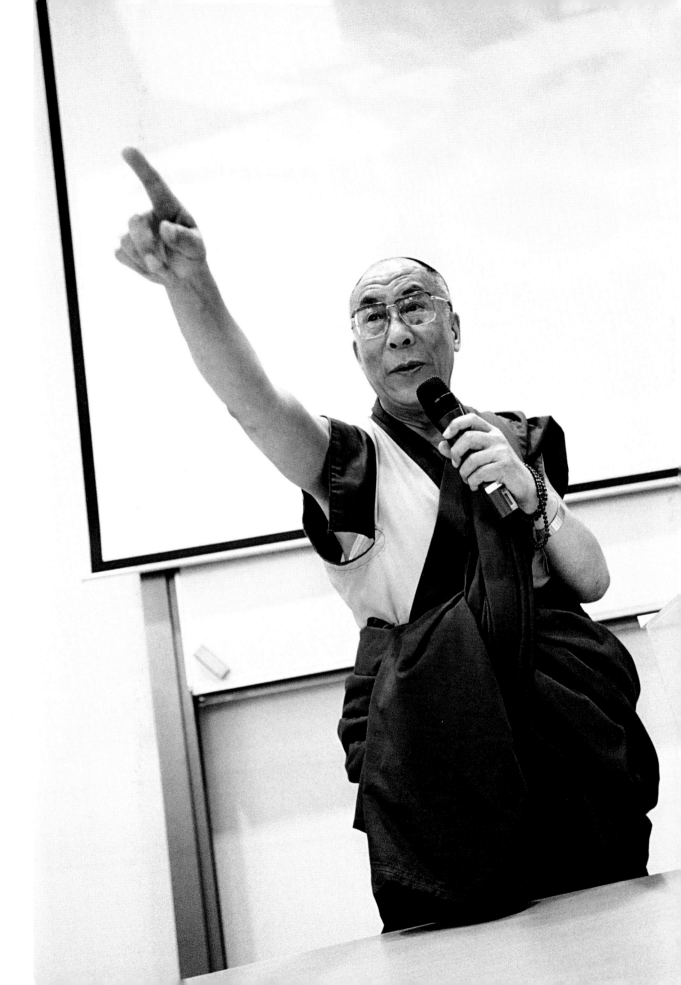

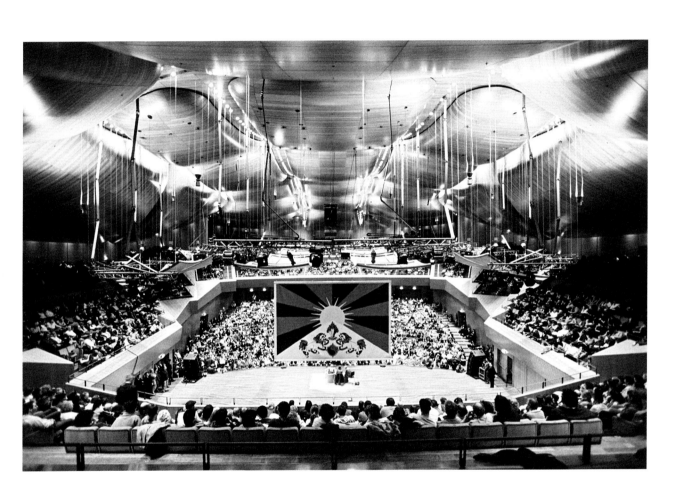

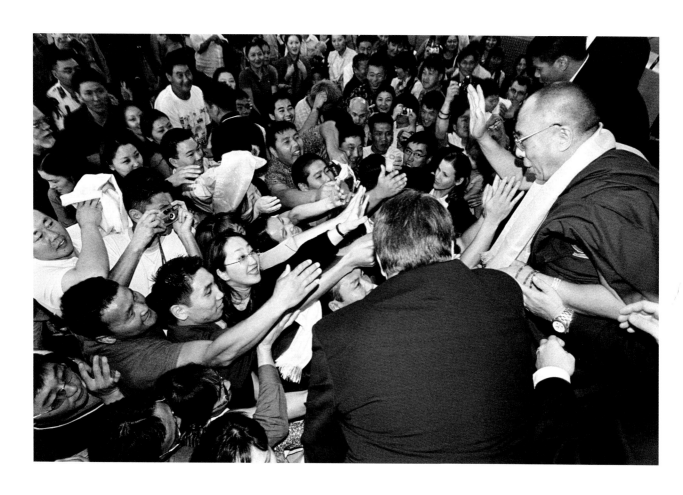

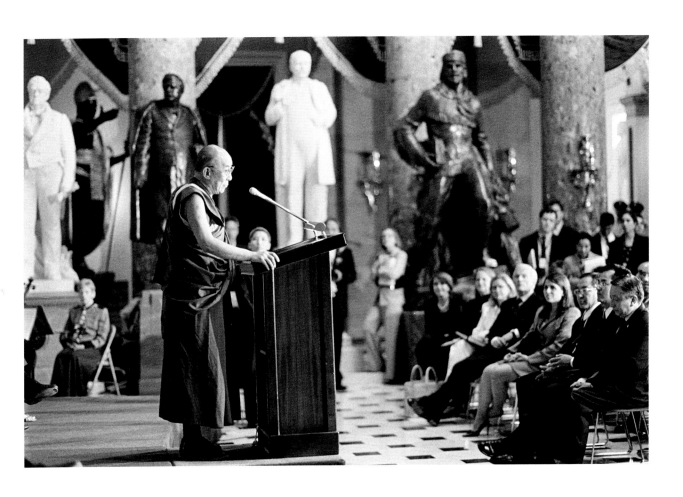

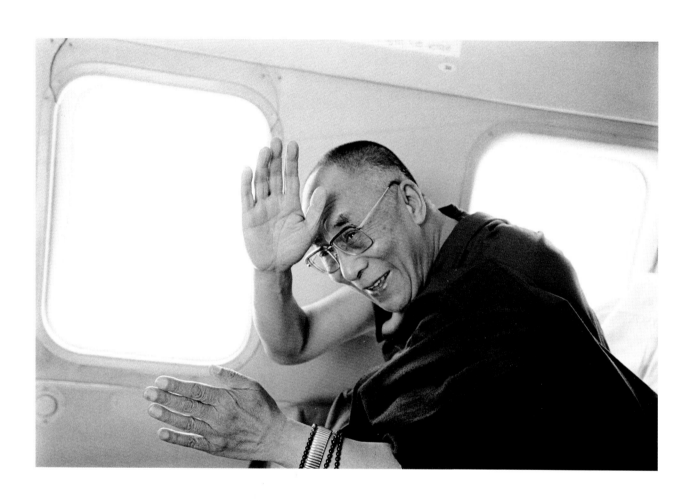

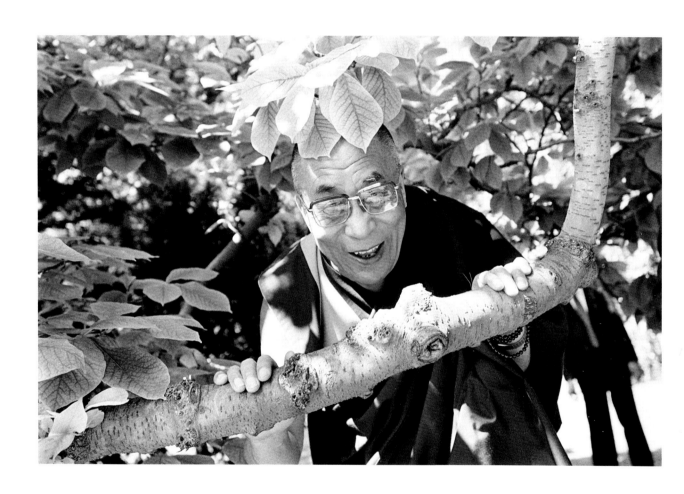

Thupten Jinpa

DIALOGUE WITH SCIENCE

The Dalai Lama's deep and enduring engagement with science has been one of the defining features of his work to date. His fascination with science began in childhood and was sparked by the mechanical objects that belonged to his predecessor, the Thirteenth Dalai Lama: a collapsible telescope and a hand-wound mechanical timepiece with a rotating globe displaying different time zones. As he explored these objects, the young Tenzin Gyatso became curious about the knowledge that made such creations possible. Later, he described the opportunity to engage with scientists as one of the blessings of his exile. Over the years, the Dalai Lama formed friendships with several prominent scientific figures of the twentieth century, including the physicists David Bohm and Carl Friedrich von Weizsäcker, the philosopher of science Karl Popper, and the neurobiologists Robert Livingston and Francisco Varela.

A major milestone in his scientific journey occurred in 1987, when he hosted a five-day dialogue at his residence in Dharamsala. This meeting, led by Chilean neurobiologist Francisco Varela, inspired the creation of the Mind & Life Institute, co-founded by the Dalai Lama, Varela, and the American businessman Adam Engle. Since then, more than thirty Mind & Life dialogues have provided a platform for the Dalai Lama to explore critical questions at the intersection of science and human flourishing.

The goals of the Dalai Lama's interest in science are twofold: First, he seeks to expand the boundaries of scientific inquiry to include the study of consciousness, which has traditionally been considered outside the purview of material science. Second, he wants science to serve humanity rather than harm it. While science itself is neutral, he argues, it must remain guided by the ethical values essential to human flourishing.

The Dalai Lama's decades-long engagement with science has had a profound impact on both scientific research and on his own tradition of Tibetan Buddhism. His call for the systematic study of the mind's positive qualities—such as compassion—coincided with groundbreaking developments in neuroscience, including advances in brain imaging and the discovery of neuroplasticity. This has contributed to the rise of contemplative science, which investigates the effects of mind-based applications like mindfulness and compassion. The Dalai Lama's encouragement of the adaptation of Buddhist techniques to

secular frameworks has played a key role in the integration of mindfulness and compassion training in education, healthcare, and other fields.

His own tradition of Tibetan Buddhism has made science a formal part of its monastic curricula. In recognition of his contribution to this endeavor, the Dalai Lama was invited to deliver the keynote address at the 2005 International Neuroscience Conference in Washington, D. C., and was awarded the 2012 Templeton Prize for his efforts to foster dialogue between science and spirituality. Through his tireless advocacy, the Dalai Lama has not only shaped modern dialogue between science and Buddhism but he has also championed a vision of science as deeply connected to humanity's shared ethical values.

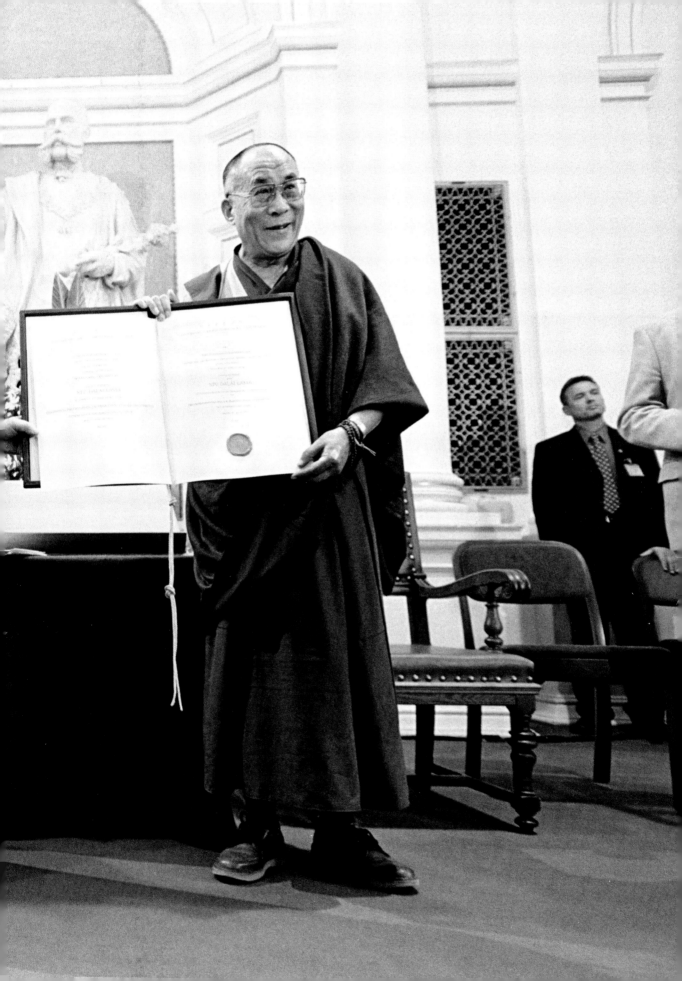

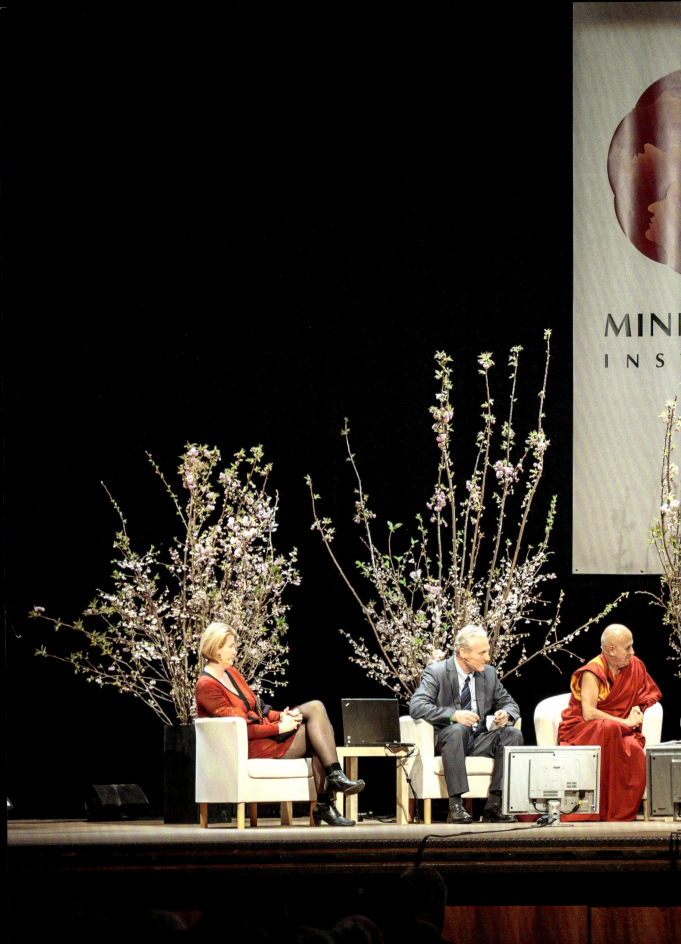

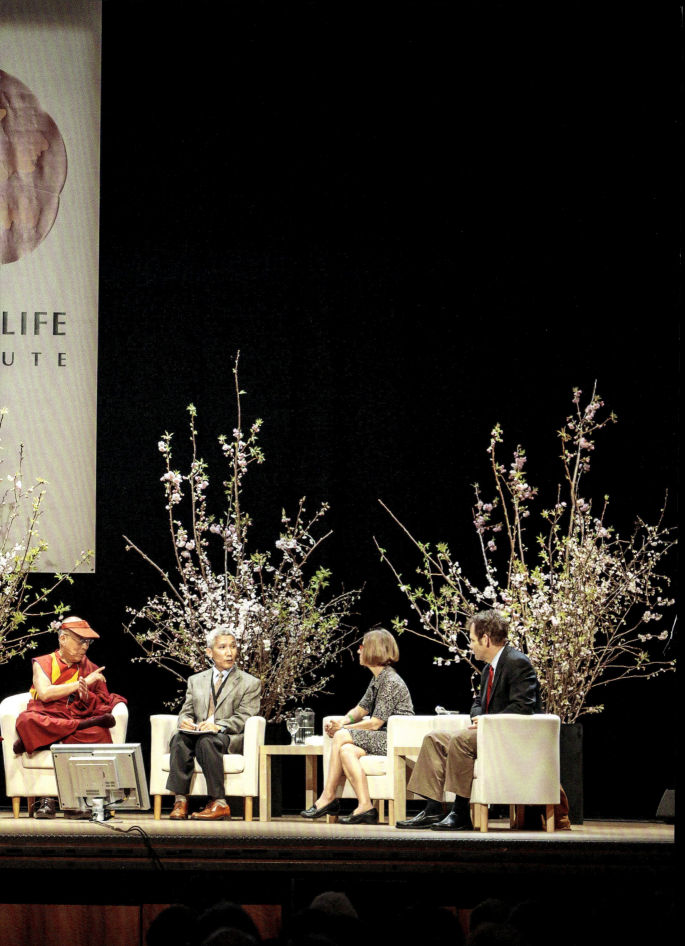

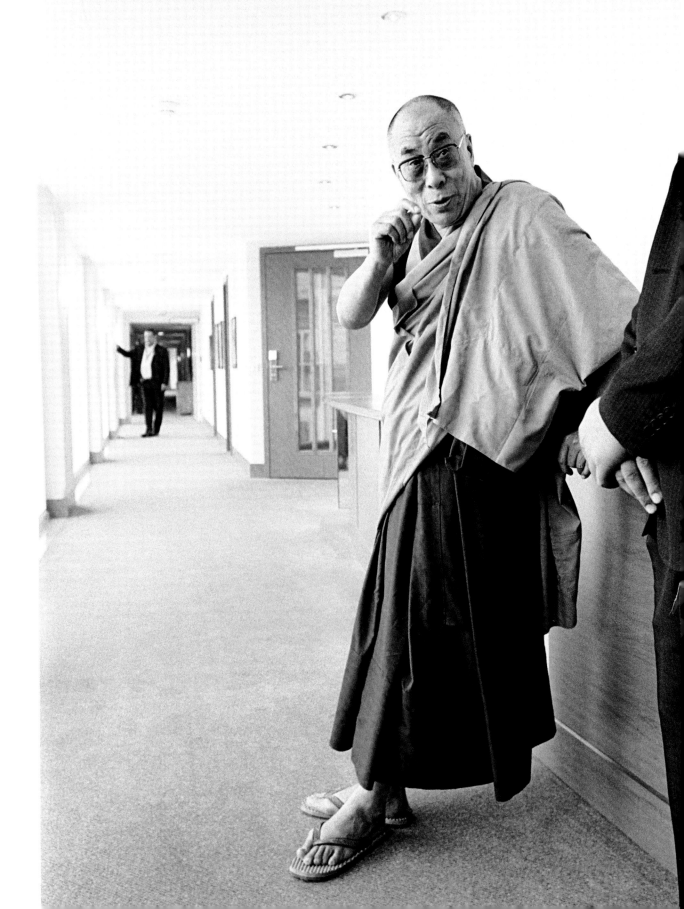

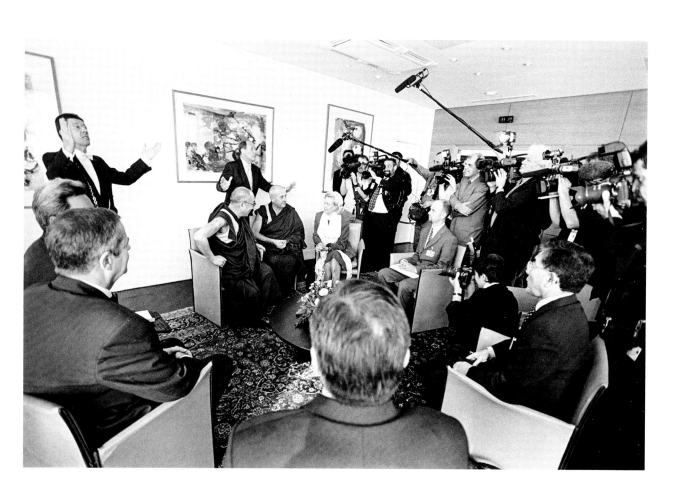

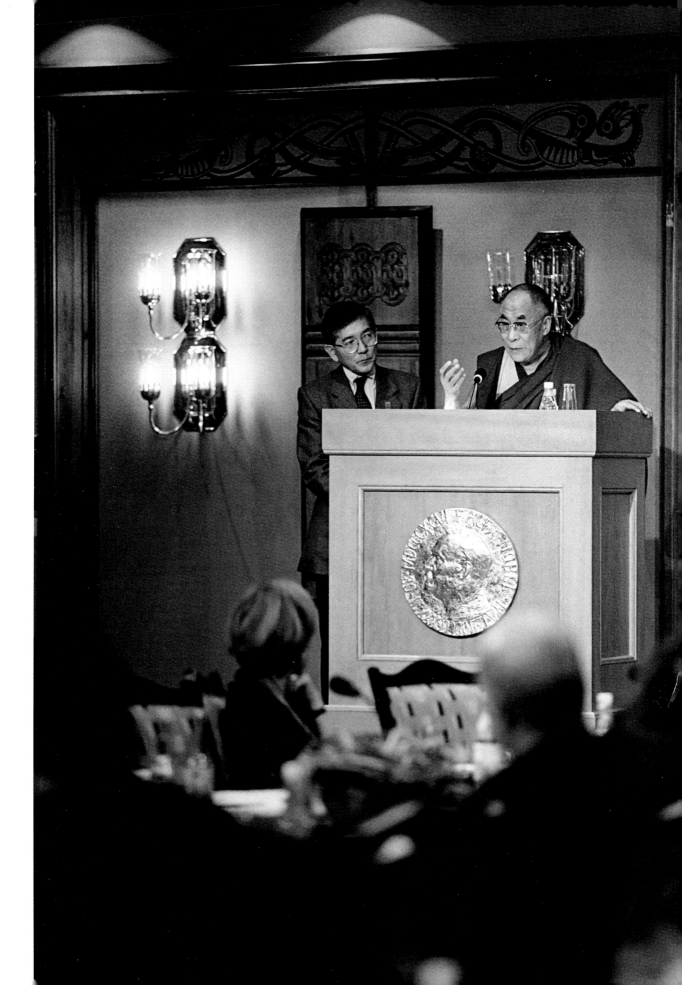

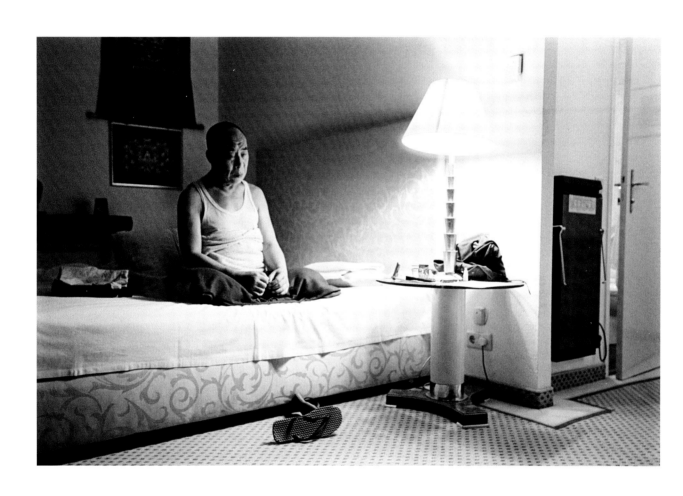

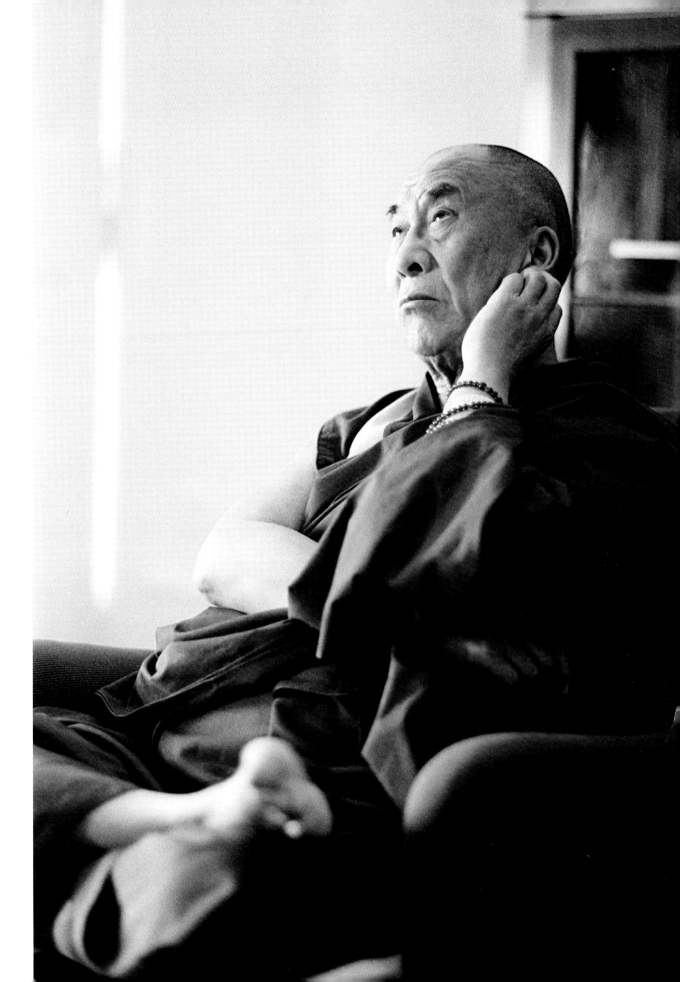

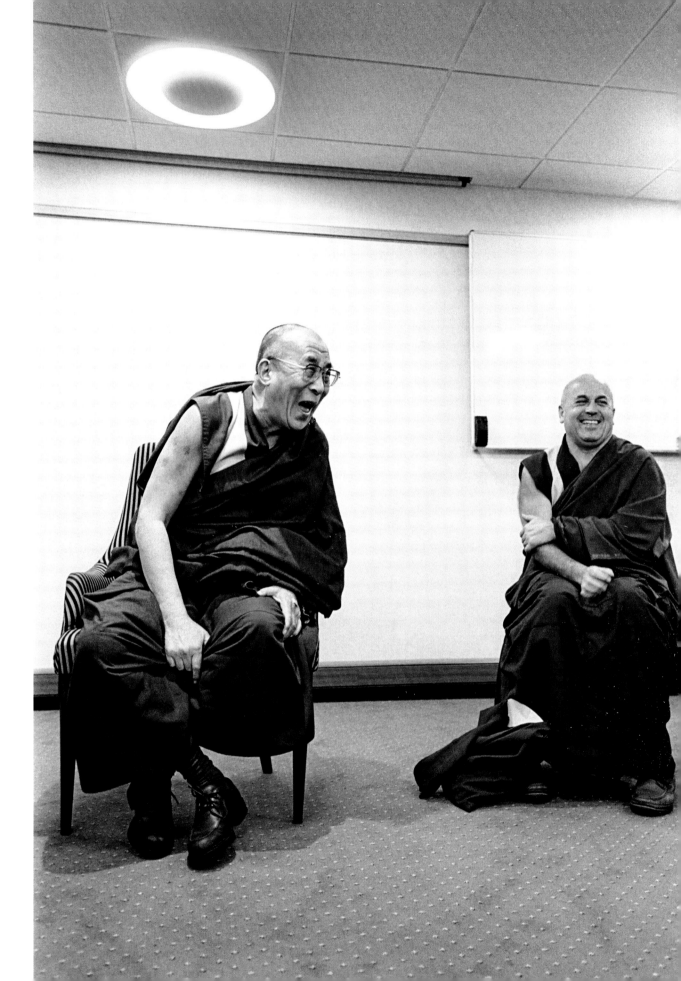

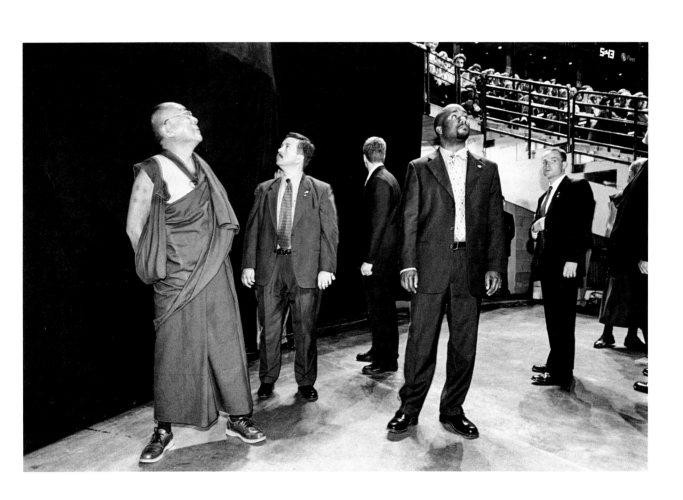

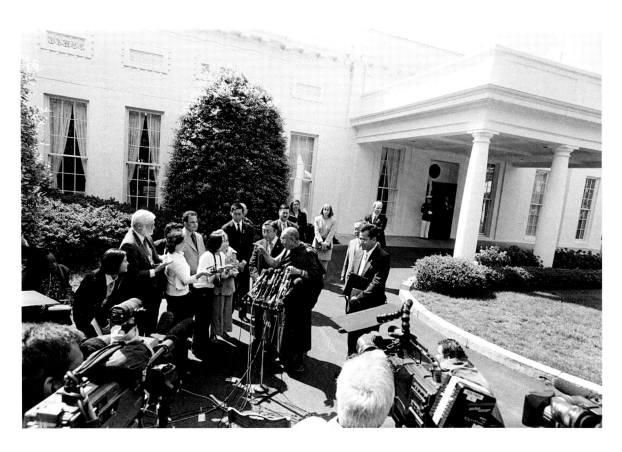

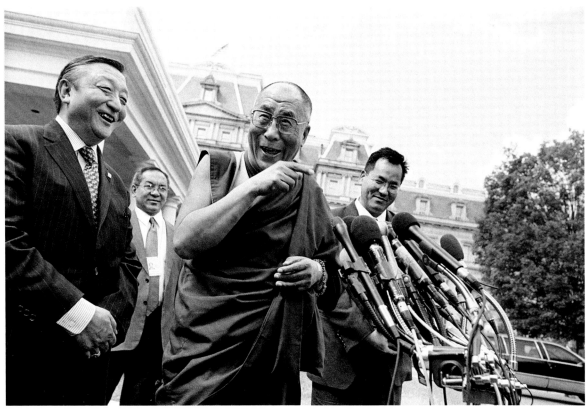

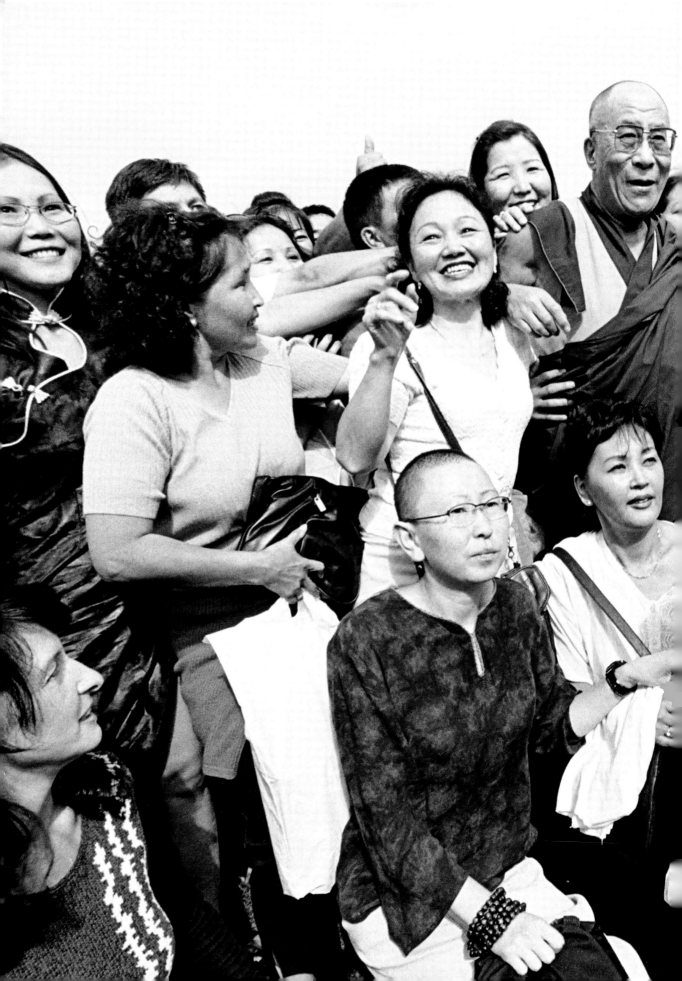

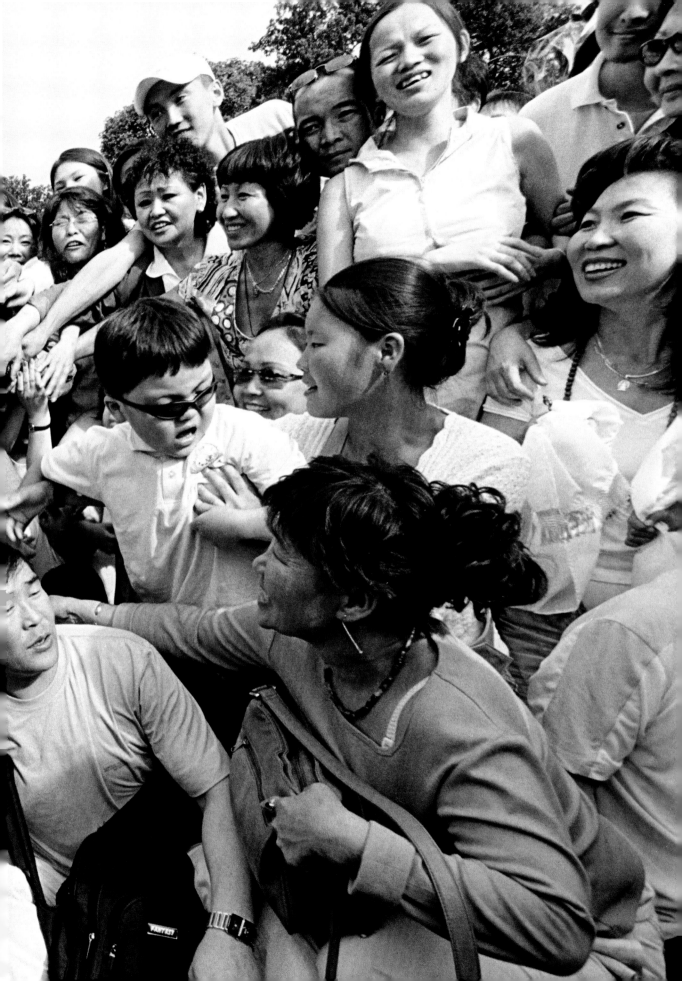

Thupten Jinpa

AMBASSADOR FOR BUDDHISM

From the seventh century onwards, Buddhism shaped Tibetan civilization, transforming it from a warrior culture with imperial ambitions into a hub of Mahayana and Vajrayana Buddhism. After the decline of Buddhism in its Indian birthplace, Tibet became the custodian of the great Nalanda tradition. Indeed, Buddhist values, insights, and practices remain integral to Tibetan culture to this day. Clad in his signature maroon robes, the Dalai Lama advocates non-violence, the oneness of humanity grounded in compassion as a universal human value, and the need to rise above our differences to address our challenges collectively. In doing so, he embodies and translates into action the core principles of Buddhism. Indeed, over the six decades that have passed since he went into exile, the Dalai Lama has become *the* most visible symbol of the many facets of Buddhism on the global stage.

As a leader, the Dalai Lama has profoundly shaped Buddhism's encounter with modernity. Most notably, he has encouraged proactive engagement with science and has rejected suspicion and defensiveness. For Tibetan Buddhism, this approach has been transformative, and science education is now a formal part of the curriculum in Tibetan monastic colleges. The Dalai Lama also encourages his fellow Tibetan Buddhists to become what he calls "twenty-first-century Buddhists" who unite faith and reason, and develop faith in the *dharma* grounded in reason. For the broader world, his dialogues with scientists have inspired a new approach to well-being that appreciates the crucial role of the mind and emphasizes mind-based tools like mindfulness, emotional regulation, and the cultivation of empathy and compassion.

Through countless interfaith dialogues and multireligious pilgrimages to sacred sites such as Jerusalem, Assisi, Varanasi, and Ajmer, the Dalai Lama has fostered greater understanding and respect among the world's religions. Such engagement is crucial to mutual respect and harmony in a pluralistic modern world in which differing beliefs co-exist. Additionally, responding to contemporary calls for gender equality, the Dalai Lama has striven to address disparities within Tibetan Buddhism. Under his leadership, Tibetan nuns now have access to the highest academic degree in the monastic system, the Geshe Lharam degree, and many of them have already earned the title of Geshema.

On his international travels, the Dalai Lama frequently emphasizes that his goal is not to propagate Buddhism in regions rooted in other religious traditions. His mission is rather to draw on Buddhist insights and to share Buddhist tools—such as focused attention, self-awareness, emotional regulation, empathy and compassion—for cultivating the mind and heart. This approach aligns with his innovative framework for interpreting Buddhist texts, whose subject matter he divides into three dimensions: science (exploration of the natural world), philosophy (inquiry into ultimate truth), and religion (doctrines and rituals). While the religious dimension is specific to Buddhists, he believes that scientific and philosophical insights belong to humanity's shared heritage and should be made accessible to all. To further this vision, the Dalai Lama oversaw the creation of a groundbreaking four-volume series, *Science and Philosophy in Indian Buddhist Sources,* which organizes Buddhist knowledge for wider dissemination. The Dalai Lama, in other words, has demonstrated remarkable foresight in many different ways, enabling Buddhism to flourish in today's complex and dynamic world.

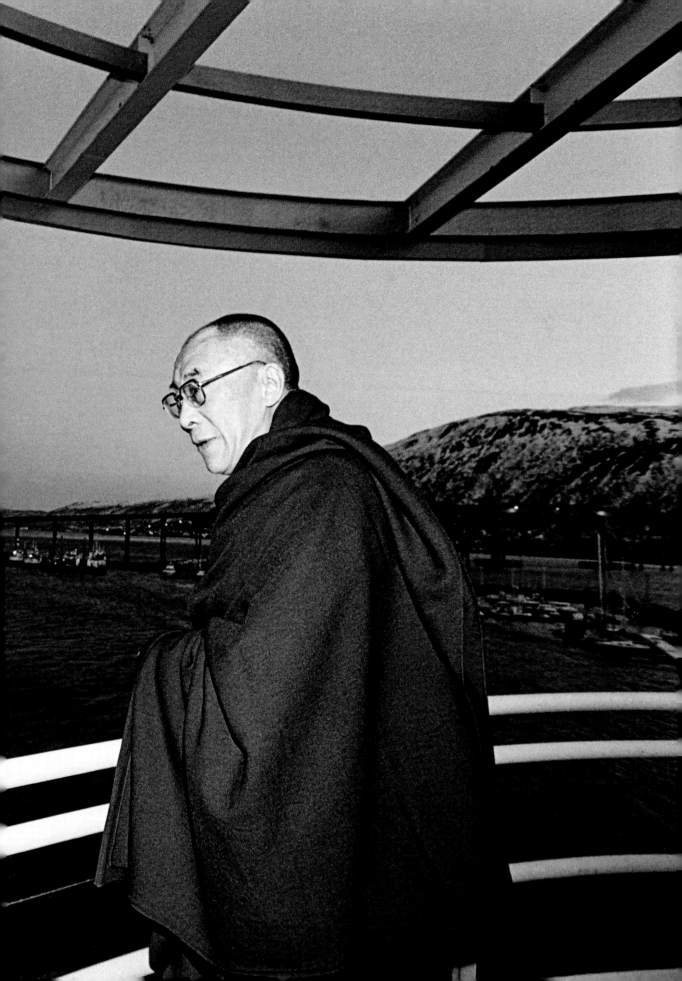

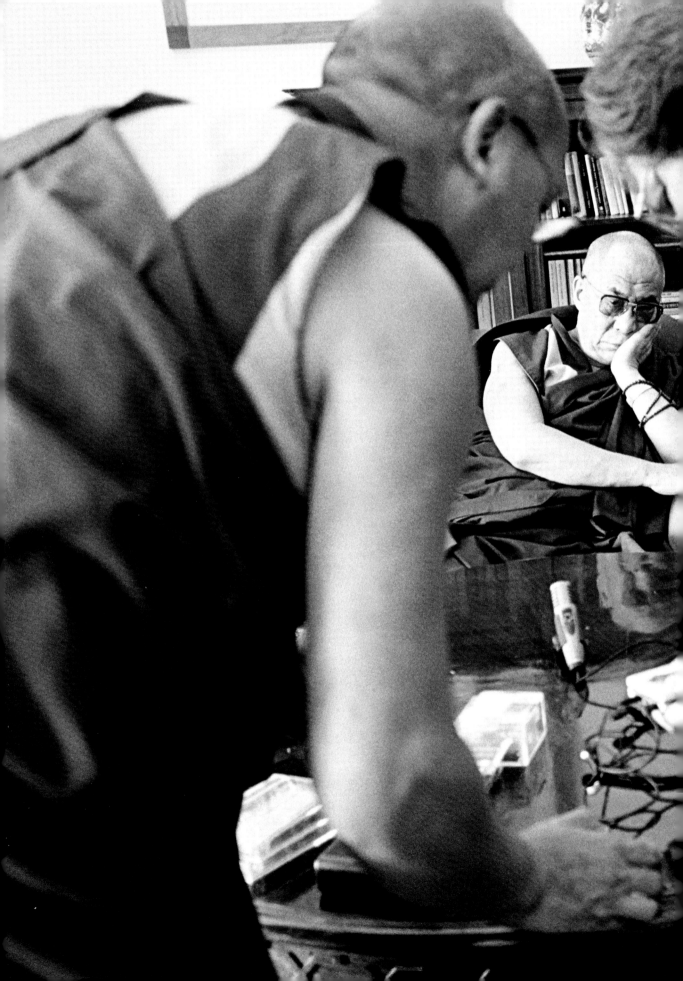

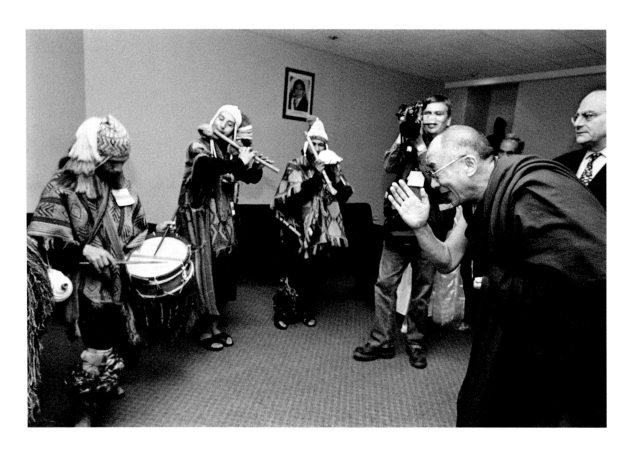
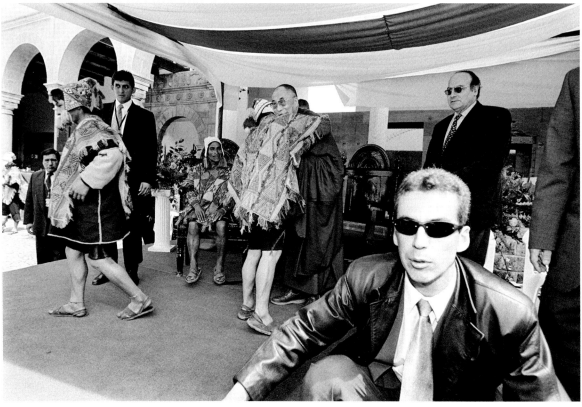

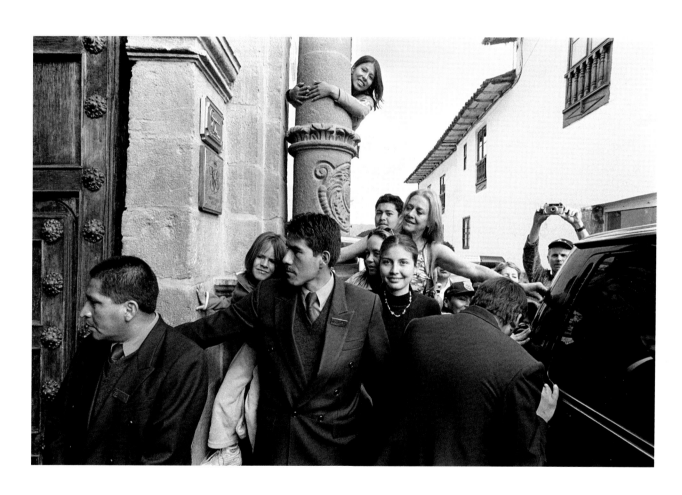

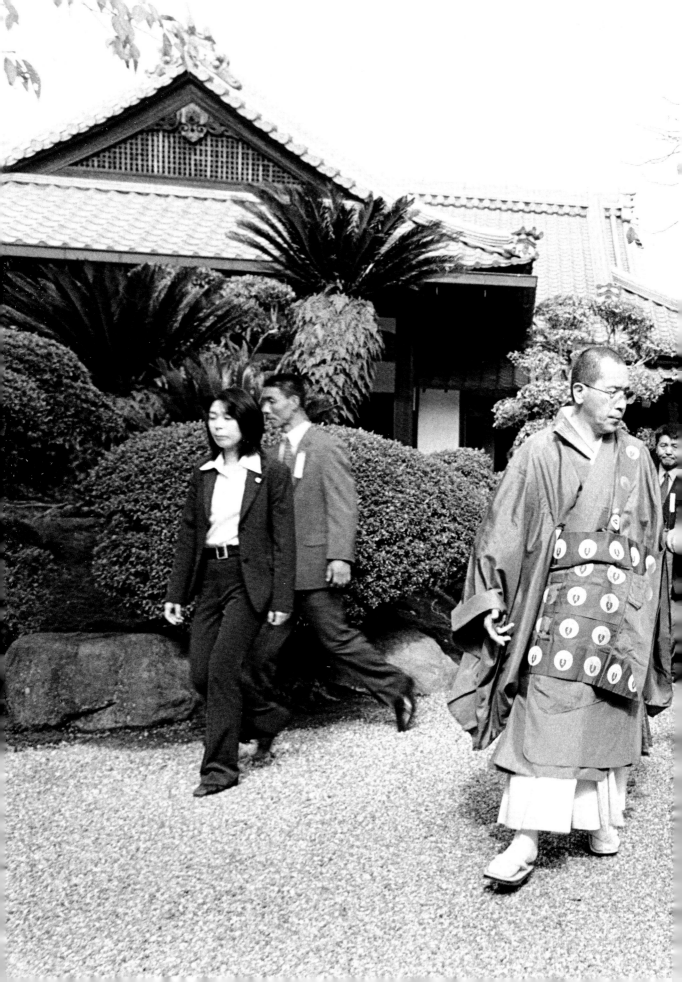

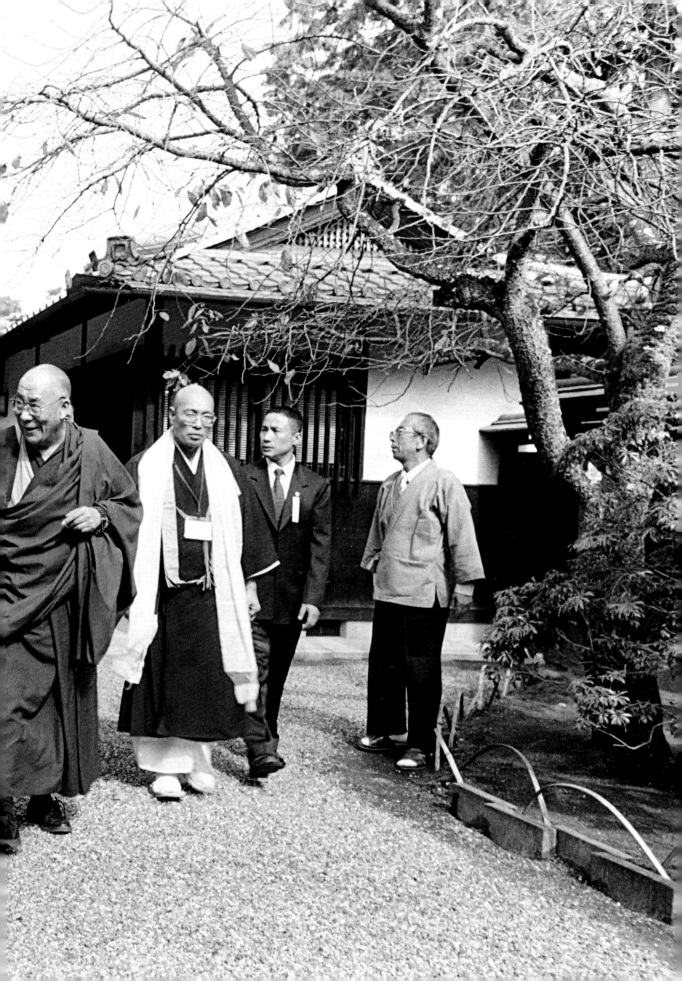

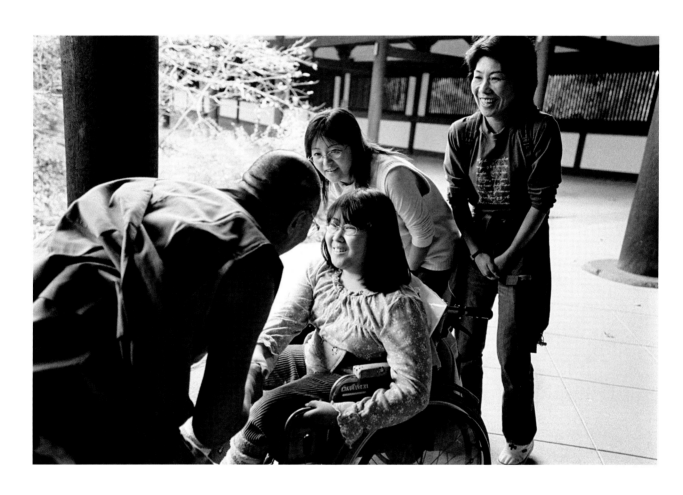

Thupten Jinpa

INTERRELIGIOUS UNDERSTANDING AND MUTUAL REVERENCE

In his public talks, the Dalai Lama often outlines his four principal commitments: promoting fundamental human values through a secular and universal approach to ethics, fostering interreligious harmony, protecting Tibetan culture, the environment, and the Tibetan people, and, more recently, creating greater awareness of, and interest in, the value of India's ancient knowledge, particularly its science of the mind.

The Dalai Lama's interfaith journey began in 1956 during the celebration of the 2500th anniversary of the Buddha's Nirvana in India. It was there that he first engaged with Hindu and Jain practitioners, exploring their rich teachings and practices. He had even more opportunities for interreligious dialogue after going into exile. A pivotal moment came in 1968, when he spent several days with Trappist monk Father Thomas Merton, who visited him in northern India shortly before his untimely death. Reflecting on this meeting in *Toward a True Kinship*

of Faiths, the Dalai Lama wrote: "The first person to bring Christianity to life for me was the late American Trappist monk Thomas Merton."

During his international travels, the Dalai Lama consistently prioritizes interfaith engagement, often organizing interreligious services or dialogue in major cities. For him, such public gatherings of different religions under one roof send a powerful message, fostering fellowship and mutual respect among diverse traditions.

The Dalai Lama's approach to ecumenism acknowledges and respects the distinct beliefs and doctrines of each religion, emphasizing that true understanding arises from recognition of these differences. He nevertheless highlights a shared focus among the world's religions: the importance of living a good life grounded in love, compassion, and forgiveness. He encourages believers to remain deeply rooted in their own faith, while cultivating reverence for other traditions. Drawing on his Tibetan heritage, the Dalai Lama distinguishes between faith and respect, arguing that one can maintain unwavering faith in one's own religion while developing admiration for others. If the majority of religious followers were to embrace this stance, he believes, the rich resources within the various traditions could truly benefit humanity, offering guidance for addressing today's collective challenges, including the climate crisis. The Dalai Lama ends his book *Toward a True Kinship of Faiths* with the following appeal: "Make the vow today

that you shall never allow your faith to be used as an instrument of violence. Make the vow today that you may become an instrument of peace, living according to the ethical teachings of compassion in your own religion."

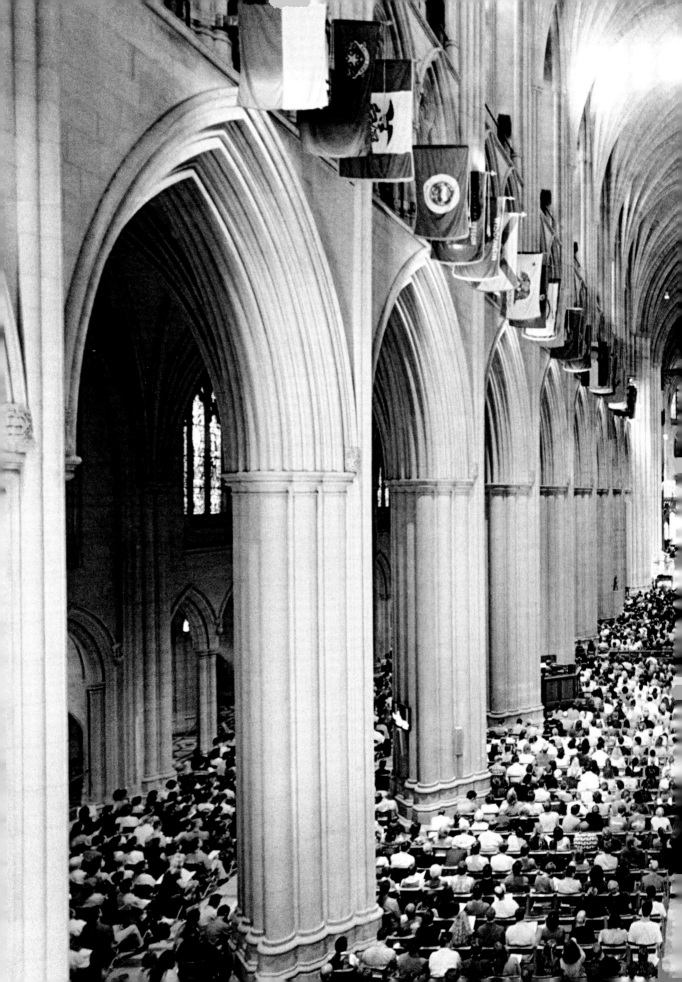

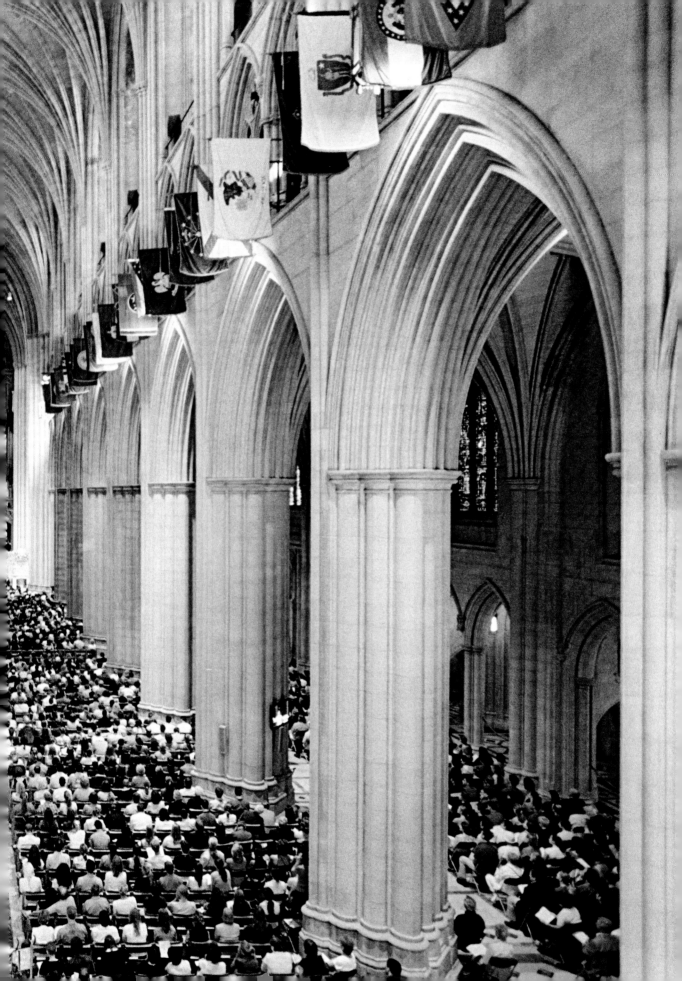

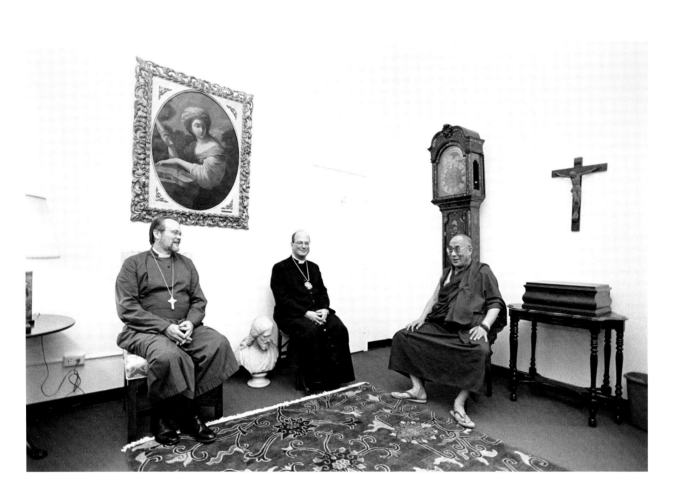

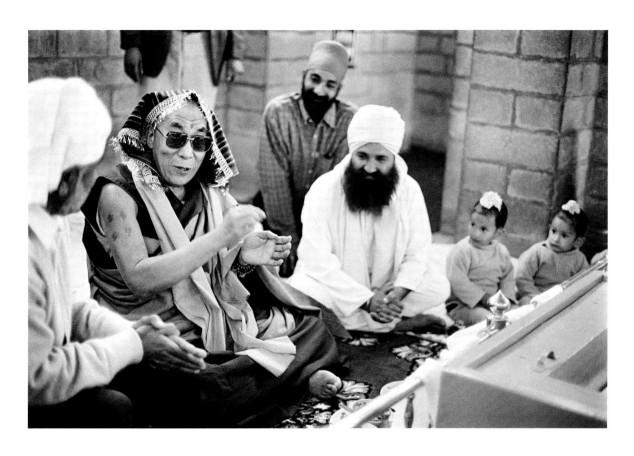
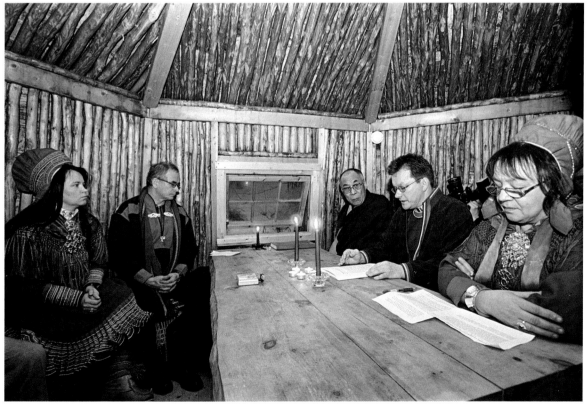

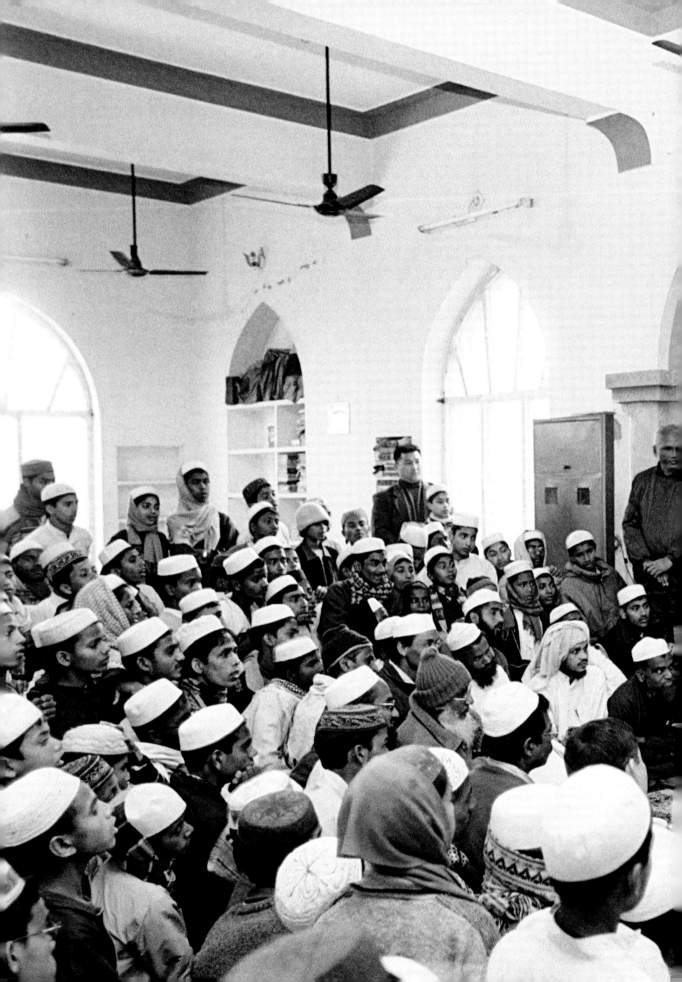

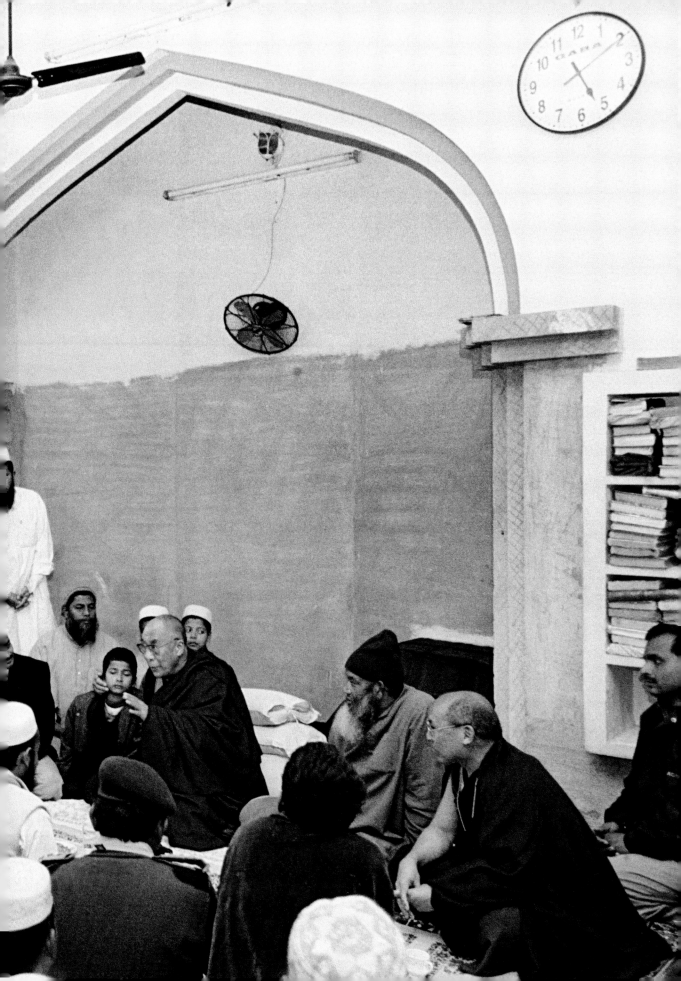

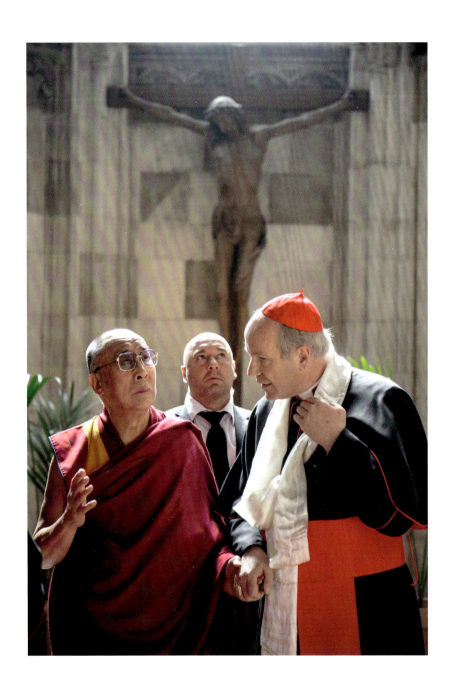

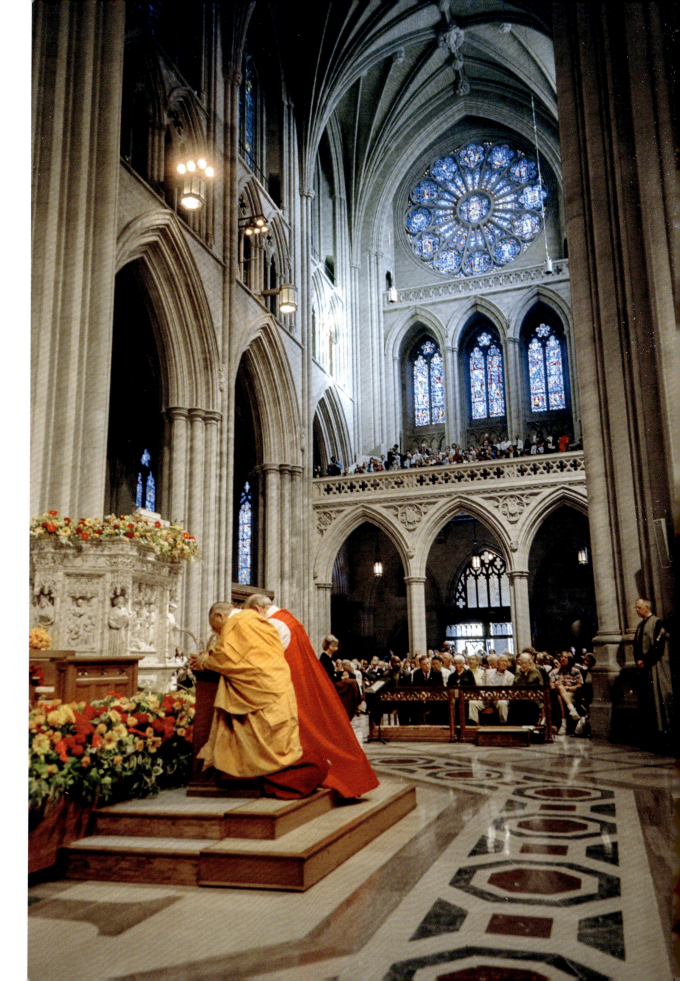

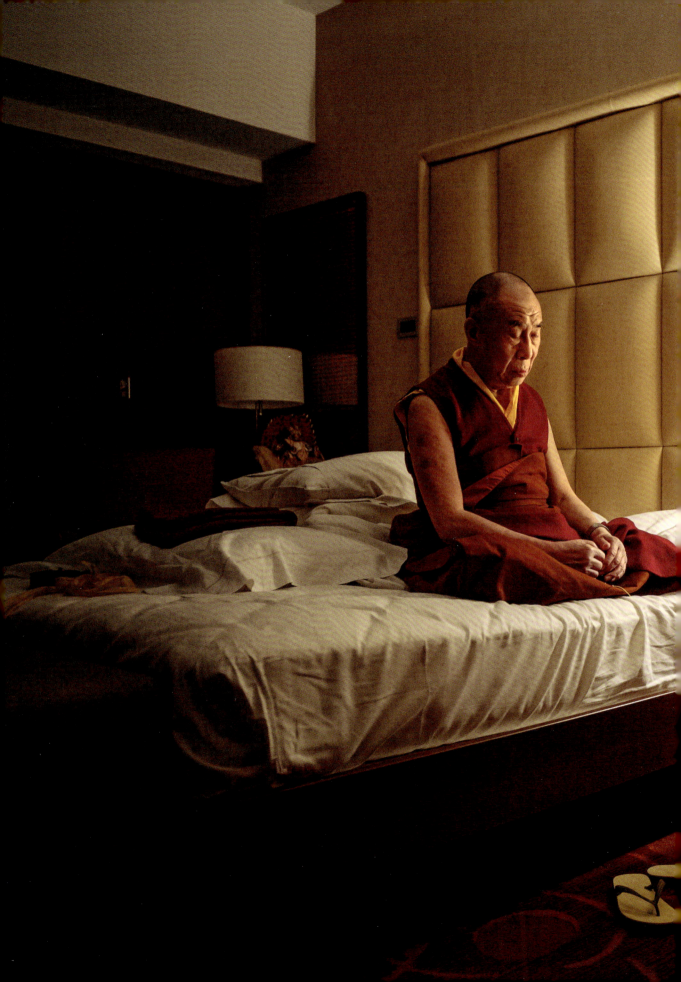

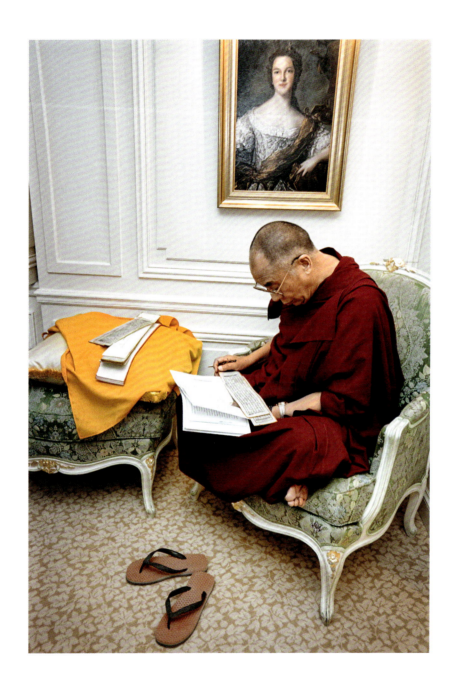

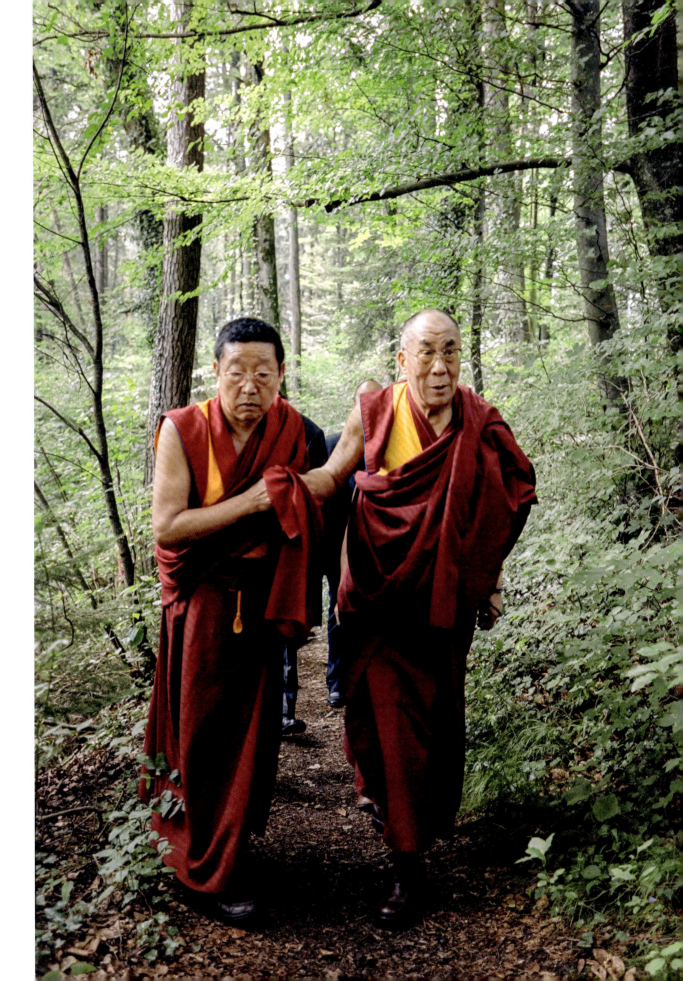

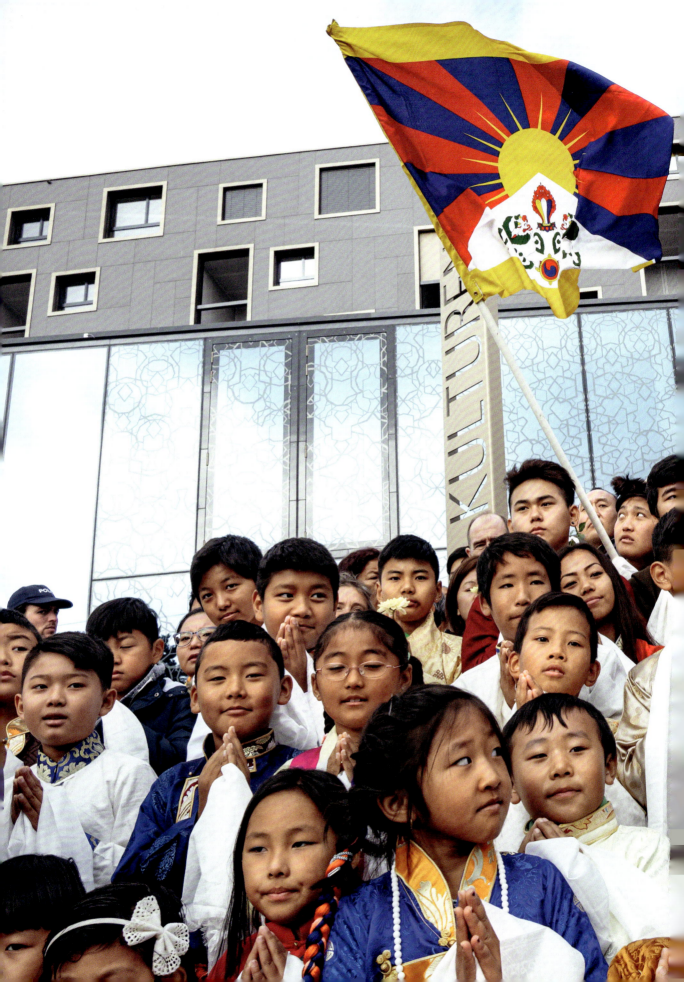

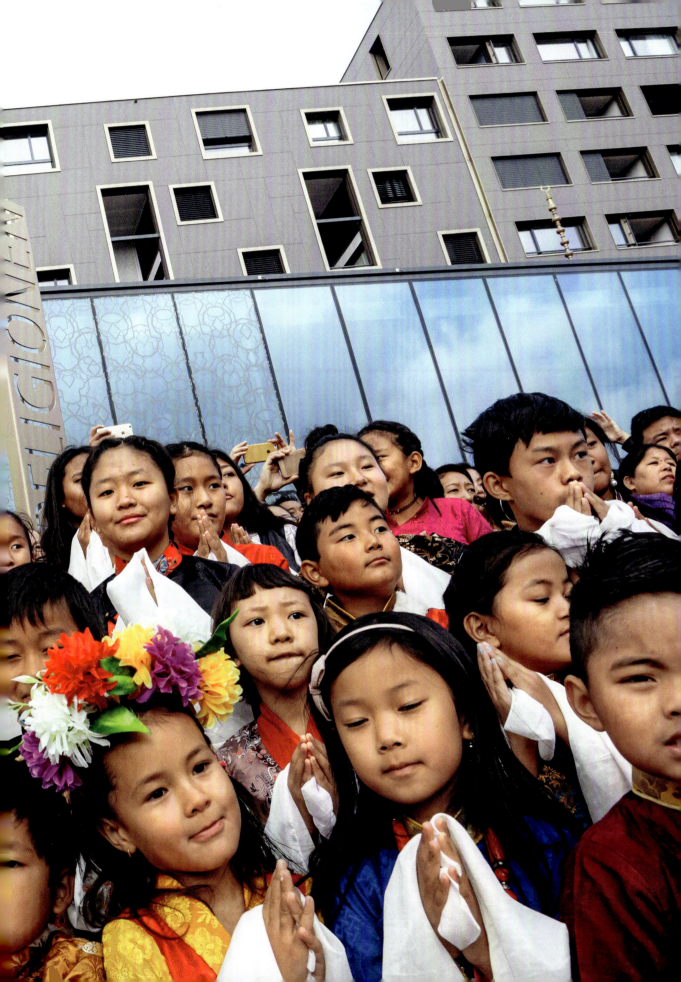

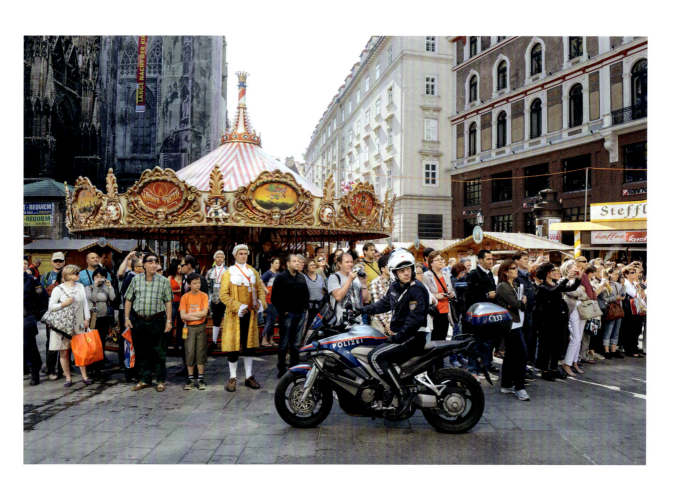

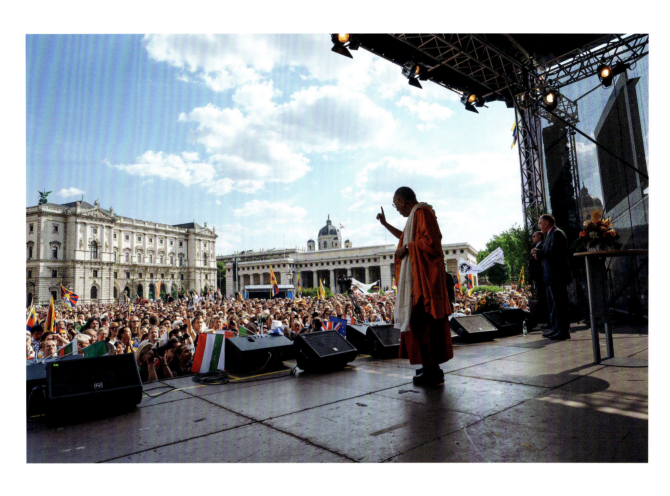

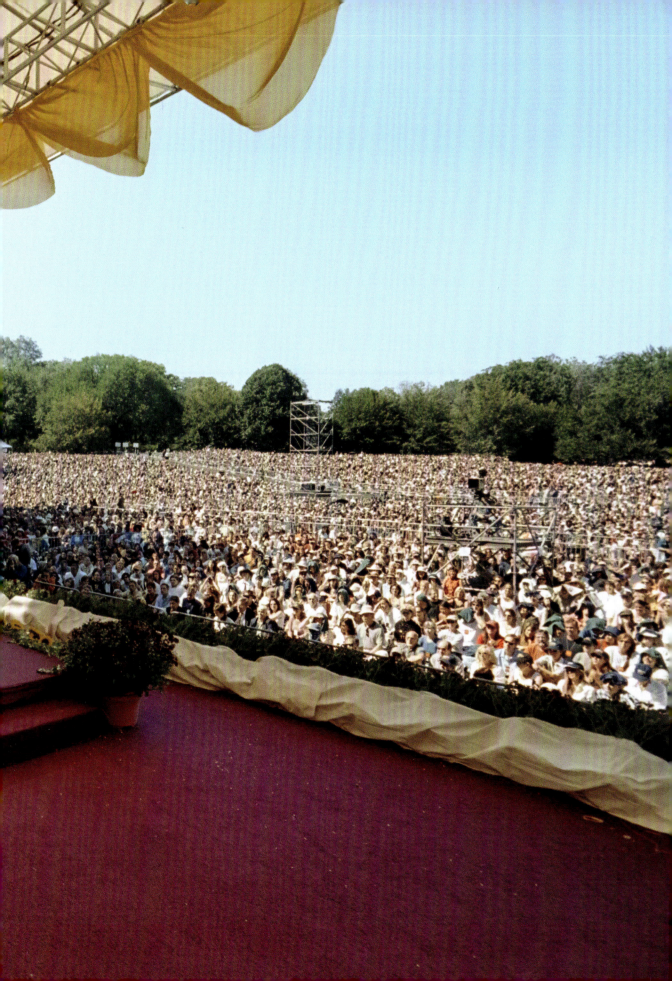

ECOLOGY AND HUMAN RESPONSIBILITY

One little-known fact about the Dalai Lama is that his Nobel Peace Prize (1989) was the first to cite the laureate's contributions to raising environmental awareness. His advocacy for environmental responsibility began early, particularly within his own Buddhist community. Drawing on the life of the Buddha, who was born under a tree, enlightened under the Bodhi Tree, and entered Nirvana beneath a tree, the Dalai Lama articulated what he called a "Buddhist perspective on nature." Over time, his environmental concerns became a central theme in his travels, particularly in Europe and the United Kingdom, where he engaged with scientists, activists, and Green Party leaders. These encounters deepened his understanding of how human behavior, particularly consumerism, contributes to ecological degradation.

The Dalai Lama has expressed particular concern for Tibet's fragile environment, which is shaped by its high altitude and dry climate. Some diplomatic

cables from the U.S. Embassy in New Delhi leaked by Wikileaks revealed that at one point, the Dalai Lama asked that U.S. policy on Tibet prioritize protecting its environment. Environmental scientists, including some Chinese researchers, had explained to him the critical role played by the Tibetan plateau in the regulation of South Asia's monsoons and as the location of the world's largest glacier lakes. Some even call the Tibetan plateau the Earth's "Third Pole" alongside the Arctic and Antarctic.

In 1990, the Dalai Lama, alongside other spiritual leaders like Mother Teresa, participated in one of the first global environmental summits, the Global Forum of Spirituality and Parliamentary Leaders on Human Survival. Two years later, he addressed the Rio Earth Summit, framing environmental issues as not just moral and spiritual challenges but also urgent matters of survival. He likened caring for "Mother Earth" to maintaining one's home, and attributed environmental destruction to ignorance, greed, and a lack of responsibility towards other life forms. Reflecting on humanity's success in addressing the ozone layer crisis, he called for collective action against the climate crisis, which he sees as today's greatest challenge.

In a recent dialogue with climate scientists and youth activist Greta Thunberg, the Dalai Lama commended her for inspiring global awareness, particularly among young people. His Holiness the Dalai Lama's words at the 1992 Rio Summit remain strikingly relevant today:

"Our ancestors viewed the earth as rich and bountiful, which it is. Many people in the past also saw nature as inexhaustibly sustainable, which we now know is the case only if we care for it. It is not difficult to forgive destruction in the past that resulted from ignorance. Today, however, we have access to more information. It is essential that we re-examine ethically what we have inherited, what we are responsible for, and what we will pass on to coming generations."

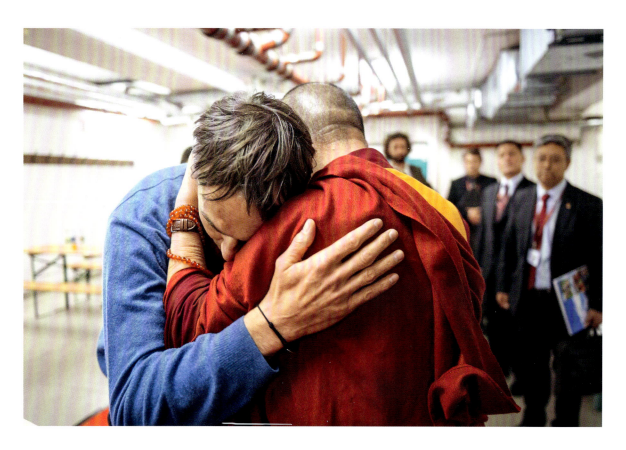

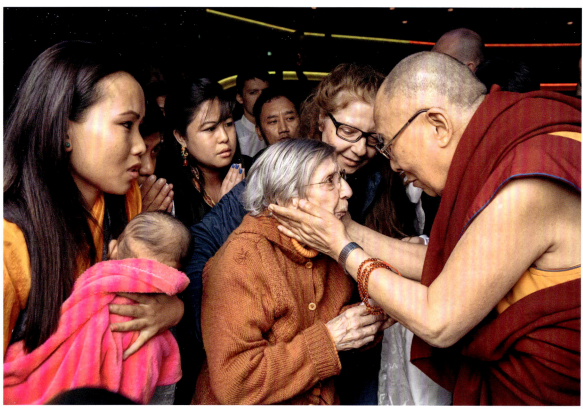

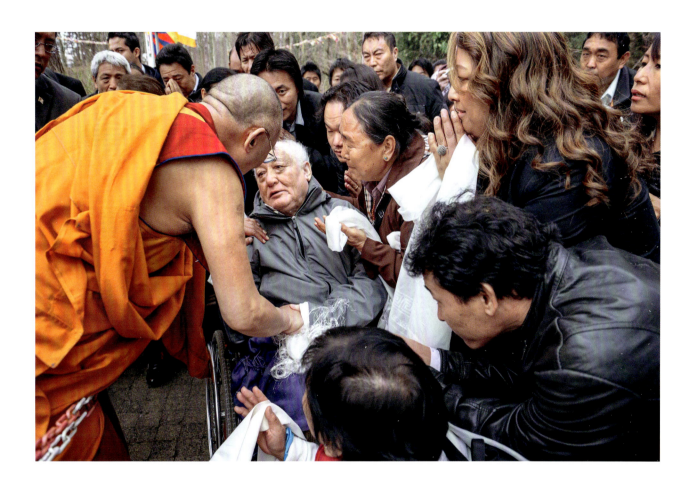

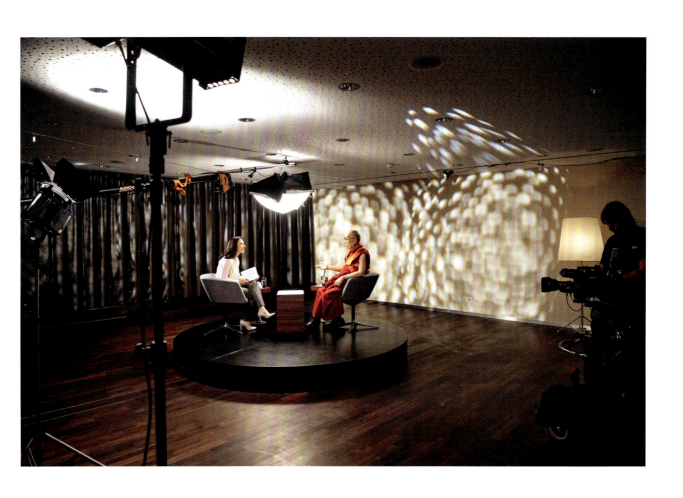

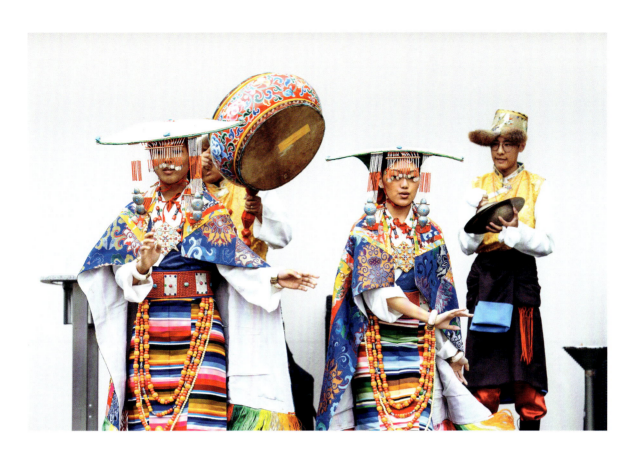

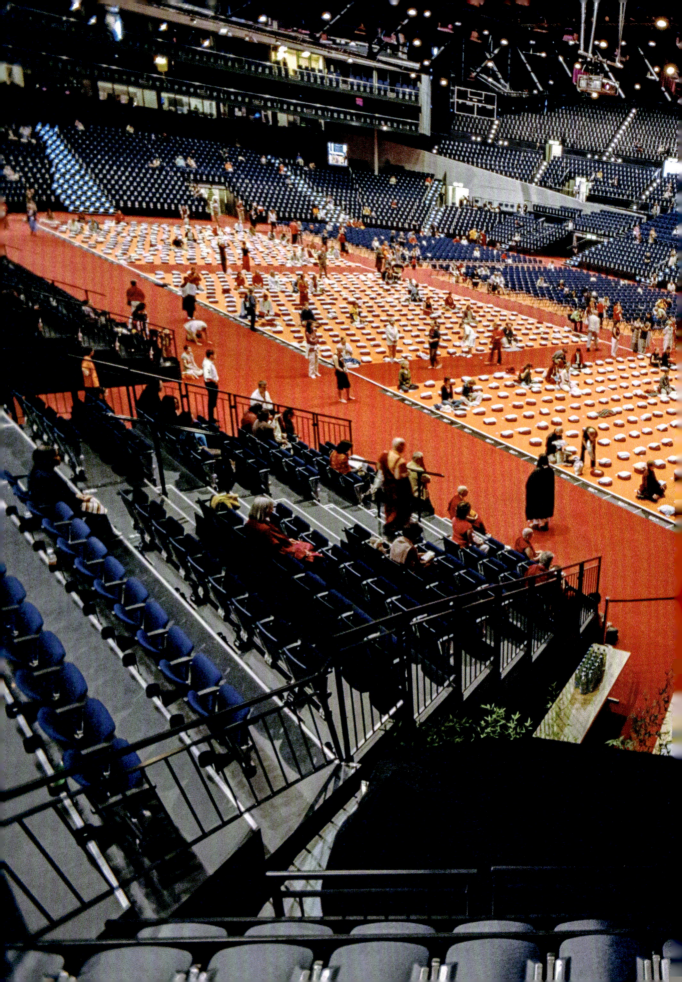

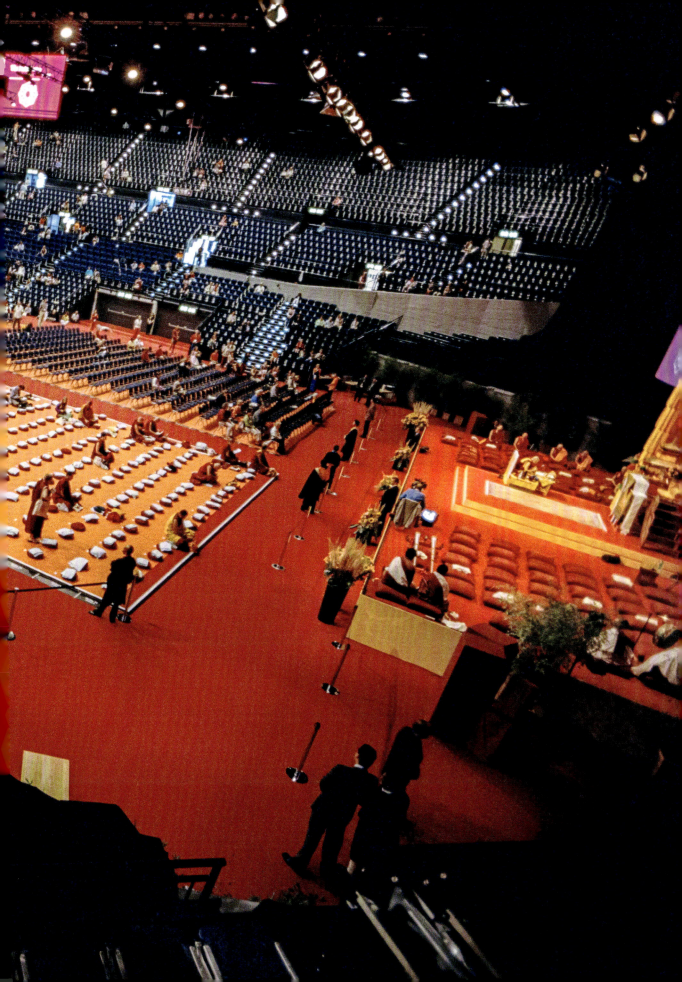

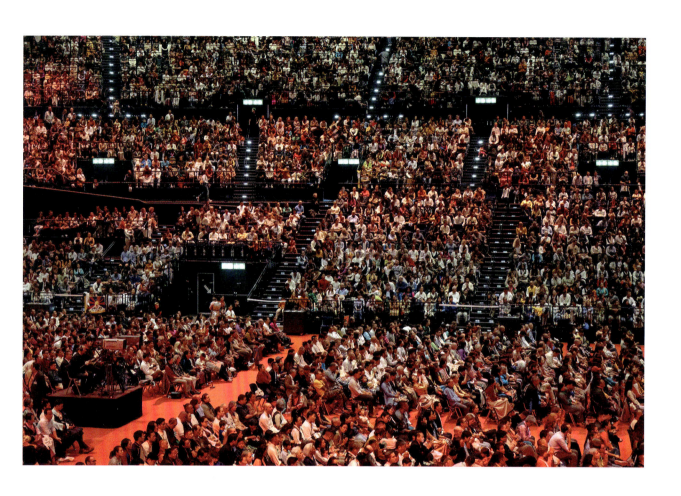

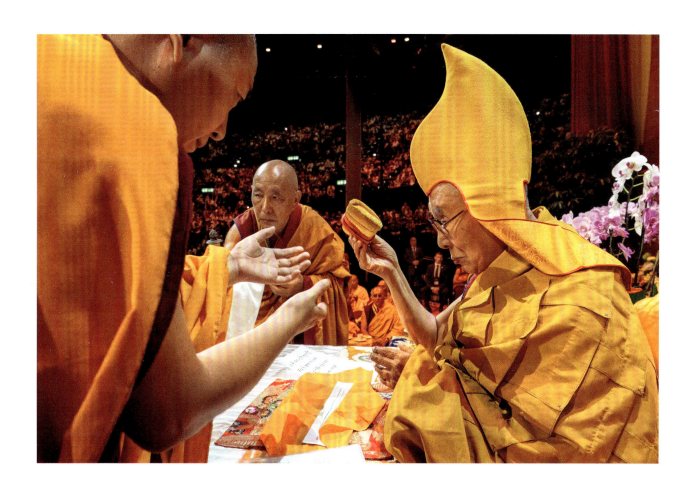

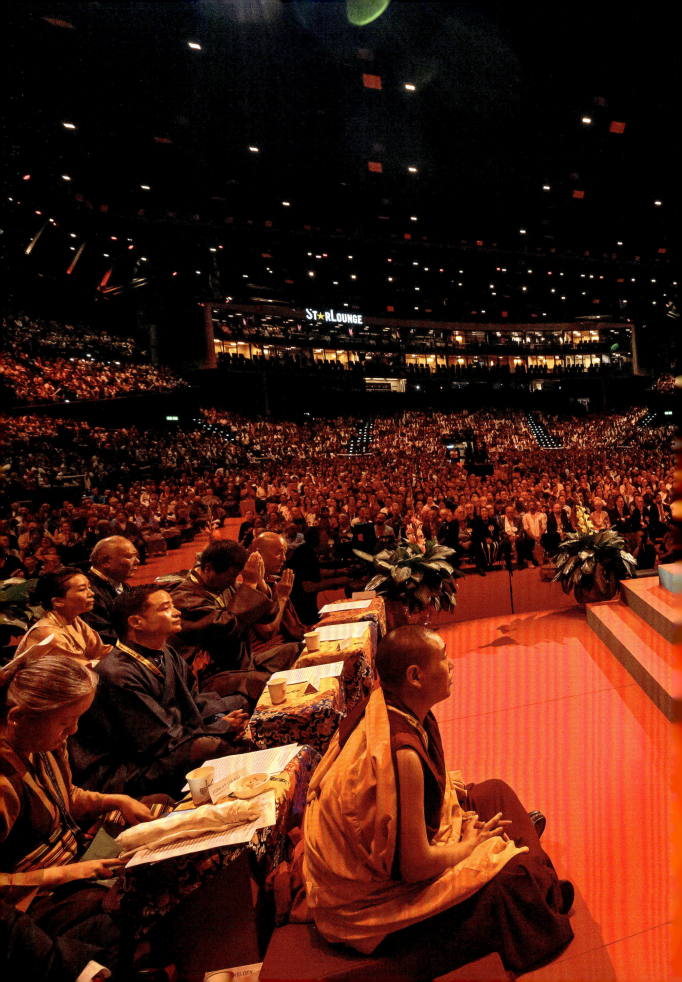

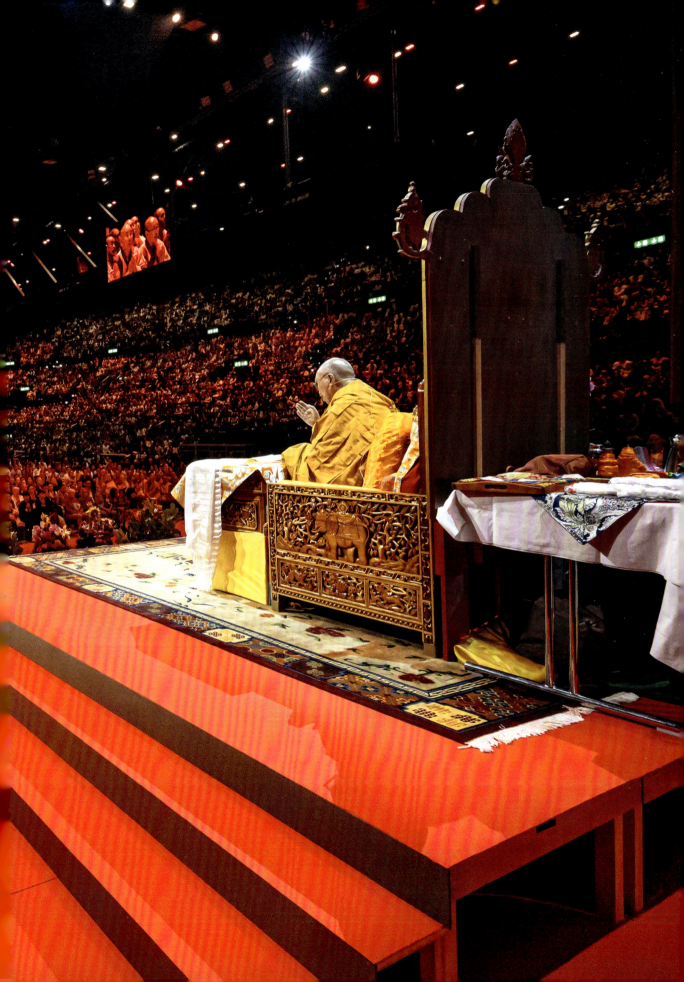

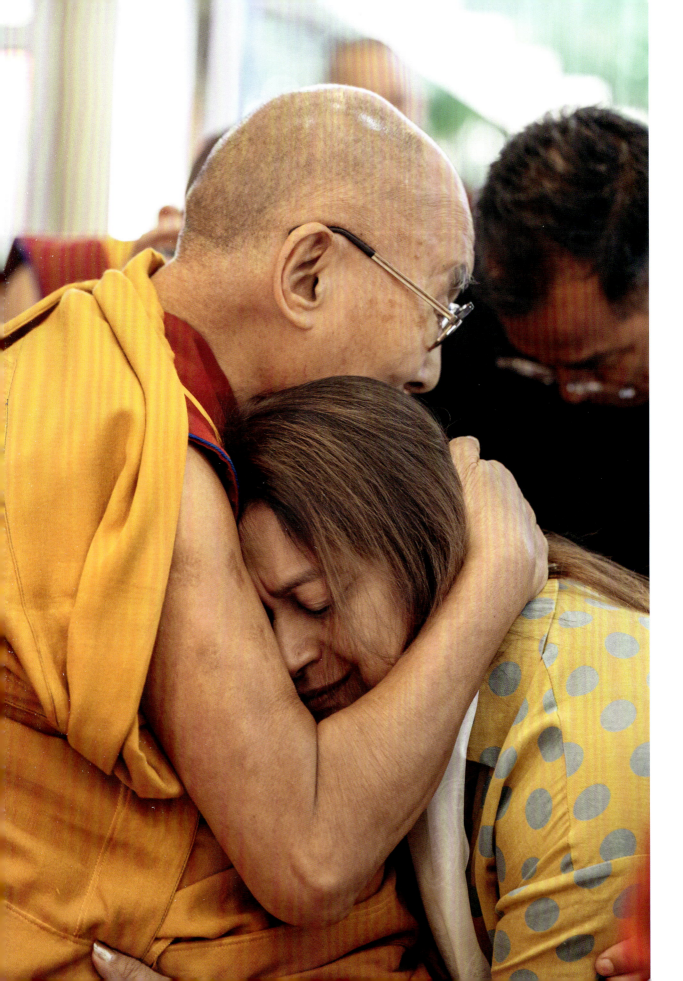

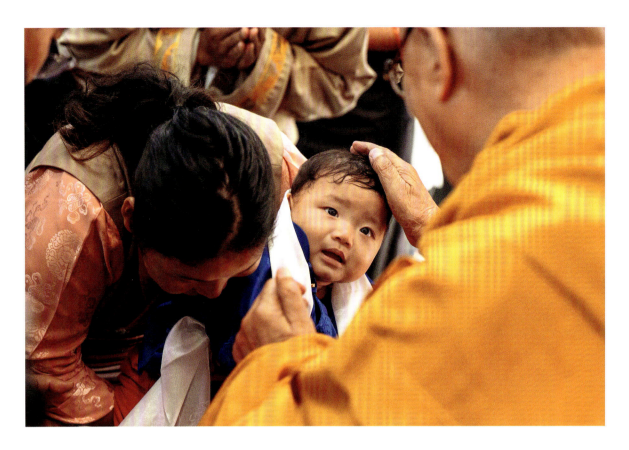

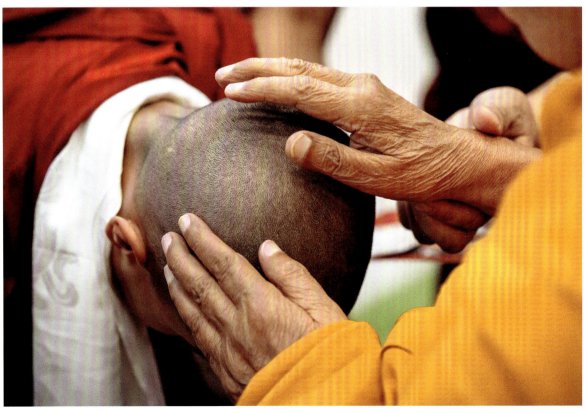

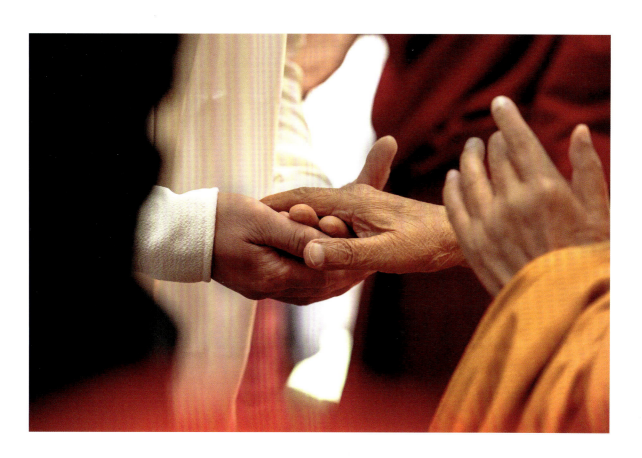
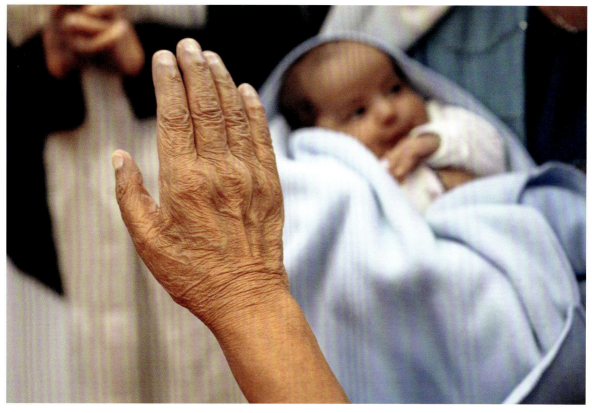

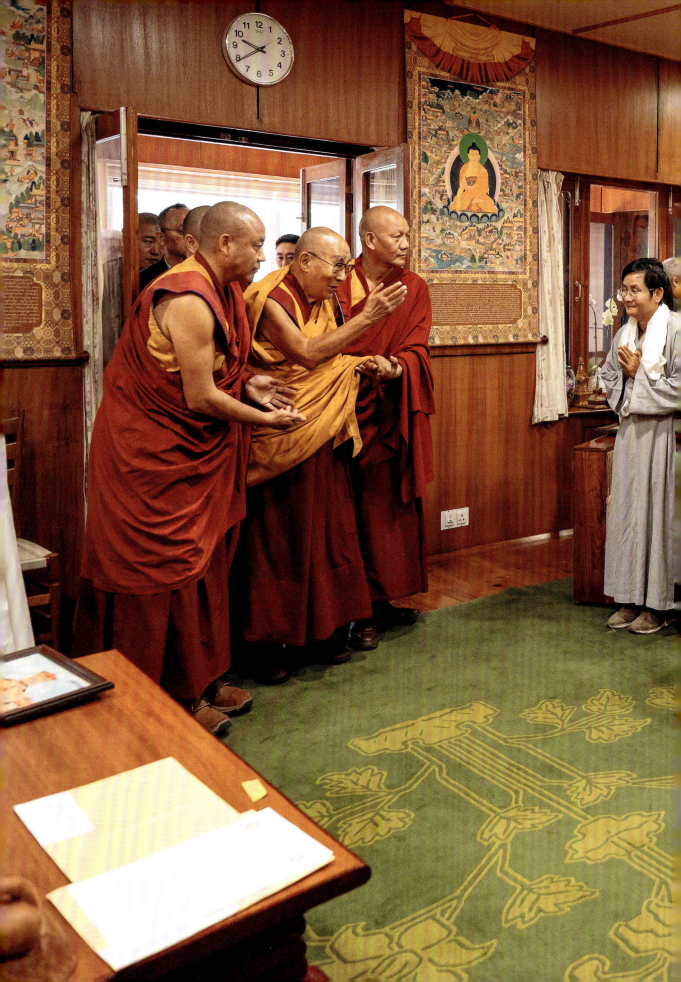

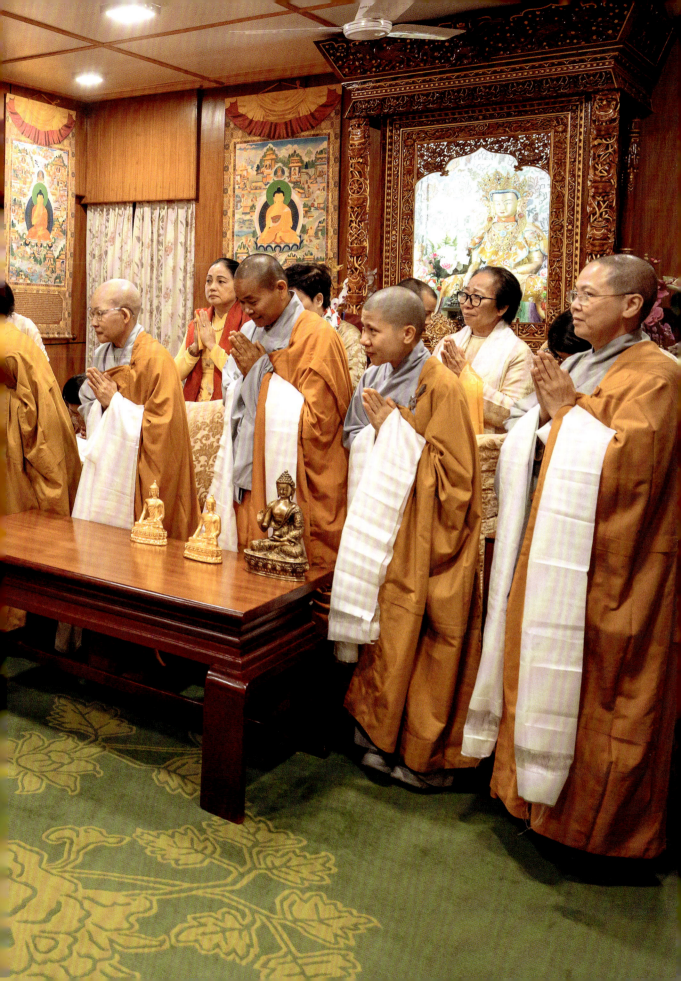

Thupten Jinpa

THE VOICE OF COMPASSION AND EDUCATION OF THE HEART

Central to the Dalai Lama's mission of promoting fundamental human values through a universal approach to ethics is his advocacy of compassion as a defining human quality. His vision reframes compassion not as a religious or moral value but as an inherent aspect of human nature. Since the 1970s, he has called for a revaluation of scientific conceptions of human nature, which he believes should include empathy and compassion, arguing that any view of humans as solely self-interested is bound to be incomplete. Today, few evolutionary scientists dispute the role of empathy and compassion in our make-up, recognizing them as crucial to our understanding of ourselves as social animals.

 For the Dalai Lama, compassion is not only natural but also crucial to personal happiness. While compassion involves concern for others' suffering, it also, paradoxically, brings joy to the one who gives it. Studies now confirm this link, suggesting that compassion

fosters feelings of connection and a sense of purpose, both of which are critical to happiness. In 2016, during a remarkable five-day dialogue on joy between the Dalai Lama and the late Archbishop Desmond Tutu, the two leaders distilled their shared wisdom into a single message: Love and compassion are the keys to lasting joy. This insight aligns with a growing body of research and the practical application of compassion training, which provides tools for individuals to strengthen their "compassion muscle."

The challenge, the Dalai Lama argues, is that as we grow older and more autonomous, we often forget the importance of compassion in our lives. We are born entirely dependent on the care of others, a fact that naturally endows us with the capacity to care for others in return. Remaining connected to this part of ourselves, the Dalai Lama believes, allows us to lead lives filled with joy and purpose. With this conviction, he advocates what he calls the "education of the heart," by which he means qualities like empathy, compassion, and the regulation of the emotions, which schools should teach alongside the conventional "education of the brain."

He speaks of "biological compassion" as an innate quality, as a seed within us that can be cultivated and expanded to include others in our radius of concern. The key to our capacity to cultivate it, he teaches, is being able to recognize our shared humanity, that just as I desire happiness and freedom from suffering, so does everyone else. In today's deeply interconnected

world, where collective challenges like climate change and inequality demand collaboration, the Dalai Lama emphasizes the urgent need to foster what he calls the "oneness of humanity." By grounding our actions in compassion and connection, he believes we can meet the demands of our time.

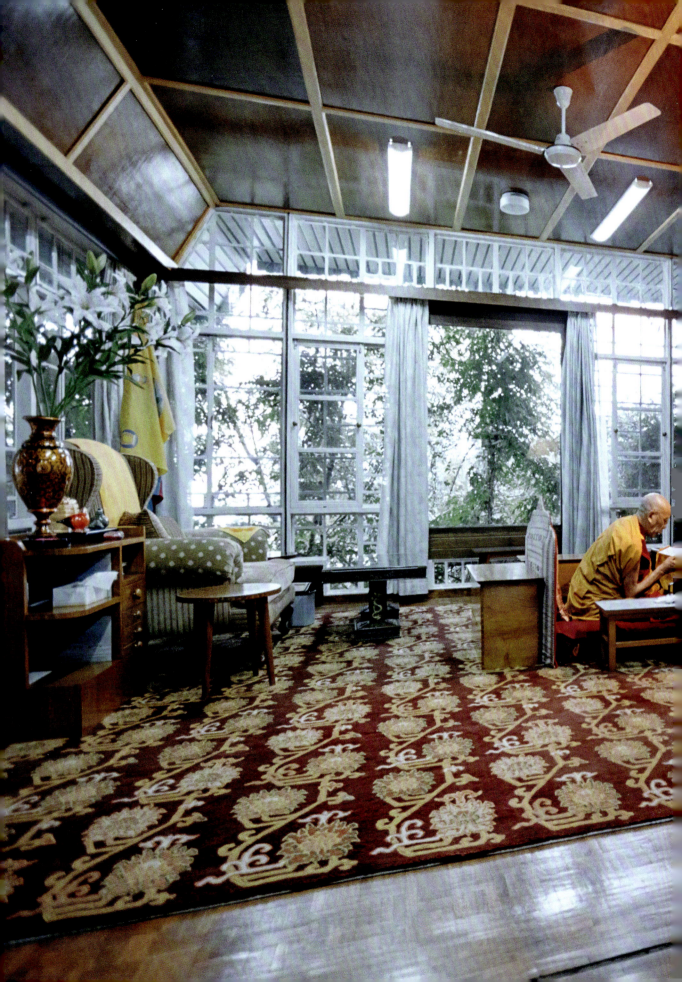

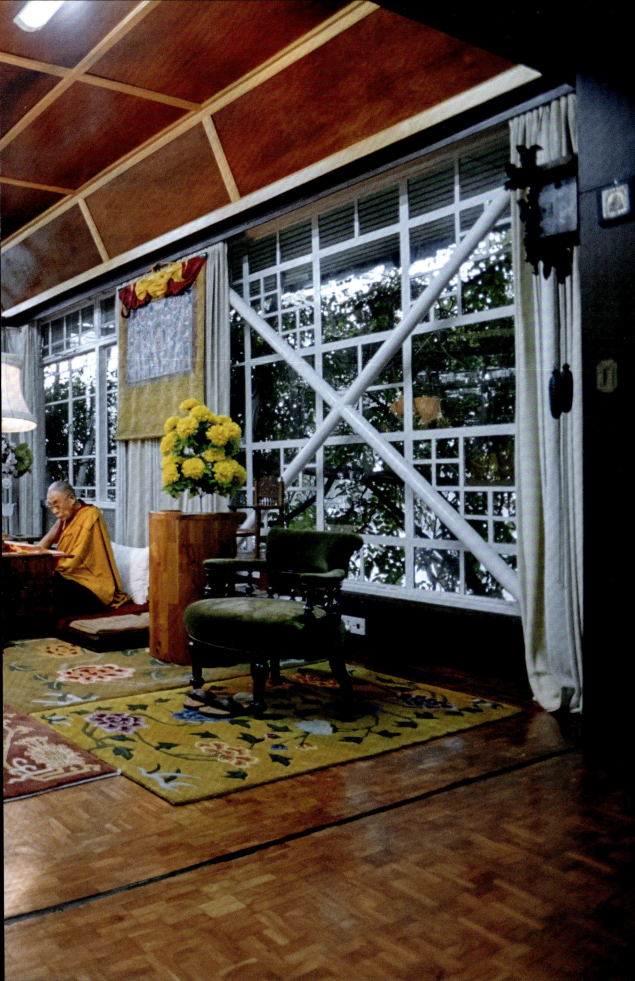

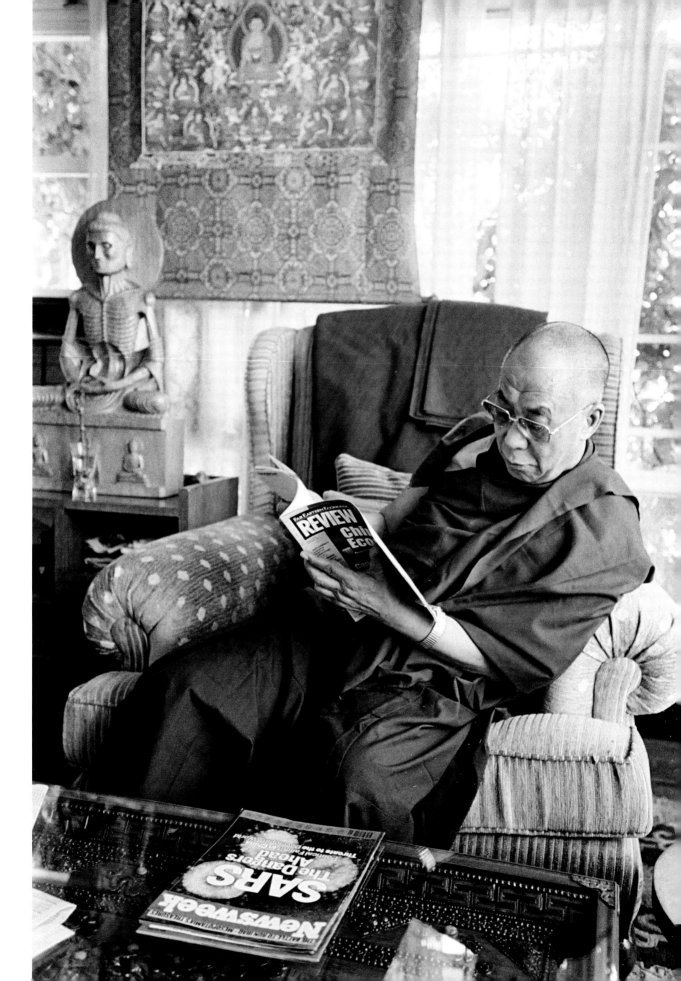

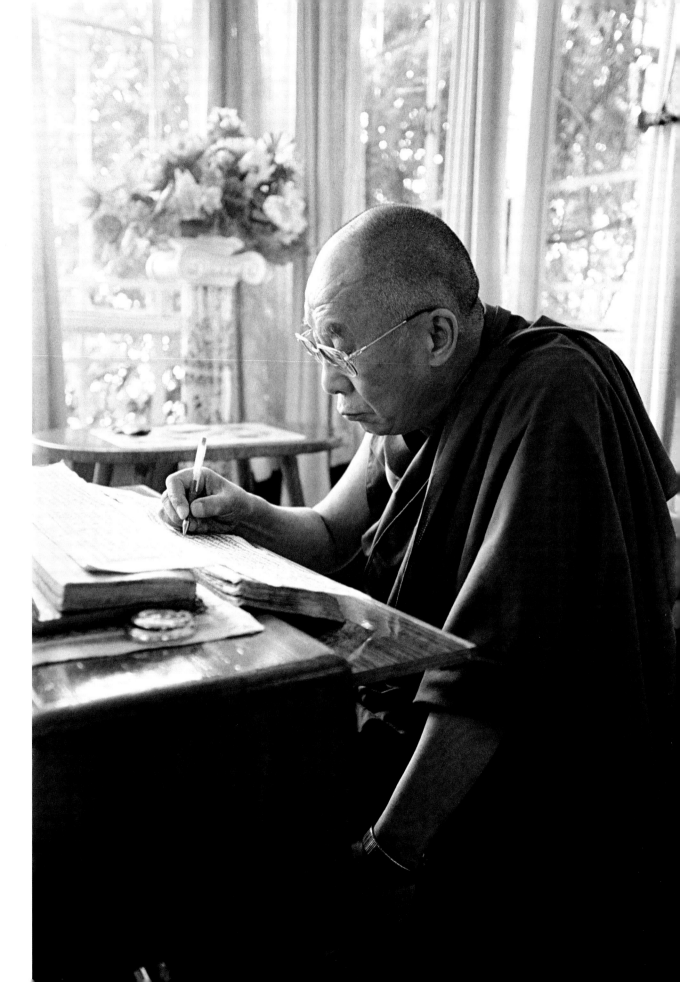

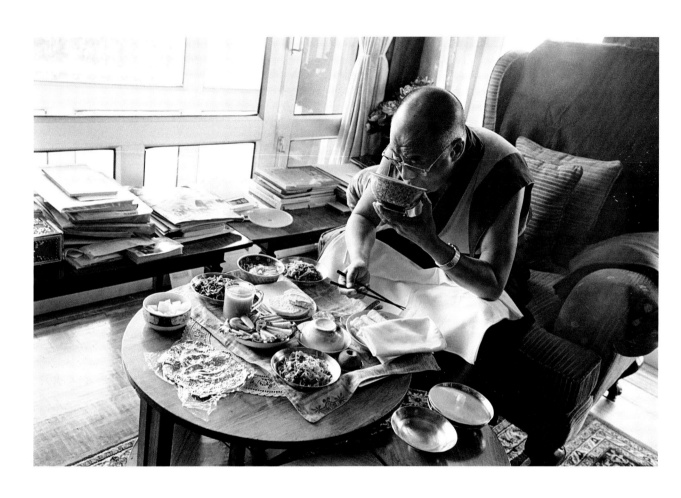

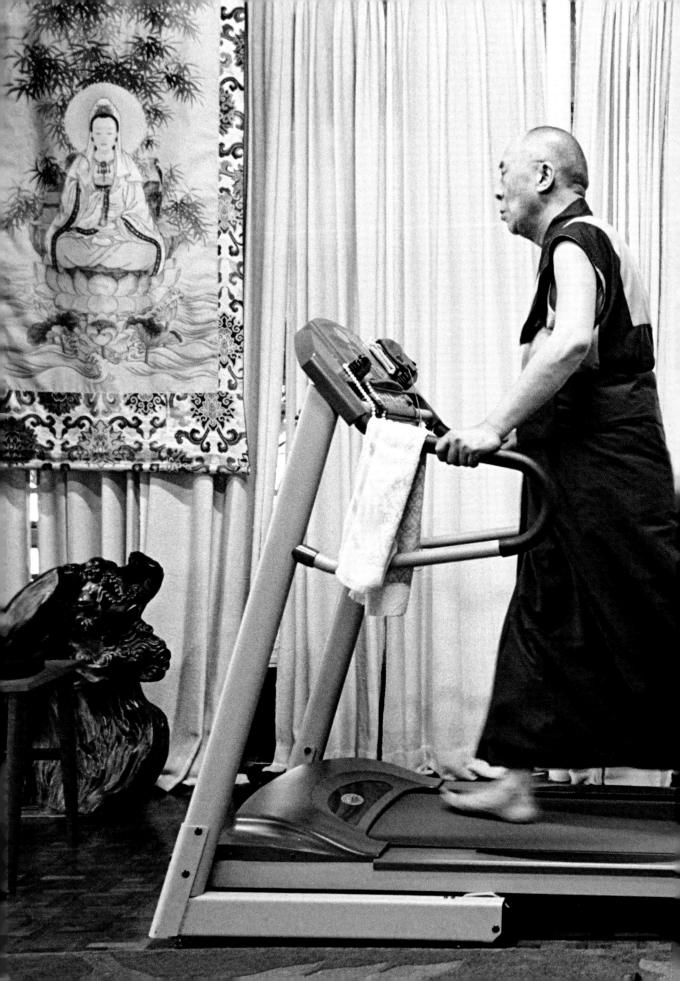

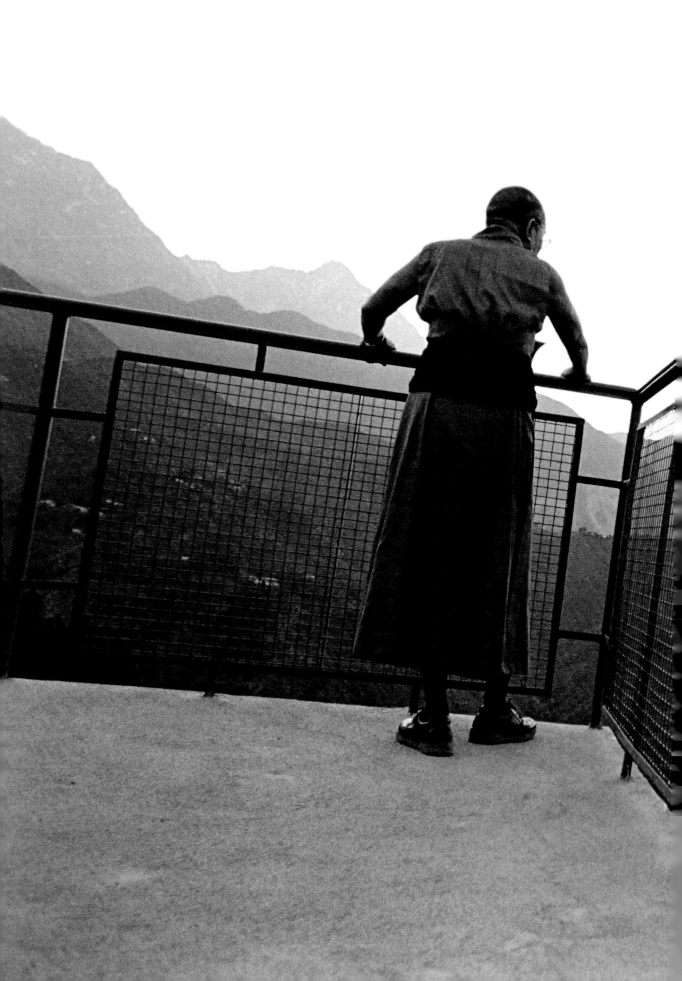

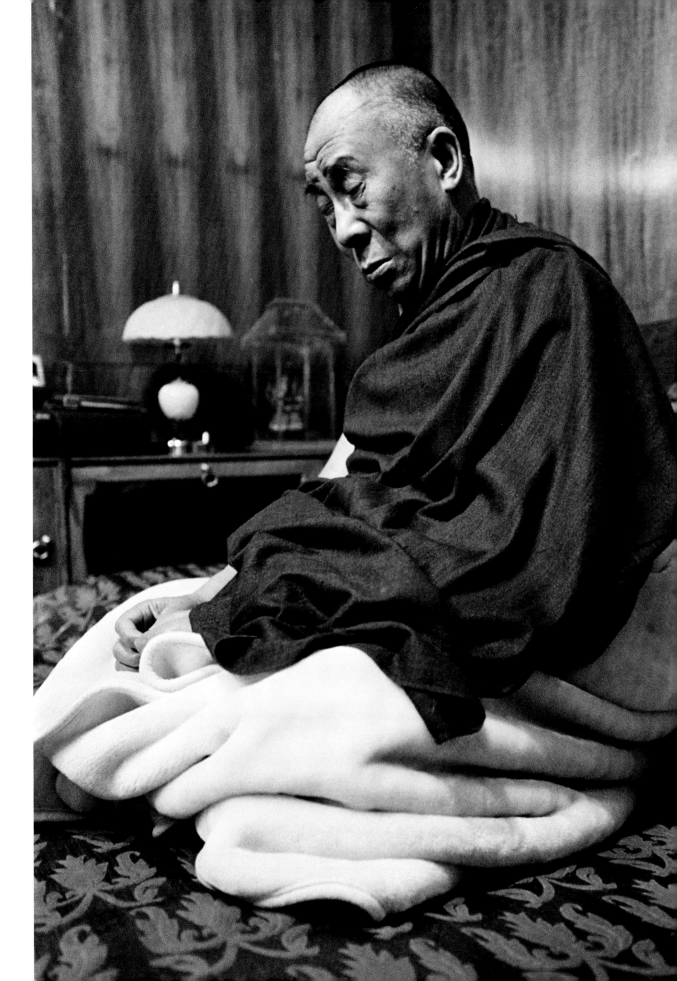

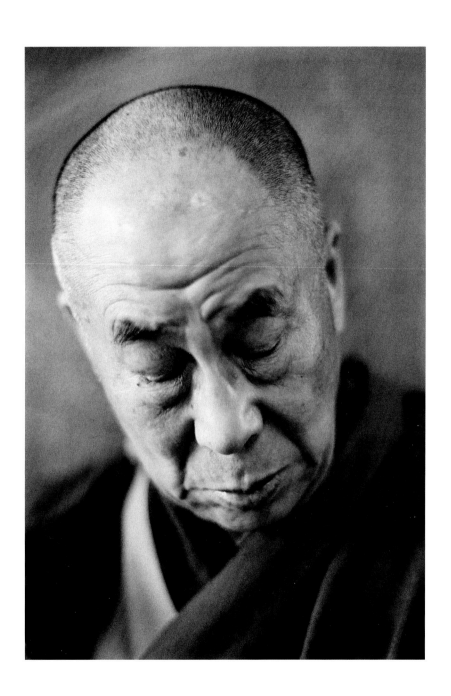

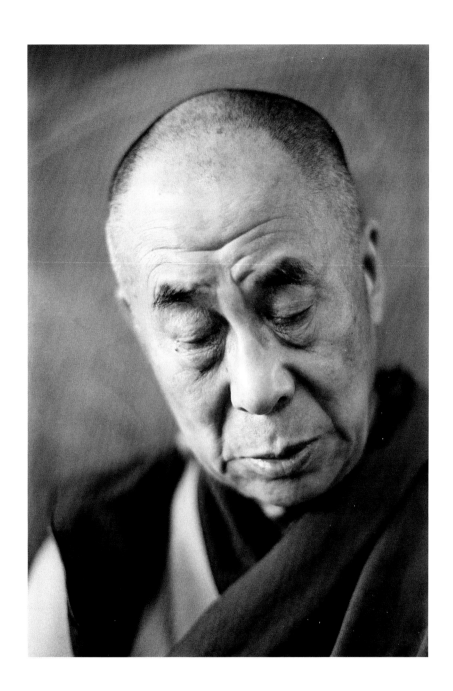

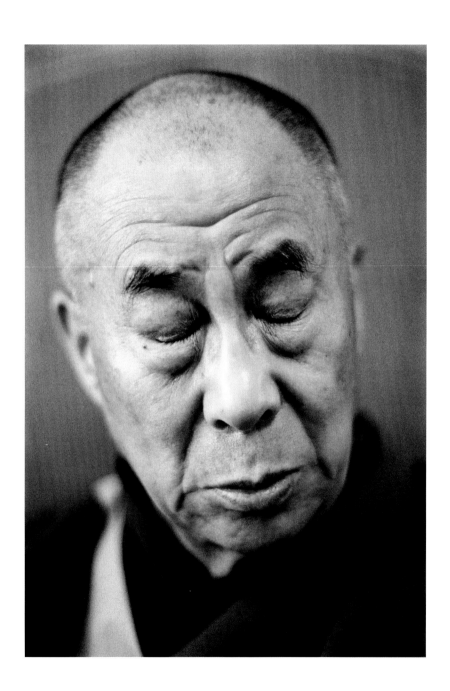

Epilogue

How did it begin? In early 1990, the journalist Hans Reutimann and I traveled to India to visit the place where the Tibetan government-in-exile had taken up residence following China's annexation and suppression of Tibet. We wanted to find out whether Tibetan culture was at risk of dying out after the first generation of refugees. Hans had been writing about Tibet since the 1960s. I was just twenty-three and had finished training as a photographer only a few weeks earlier. The invasion of Tibet had cost 1.2 million Tibetans their lives and destroyed much of their culture, including more than 6,000 sacred buildings. The question uppermost on our minds was whether the Tibetan diaspora born in Tibet would be able to pass on their knowledge to the next generation of Tibetans born in exile.

We visited the large refugee camp in southern India as well as the Sera Monastery in exile, which even then housed 3,500 monks. We spoke to freed political prisoners, who had endured unimaginable torture. We listened to the stories of refugees who had escaped over the Himalayas in peril of their lives. We interviewed a female guerilla fighter who had fought against the Chinese. The sufferings inflicted on these people as a result of the annexation of Tibet left me deeply moved, all the more so since then, as now, they were being all but ignored by the world's media. Tibet thus became *my* theme and the issue to which I would dedicate myself as a photojournalist.

In Dheradun, we produced portrait photographs of the great master craftsmen passing on their skills to their young apprentices. We photographed Cham dances, weather-makers, and the oracle of state, as well as intellectuals, musicians, and poets. We spoke to peasants and politicians.

One of the highlights of our trip was McLeod Ganj, the little hill station above Dharamsala that is home to the Tibetan government-in-exile. This is where the Dalai Lama settled following his dramatic flight from Tibet in 1959. I photographed the Dalai Lama during the long interviews he gave there and his New Year prayers. I also portrayed him at his residence, whether in the garden or in his private quarters. Being young and arrogant, I took all of this for granted. After all, I was now a photojournalist and photojournalists fraternize with superstars and heads of state. Not until much later did I realize what a privilege I had been afforded.

In June of the same year, we presented the results of our inquiry in an exhibition of photographs flanked by texts at the University of Zurich. *Tibetische Kultur auf fremder Erde* (Tibetan Culture on Foreign Soil) was to be opened by no less a figure than the Dalai Lama himself, whose presence drew a host of press, radio, and television reporters, making it an important milestone in my as yet nascent career. The Auditorium Maximum was so packed that the crowds spilled over into the corridors and stairwells, and there were plans to relay the Dalai Lama's address to several other lecture theaters. Yet no sooner had the Dalai Lama stepped up to the rostrum than the university secretary dashed in, seized the microphone and instructed everyone present to evacuate the building immediately. The university had apparently received a bomb threat against the Dalai Lama. There was no panic. On the contrary, the room fell silent. People were upset about not getting to hear the Dalai Lama speak.

While police bodyguards piloted the Dalai Lama and the university rector towards the emergency exit, the rest of us had to find our own way to safety. This meant following narrow staircases down into the gloomy, labyrinthine basement. Then came the shock: The emergency exit was locked! There was a lot of nervous back and forth as people on walkie-talkies demanded the key. The uncertainty made us all very tense and excitable. The Dalai Lama had since been taken into an office, where he sat down on an office chair and gaily spun round in

circles. Being curious, he also pulled out all the desk drawers to see what treasures the staff kept stowed away in them. Speaking to him in jest, I remarked that it was all very well for him. As a god, he had nothing to fear from a bomb threat and could simply fly out the window. "Yes, like a little bird!" he laughed, and rising from his chair began hopping around the office, flapping his arms up and down like a bird.

Suddenly, the emergency exit giving onto the underground garage was opened, and everything happened very fast: The police bundled the Dalai Lama into a limousine—and he was gone, leaving us behind in the cold basement.

Next day, the press, radio, and television were full of the alleged bomb threat and no one had anything at all to say about my photographs. Only later, when the initial disappointment had passed, did I grasp just how momentous the occasion had been. How could someone whose life and limb were on the line remain so relaxed and cheerful? How could anyone have such a supreme command of their emotions? Those were the questions I asked myself first—and that spurred me on to still more visual lines of inquiry.

You might think that photographing the same person over such a long period would give rise to a certain routine. But the Dalai Lama has an extraordinary capacity to constantly surprise and impress us anew. His discipline, his knowledge, his fellow-feeling, and his warmth are inexhaustible. My respect for him has therefore only grown over the years.

Manuel Bauer, January 2025

Captions

by Christian Schmidt

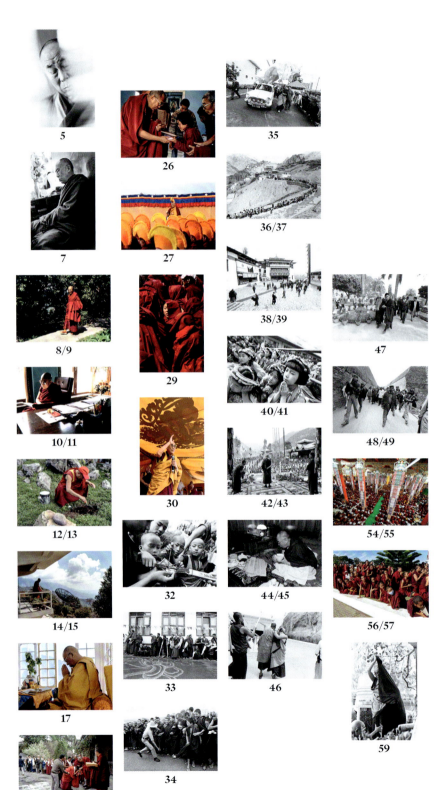

5, 7

At his residence in Dharamsala. Unless he is traveling, the Dalai Lama spends his Sundays in seclusion. His day begins as always with meditation at 3:30 a.m.; but there are no audiences on Sunday, nor does he attend to his administrative tasks. After meditating, he studies Buddhist texts. Dharamsala, Himachal Pradesh, India, May 18, 2003

8/9

Walking in the garden of his residence. Dharamsala, Himachal Pradesh, India, February 22, 1990

10/11

The Dalai Lama in his office. Dharamsala, Himachal Pradesh, India, February 22, 1990

12/13

In the garden of his residence. Nature is the basis of all life. All life forms are interconnected. "Our planet is our home, our only home," says the Dalai Lama. "Where are we to go if we destroy it?" Dharamsala, Himachal Pradesh, India, February 22, 1990

14/15

His people oppressed, his country occupied, the Dalai Lama has been living in exile, 1437 kilometers away from his palace in Lhasa, since 1959. According to the Central Tibetan Administration, the occupation cost more than 1.2 million Tibetans their lives in the first thirty years alone. On the balcony of his residence in Dharamsala, Himachal Pradesh, India, February 22, 1990

17

The Dalai Lama preparing for the Sixteen Drops of the Kadam Empowerment. The goal of this meditation practice is to narrow the mind's focus from the vast expanse of the cosmos to the core of the innermost self, eventually visualizing oneself as the Buddha in a pure universe and so developing the potential for enlightenment. Every one of the sixteen drops stands for a specific stage on this journey. The last step embodies the essence of enlightenment: a golden ocean of consciousness, free of dualism, and steeped in all-encompassing compassion. Diskit, Nubra-Tal, Ladakh, India, July 24, 2003

24/25, 26

The Dalai Lama receiving Tibetans who have recently fled to India. Dharamsala, Himachal Pradesh, India, February 23, 1990

27
The Tibetan New Year (*losar*) "My religion is very simple," says the Dalai Lama. "My religion is compassion." Tsuglagkhang Temple, Dharamsala, Himachal Pradesh, India, February 26, 1990

29
Kalachakra Empowerment in Jispa. Kalachakra is a meditation practice for purging the self of inner obstacles and developing a spirit of wisdom and compassion with the ultimate aim of achieving enlightenment and liberating all life forms from the cycle of birth and death (Samsara). Jispa, Lahaul, Himachal Pradesh, India, July 16, 1994

30
Kalachakra Empowerment in Amaravati. It was here that the Buddha is said to have performed the first Kalachakra Empowerment in ca. 490 B.C. Amaravati, Andhra Pradesh, India, January 11, 2006

32
Novices lighting incense sticks in preparation for the arrival of the Dalai Lama. Jonang Takten Phuntsok Choeling Monastery, Sanjauli, Himachal Pradesh, India, June 12, 2002

33
The Sera Monastery in exile awaiting the Dalai Lama. Not only did the Indian government grant Tibetan refugees asylum but it also provided land for their homes and monasteries. The monasteries in India, however, are but a poor substitute for the more than 6,000 sacred buildings that have been destroyed or access to them rendered impossible since Tibet was first occupied. Bylakuppe, Karnataka, India, August 2, 2001

34
Expecting the Dalai Lama. While there are no reliable figures, at least 130,000 people are known to have fled their native Tibet since it was first occupied by China. Gyudmed Tantric Monastic University, Hunsur, Karnataka, India, December 8, 1993

35
Arrival of the Dalai Lama at Namdroling Monastery. Bylakuppe, Karnataka, India, August 3, 2001

36/37
Tibetan Buddhism extends far beyond the country's geographical boundaries, and for centuries it has been widespread on the Indian side of the Himalayas, too. The Dalai Lama therefore visits the faithful even in the most remote corners of the Subcontinent, including here at the 900-year-old Dhankar Monastery that is a twelve-hour drive from his residence. Spiti, Himachal Pradesh, India, May 23, 2003

38/39
It was not far from Tawang Monastery that the 6th Dalai Lama was born in 1682. He was the only Dalai Lama to abandon the ascetic way of life and adopt a secular lifestyle. His love poetry makes him a popular figure with Tibetans, even today. Other Dalai Lamas, by contrast, are known as political leaders who played a crucial role in steering their nation's fortunes. They are known as the "great" Dalai Lamas. Among them is Tenzin Gyatso, the 14th and current Dalai Lama. Tawang Monastery, Arunachal Pradesh, India, May 4, 2003

40/41
Ceremony at Tsuglagkhang Temple. For many years, some 3,000 Tibetans fled to India every year. This figure has since plummeted to fewer than a hundred. The main reasons for this are worsening Chinese repression and stricter border controls, so that many escape attempts end in death. Tsuglagkhang, Dharamsala, Himachal Pradesh, India, June 3, 2002

42/43
Until the outbreak of the Covid pandemic, the Dalai Lama spent half the year traveling. As the spiritual leader of his people, he visits the faithful among the diaspora and spreads his message of peace and compassion all over the world, as here, during a stopover at Pema Choeling Monastery. Rupa, Arunachal Pradesh, India, May 1, 2003

44/45
It is 5.30 a.m. and the Dalai Lama is preparing for a teaching at Tawang Monastery near the border with Tibet. He eats muesli for breakfast, and the monastery kitchen has managed to find a package of "Alpen Original" for him. The breakfast flakes based on an idea from Switzerland were originally produced by a British firm, which later passed into Chinese and then American hands. His Holiness views globalization as a mixed blessing. Whereas it certainly has the potential to advance humanity, such progress is desirable only if universal human values such as compassion, cooperation, and responsibility are fostered at the same time. Tawang Monastery, Arunachal Pradesh, India, May 8, 2003

46
The Dalai Lama with Ngawang Chamba Stanzin, the abbot of Thiksay Monastery and the 9th reincarnation of Jangsem Sherab Zangpo, on a visit to the 600-year-old Diskit Gompa, the oldest monastery in the Nubra Valley. Nubra Valley, Ladakh, India, July 29, 2003

47
Together with Shiwalha Rinpoche Nueden Taksham, believed to be the 9th reincarnation of Shantideva, the Dalai Lama approaches the entrance to what used to be Nalanda University. Founded in Late Antiquity, it ranked among the world's largest educational institutions right up to the 13th century. It was here, in the 8th century, that Shantideva wrote *The Bodhicaryavatara* in which he describes awaking from the sleep of unknowing, overcoming suffering, and recognizing the true nature of reality. The Dalai Lama has campaigned for the preservation of this traditional Indian knowledge. He is firmly convinced that explorations of the mind and analytical meditation combined with modern scientific methods have the potential to pilot the world into a more peaceful future. Nalanda, Bihar, India, January 14, 2002

48/49
Members of the "Black Cats," an Indian government anti-terror unit, guard the Dalai Lama against assassination attempts amid the ruins of Nalanda University. Nalanda, Bihar, India, January 14, 2002

54/55
Even in exile in India, Tibetan monasteries are often home to several thousand monks, just as they once were in Tibet. Meditating is an integral part of monastic life: "Many people believe that meditating means sitting quietly and not thinking," says the Dalai Lama. "But you cannot spend your whole life not thinking!" Drepung Loseling Monastery, Mundgod, Karnataka, India, December 8, 2012

56/57
Arrival of the Dalai Lama. Mundgod, Karnataka, India, December 8, 2012

59
On a pilgrimage to Bodh Gaya in 2003, the Dalai Lama visits the Bodhi Tree under which the Buddha achieved Nirvana. His Holiness regularly pays homage to this tree. On a visit to the site in 2022, he had a message of hope for the 300,000 pilgrims assembled there: "Physically, we are still separated from our brothers and sisters in Tibet. But spiritually, we are very close to them. I pray for them all. I am confident that the truth will ultimately prevail." Bodh Gaya, Bihar, India, January 7, 2003

61

A blind Tibetan woman has the Dalai Lama breathe onto her eyes. Many devout Buddhists credit the Dalai Lama with the power of healing, even if he himself does not believe it. If he did possess such powers, he once joked, he would have dealt with his painful knee long ago! When asked for help, however, he readily obliges, which in some cases brings relief or even spontaneous recovery. He nevertheless prefers to attribute such effects less to his own supernatural forces than to the powerful faith of the sufferer. Thupten Dorje Drak Ewam Chogar Chökhor Namgyal Ling Monastery, Kasumpti, Shimla, Himachal Pradesh, India, June 16, 2002

63

Although the Dalai Lama knows countless sacred texts off by heart, they affect him deeply every time he reads them. Here, a passage about compassion has moved him to tears. Teaching at Tabo Monastery, Spiti, Himachal Pradesh, India, May 24, 2003

64

The Dalai Lama in front of the Mahabodhi Stupa in Bodh Gaya. A stupa contains the mortal remains of great masters, sacred texts, and mantras. Venerating stupas serves both to cleanse worshippers of harmful actions (negative karma) and to help multiply those beneficial actions that will further their spiritual growth and liberate them from the cycle of suffering (positive karma). Growing on the west side of the Mahabodhi Stupa is an offshoot of the sacred fig tree under which the Buddha attained enlightenment (Bodhi). Mahabodhi Stupa, Bodh Gaya, Bihar, India, January 7, 2003

65

Visit to the Dhamekh Stupa in Sarnath near Varanasi. It was here that the Buddha, having awakened from the sleep of unknowing, is said to have given his first teaching. The subject was the Four Noble Truths. The first truth: Life in the cycle of birth and death is full of suffering. The second truth: There are causes that lead to suffering, especially desire, hatred, and ignorance. The third truth: There is an end to suffering. The fourth truth: There is a path that leads to the end of suffering and that path rests on ethical behavior, mindfulness, and wisdom. These insights remain at the core of all Buddhist teaching even today. Dhamekh Stupa, Sarnath, Uttar Pradesh, India, January 21, 2003

67

Refugee monks and nuns have tried to reconstruct as many as possible of the now destroyed religious buildings they left behind in their native Tibet. They and their families make significant financial sacrifices to this end. The Dalai Lama nevertheless begs his followers to heed the example of Mother Teresa by spending less money on buildings than on social projects. Namdroling Monastery, Bylakuppe, Karnataka, India, August 3, 2001

69

Teaching at the Jonang Takten Phuntsok Choeling Monastery, the Dalai Lama dons the headdress of a scholar. *Dalai Lama* translates literally as "ocean-like teacher." He is regarded as one of the wisest individuals in the world and as an internationally recognized moral and spiritual authority. This authority rests on his life-long study of Buddhist scripture, his way of life, and the well over a hundred thousand hours that he has spent meditating. Sanjauli, Himachal Pradesh, India, June 14, 2002

70/71

After the Tibetan New Year (*losar*), new prayer flags are strung up along the Lingkhor pilgrimage path. Dharamsala, Himachal Pradesh, India, February 23, 2004

72/73

A woman from Ladakh awaits the arrival of the Dalai Lama for a Kalachakra Empowerment. Her bejeweled headdress tells of the symbolic importance of turquoise to Tibetan culture. Called the "stone of heaven" in Tibetan, it symbolizes life, health, and vitality, as well as guarding against misfortune and evil spirits. Leh, Ladakh, India, July 6, 2014

74/75

Returning from the island of Nagarjunakonda, named for the monk Nagarjuna, who lived here in the 2nd century. The Dalai Lama describes Nagarjuna as the "second Buddha" since it was his ideas that put Buddhism on the path to *Mahayana* Buddhism. *Mahayana* Buddhism attaches great importance to altruism, both for overcoming one's own sufferings and for helping all sentient beings towards enlightenment. Andra Pradesh, India, January 3, 2006

76

Monks on their way to hear the Dalai Lama teaching at the Gaden and Drepung Monasteries. Mundgod, Karnataka, India, December 4, 2012

77

Monks plying the audience with butter tea while the Dalai Lama speaks about the "stepped path to enlightenment." Drepung, Mundgod, Karnataka, India December 4, 2012

78/79

Arrival at Drepung Monastery. Mundgod, Karnataka, India, December 6, 2012

80

The Dalai Lama greets the dignitaries who will be taking part in the Kalachakra Empowerment. *Kalachakra* ("Wheel of Time") is one of the most comprehensive teachings and meditation practices in Tibetan Buddhism; it is also a philosophical concept that unites the cosmic, the physical, and the spiritual. Kalachakra builds a bridge between outer reality (macrocosm) and inner experience (microcosm). Amaravati, Andhra Pradesh, India, November 16, 2006

81 top

On a visit to the Gaden Jangtse Monastery. The Dalai Lama is believed to be the manifestation of Chenrezig, the Bodhisattva of Compassion and patron saint of Tibet. Bodhisattvas are exceptional individuals who voluntarily forgo Nirvana so that they can be reborn to serve humanity, which is what the Dalai Lama is doing in his current incarnation. He shares his message of compassion and altruism to alleviate suffering in the world; he teaches that peace begins with inner peace, and he calls on us to think beyond national, religious, and cultural categories and to develop a global perspective for global engagement. Gaden Jangtse Monastery, Mundgod, Karnataka, India, December 5, 2012

81 bottom

Rizong Rinpoche, one of the leading clerics of the Gelug School, offers the Dalai Lama a Long Life Ceremony. The Gelug School, or "school of the virtuous," is one of the four main schools of Tibetan Buddhism; the Dalai Lamas traditionally hail from this school. Gaden Jangtse Monastery, Mundgod, Karnataka, India, December 5, 2012

82, 83, 84/85

Kalachakra Empowerments last around ten days, and since they typically attract several hundred thousand faithful, they are also a major logistical challenge. Alongside the official organizers and local businesses, numerous monks and lay volunteers also get involved. They hand out water, butter tea, and bread; and they also set up big screens to ensure that all those present have a clear view of the ritual. Encampment at the Kalachakra Empowerment in Amaravati, Andhra Pradesh, India, January 8–13, 2006

86/87

On the way to Diskit Phodrang, the Dalai Lama's local residence, at the conclusion of the "Sixteen Drops of the Kadam Empow-

Captions

81 bottom

65

82

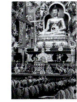

67

72/73

83

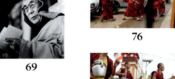

74/75

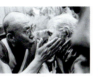

69

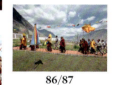

84–85

erment. Many monasteries have rooms set aside for the Dalai Lama to stay in should he come to visit. Diskit, Nubra-Tal, Ladakh, India, July 24, 2003

88/89

For many Tibetans, seeing the Dalai Lama in person is a highlight of their lives. Tawang, Arunachal Pradesh, India, May 6, 2003

90/91

The Dalai Lama's teachings are broadcast on shortwave in multiple languages. A high-ranking Indian policeman listens on headphones to the Kalachakra Empowerment at Bodh Gaya, where the Buddha attained enlightenment. Later he will say that although a Hindu, he has never heard such a learned and wise guru as the Dalai Lama. Bodh Gaya, Bihar, India, January 16, 2003

92/93

Schoolchildren awaiting the arrival of the Dalai Lama outside the capital of Ladakh. Ladakh is already feeling the effects of climate change, a subject that the Dalai Lama talks about regularly. This is what he said about it in 2018: "We are all affected by climate change and global warming. So we must develop a feeling for the essential oneness of humanity. Only thinking of ourselves does not lead to positive results. If, however, being mindful of the essential oneness of humanity, we work together, we can avert the worst consequences of climate change." Leh, Ladakh, India, July 18, 2012

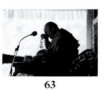

61

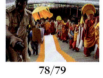

76

86/87

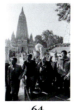

63

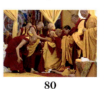

77

64

78/79

88/89

80

90/91

81 top

92/93

357

Captions

94
Preparations for the Dalai Lama's visit to a school in Tawang. More than half a century after he was forced into exile, the Tibetans' spiritual leader is as revered as ever, even among those generations who have never seen their homeland. "Children respond readily to compassion, so we must find ways of nurturing such character traits," says the Dalai Lama. "The time spent at school should include methods of promoting inner peace." Choepheling Public School, Tawang, Arunachal Pradesh, India, May 4, 2003

95
The Dalai Lama's personal altar in his meditation room. His Holiness is convinced that meditation influences the neuroplasticity of the brain and helps regulate emotions such as anxiety and anger: "All humans have an innate desire to overcome suffering and find happiness," he says. "Meditation to train the mind to think differently is an important way of avoiding pain and being happy." Dharamsala, Himachal Pradesh, India, August 16, 2004

101
The Dalai Lama leaving Tawang by helicopter. Situated close to the Tibetan border, Tawang reminds him of that time in 1959, when, sick and exhausted from fleeing the Chinese forces of occupation, he broke his journey here. Above Tawang, Arunachal Pradesh, India, May 5, 2003

103 top and bottom
Stopover in Kullu. Local leaders met the Dalai Lama at the airport and presented him with a hat that is traditional to their region. Traveling from Kullu to Tabo, Himachal Pradesh, India, May 21, 2003

104/105
Eager spectators watching the automobile convoy taking the Dalai Lama to Tashi Choeling Monastery. The Soviet dictatorship suppressed Tibetan Buddhism in Mongolia, and only after the collapse of the USSR did it enjoy a revival there. Ulaanbaatar, Mongolia, August 24, 2006

106/107
Visit to the Jampaling Center. Ulaanbaatar, Mongolia, August 23, 2006

108/109
After teaching at the National Central Stadium. The theme of the Dalai Lama's talk was the principle of *tendrei toepa*, which says that all phenomena are interdependent and possess no independent, autonomous existence of their own. On his visit,

358

the Dalai Lama also performed a White Tara Empowerment. A female manifestation of the Buddha, White Tara is regarded as the deity of long life. National Central Stadium, Ulaanbaatar, Mongolia, August 23, 2006

110 top

Visit to Gandan Tegchenling Monastery, the most important Buddhist monastery in Mongolia. The 13th Dalai Lama fled here in 1904 after British troops invaded Tibet. Britain, at the time, was trying to prevent Tibet from entering into an alliance with Tsarist Russia, which would have enabled Russia to extend its sphere of influence as far as the border with British India. The 13th Dalai Lama was able to return to Lhasa in 1908. Forty-one years later, a Dalai Lama was again driven out of his home country when Chinese troops invaded Tibet. Ulaanbaatar, Mongolia, August 22, 2006

110 bottom

Lunch in the large yurt of Gandan Tegchenling Monastery. Ulaanbaatar, Mongolia, August 22, 2006

111 top

The Dalai Lama being shielded against the cold wind during the preparations for an empowerment at the Janraisig Temple of the Gandan Tegchenling Monastery. Ulaanbaatar, Mongolia, August 27, 2006

111 bottom

At Gandan Tegchenling Monastery. Ulaanbaatar, Mongolia, August 27, 2006

113, 115

An empowerment in the Janraisig Temple of Gandan Tegchenling Monastery. Ulaanbaatar, Mongolia, August 28, 2006

116/117

"The only purpose of religion is to foster love and compassion, patience, tolerance, humility, and forgiveness." This is what the Dalai Lama said when teaching the principle of *tendrei toepa* prior to the White Tara Empowerment. National Central Stadium, Ulaanbaatar, Mongolia, August 24, 2006

118, 119

The Dalai Lama left Mongolia again in August 2006. The Mongolian government had invited His Holiness to visit in defiance of Chinese threats, and China responded by temporarily closing both its borders and airspace. Although the Mongolian government stood firm, the Dalai Lama has since been prevented from traveling to Ulaanbataar. Following another visit of his in 2016, the Chinese threatened to break off negotiations for a desperately needed billion-strong loan should Mongolia continue to welcome the Dalai Lama; and this time, the Mongolian government caved in to the pressure. Chinggis Khaan International Airport, Ulaanbaatar, Mongolia, August 28, 2006

120, 121, 122/123, 124/125

The Dalai Lama begins his Sundays with a *khora,* a ritual circumambulation of his temple in Dharamsala. Back in the meditation room of his residence, he prostrates himself to show his respect and gratitude to the three jewels of Buddhism: the Buddha himself, the *dharma* (the teachings of Buddhism), and the *sangha* (the community of ordained people and other practitioners who have reached a certain stage on the path to enlightenment). Prostrations, alongside prayers, are central to the Dalai Lama's daily religious practice. In the evening, after his shower, he reads about current affairs. Dharamsala, Himachal Pradesh, India, May 18, 2003

127

Since being forced into exile in 1959, the ruling Dalai Lama is regarded as one of the most charismatic figures in the world. He campaigns tirelessly for a peaceful solution to the Tibet conflict, while at the same time spreading his vision of global peace. To the Chinese leadership in Beijing, however, he is still a dangerous separatist, who wants his homeland to be an independent state in contravention of the Chinese constitution. Yet the Dalai Lama has repeatedly declared his commitment to a "Middle Way" entailing autonomy and religious freedom for Tibet as part of China. Diskit, Nubra-Tal, Ladakh, India, July 24, 2003

128

In 2004, the Dalai Lama withdrew from public life to spend several weeks meditating. Here he is holding two frequently used ritual objects: a bell (*ghanta*) and a diamond scepter (*vajra*). The bell symbolizes wisdom, the female principle, and emptiness as the definitive truth, while the scepter stands for actions prompted by all-encompassing compassion, the male principle, and conventional truth. The two ends of the diamond scepter symbolize relative and absolute truth. The Dalai Lama's residence, Dharamsala, Himachal Pradesh, India, August 16, 2004

129

The Dalai Lama uses his *mala* for reciting mantras such as "Om Mani Peme Hung." Reciting that mantra transports him into a state of compassion, empowering him to forgive both himself and others for the pain that we humans knowingly or unknowingly inflict on each other. The 108 beads of the *mala* stand for the 108 volumes of the teachings of the Buddha or for the 108 worldly desires that are to be overcome. The one extra bead, larger than the others and known as the *guru*, marks the beginning and end of the *mala*. The Dalai Lama's residence, Dharamsala, Himachal Pradesh, India, August 16, 2004

130

The Dalai Lama making a symbolic offering to the Destroyer of Death, Yamantaka, during a retreat. The offering comprises several bowls of precious stones. The Dalai Lama's residence, Dharamsala, Himachal Pradesh, India, August 15, 2004

131

The Dalai Lama on a retreat in his personal meditation room. He reads sacred texts printed with hand-cut woodblocks. The elongated shape of the pages dates back to the time before the invention of paper, when people wrote on palm fronds. The Dalai Lama's residence, Dharamsala, Himachal Pradesh, India, August 15, 2004

The Kalachakra Ceremony
by Thupten Jinpa

All the images presented here are of the Kalachakra Empowerment Ceremony conducted by His Holiness the Dalai Lama in Leh, Ladakh, in July 2014. The multiday event drew over 150,000 devotees from around the world, including from inside Tibet.

138/139
Offerings—butter lamp, incense, water bowls, and *tormas* (sculpted dough decorated with butter)—laid out on the altar as part of the preparation rituals.

140/141
Consecration of the ritual daggers (*phurbas*) that will later symbolize the ten directions (four cardinal and four intermediate directions plus above and below) around the mandala once it is complete. The dagger for "above" is placed in the east, that for "below" in the west. The daggers pin interfering forces to the outer edge of the platform to prevent them from disturbing the empowerment.

142/143
As *Vajra* Master (the lama conducting the empowerment ceremony), His Holiness the Dalai Lama blesses the ground by means of a dance on the platform on which the sand mandala will be created. He is assisted by monks of the Namgyal Monastery, who have long served as ritual attendants for His Holiness during major ceremonies.

144/145
The Dalai Lama and attendant monks bless the mandala site, circumambulating the raised platform in a clockwise direction as part of the initial consecration ritual.

146 top
The ritual dance offered to the mandala's deities is an essential element of the consecration ritual, invoking blessings on the site of the mandala.

146 bottom, 147 top and bottom
Monks dressed in ceremonial costumes chant and perform the *saghar* ritual dance around the platform. Their rhythmic movements and melodious recitations are an integral part of the ritual to sanctify the site of the mandala.

148 top
A monk performing a specific *mudra* (hand gesture) as an essential element in the ritual proceedings in preparation for the creation of the mandala.

148 bottom
One of the monks assisting the Dalai Lama in the performance of the rites connected with the Kalachakra Empowerment. Long sessions of chanting are an integral part of the preparations.

149 top
His Holiness the Dalai Lama holds the *vajra* (scepter) in his right hand and the bell in his left to symbolize the inseparable union of method and wisdom at the heart of the Buddhist path. On the table before him lie sacred ritual items: a hand-drum, a container filled with rice and flower petals, and a ritual cup on a stand containing consecrated liquid, typically black tea.

149 bottom
The deep, resonant tones of Tibetan long horns (*dungchen*) blown by monks echo across the ritual space

150
The Dalai Lama carefully marks the foundational lines defining the basic structure of the mandala. This act initiates the creation of the intricate draft mandala.

151 top and bottom
His Holiness and the monks anoint specific points on the blue surface on which the sand mandala will later be constructed. The Dalai Lama himself participates in the process of outlining the details of the mandala.

152/153
The complete draft mandala will serve as the basis for the subsequent application of colored sands to bring the full mandala to life.

154/155
The key points at which symbols of the mandala deities are to be created are marked. The Kalachakra mandala is the seat of 722 deities. These are invoked by name and invited to take their place in the mandala. Each purified barley seed represents one deity.

156/157
The careful marking of key points corresponding to the locations of specific deities is part of the preparatory process.

158 top and bottom, 159 top and bottom
Preparation of the rainbow-colored thread symbolizing the "wisdom lines" that will hover above the draft mandala's main structural lines. These imaginary lines, suffused with symbolic meaning, are visualized as merging with the mandala's design.

160 top
His Holiness the Dalai Lama pours sand through a funnel to create the first colored lines of the mandala. The rubbing of the funnel by a second funnel sets in motion a fine trickle of sand.

160 bottom
A dextrous monk pours colored sands onto the eight-petalled lotus at the center of the mandala.

161 top
As the monks continue the intricate process of constructing the mandala, the Dalai Lama, as *Vajra* Master, remains seated, deep in meditation and chanting prayers.

161 bottom, 162, 163, 164/165
Working in shifts for several days, the monks continue the long process of creating the sand mandala.

166/167
Carefully and joyfully, the monks add the finishing touches to the mandala, ensuring its patterns are perfectly aligned.

168/169
The sacred process of creating an intricate sand mandala is over. The result is a masterpiece of sacred geometry and vibrant colors that can be read as the plan of a three-dimensional temple with four entrance gates. Like a map, it enables attendees to visualize their way into the mandala, encountering deities en route.

170 top and bottom, 171 top and bottom
Close-up views of some of the patterns and figurative motifs that are part of the sand mandala.

172
With the mandala complete, the curtains around the platform are drawn to preserve its sanctity. Ten ritual vases symbolizing the ten principal deities of the Kalachakra, each crowned with leafy twigs, are then placed around the mandala, marking the ceremonial transition to the next stage: the Kalachakra Empowerment itself.

173 top
Using the rainbow-colored thread to connect his heart to the vases, the Dalai Lama consecrates the water they contain in preparation for the sacred role that it will play in the Kalachakra Empowerment.

Captions

Captions

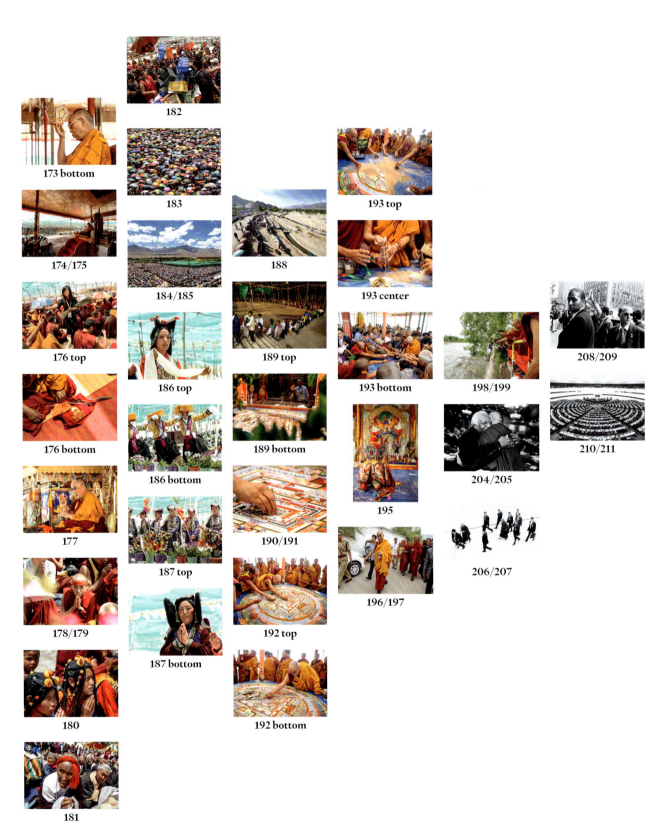

362

173 bottom
The Dalai Lama holds aloft the diadem that is an important emblem in the empowerment ceremony. It represents the crown of the deity Kalachakra and so symbolizes the Dalai Lamas's transformation into Kalachakra. After long meditation, the Dalai Lama is ready to guide devotees through the Kalachakra Temple and help them visualize the 722 deities.

174/175
The Dalai Lama addressing the large congregation gathered for the Kalachakra Empowerment. The Kalachakra in Leh was attended by over 150,000 devotees.

176 top
An usher distributes kusha grass to the attendees. This sacred grass, symbolizing purification, is placed under the bed to remove obstacles and smooth the spiritual path embarked upon during the multiday ceremony.

176 bottom
A monk with his kusha grass.

177
The Dalai Lama performing the Kalachakra Empowerment; the raised platform bearing the completed sand mandala, stands to his right.

178/179
Young monks participating in the empowerment; the red band represents a blindfold to be used in the initial stages of the ceremony before the attendees are ready to "see" the mandala and its deities.

180
Devotees from Kham in eastern Tibet in traditional costumes and jewelry, praying at the multiday preparations for the Kalachakra Empowerment.

181
Devotees praying during the empowerment ceremony

182
Volunteer ushers helping to distribute bread at the teaching site

183
The devotees shield themselves against the strong sun of Ladakh's high-altitude plateau, creating a sea of colorful umbrellas.

184/185
The congregation at the Kalachakra Empowerment makes for a striking spectacle: Thousands are gathered under the large green canopy, while those outside the canopy have to rely on umbrellas to protect themselves from the intense sunlight.

186 top
A member of the Tibetan Institute of Performing Arts (TIPA) sings a song in honor of the Dalai Lama, marking the conclusion of the Kalachakra Empowerment.

186 bottom
Artists from TIPA perform together in celebration of the conclusion of the Kalachakra Empowerment.

187 top
Ladakhi women in resplendent traditional costumes and turquoise-studded headdresses sing together to celebrate the conclusion of the Kalachakra Empowerment.

187 bottom
A Ladakhi woman in traditional attire and jewelry standing among the attendees at the Kalachakra Empowerment

188
Devotees line up to view the sand mandala and receive its blessing after the conclusion of the Kalachakra Empowerment.

189 top
Devotees forming an orderly line as they approach the platform where the mandala is fully unveiled for viewing

189 bottom
Devotees gaze at the mandala with reverence, seeking its blessing.

190/191, 192 top
The sand mandala having served its purpose as a basis for visualizing deities during the empowerment, the Dalai Lama initiates its dismantling by carefully taking a pinch of colored sand from the center. The dismantling of the mandala symbolizes the impermanence of all phenomena.

192 bottom
His Holiness sweeps the sands inwards from the outer edges to the center.

193 top, 193 center
The mandala sands are swept up and poured into glass jars.

193 bottom
The Dalai Lama gives those around him a small sprinkling of sand each.

195
Most of the sands are placed inside a ritual vase adorned with a diadem.

196/197
Leading a ceremonial procession, the Dalai Lama and the monks carry the mandala sands to their final destination.

198/199
The sacred sands are offered up to a flowing river, symbolizing the transference of blessings to the natural world and to all sentient beings, including all aquatic creatures. The sand that was borrowed from nature to draw the mandala is now returned to nature.

204/205
The Dalai Lama and the former Archbishop of Cape Town, Desmond Tutu (1931–2021), were good friends, as is apparent from the warmth of their reunion at the Nobel Peace Prize Centennial in Oslo. Both have devoted their whole lives to the cause of world peace. The Nobel Peace Prize went to the Dalai Lama in 1989 and to Desmond Tutu in 1984. While standing outside listening to the Norwegian Foreign Minister's centennial address, Archbishop Tutu began to shiver from the cold. Seeing this, the Dalai Lama took his friend's hands and tucked them under his robe. Oslo, Norway, December 7, 2002

206/207
Surrounded by security guards, the Dalai Lama withdraws for his lunch break during a Kalachakra Empowerment. The guards are there to protect His Holiness against assassination attempts. Their briefcases contain not papers but bulletproof mats. Stadthalle, Graz, Austria, October 19, 2002

208/209
The Dalai Lama on a visit to New York to give a teaching at the Beacon Theatre in 2003. He greets the crowd waiting expectantly in front of the theater. Two days later, speaking in Central Park, he will open his address with the self-deprecating disclaimer: "I've nothing to offer, nothing special, just blablabla," though as an ambassador for peace he will soon switch to his core message: "The concept of war has had its day. Destroying your neighbor is basically destroying yourself." Beacon Theatre, New York City, USA, September 20, 2003

210/211
The Dalai Lama addressing the European Parliament. "Many of the world's problems and conflicts arise because we have lost sight of the basic humanity that binds us together as one human family. We tend to forget that for all our manifold races, religions, cultures,

languages, ideologies, and so forth, we humans are basically the same in our desire for peace and happiness: We all want happiness and we do not want suffering." European Parliament, Strasbourg, France, October 24, 2001

212, 213
Nobel Peace Prize laureates gather in front of the Norwegian Parliament to demand the release of fellow prize-winner Aung San Suu Kyi, who at the time was imprisoned in Myanmar. The Dalai Lama was delighted at the chance to meet Elie Wiesel and Rigoberta Menchú Tum. Oslo, Norway, December 8, 2001

214 top
In the office of U.S. Secretary of State Colin Powell. The Dalai Lama signs the guest book with his secretary Tenzin Taklha at his side. Washington D.C., USA, September 9, 2003

214 center
One of the first non-Asian heads of state to officially welcome the Dalai Lama was Czech President Václav Havel, formerly a political prisoner and human rights activist. His 1989 invitation to the Dalai Lama strengthened Tibet's position on the international stage—and provoked China's displeasure. Havel and the Dalai Lama were bound by a close friendship. Official residence of the president, Prague, Czech Republic, July 2, 2002

214 bottom
The Dalai Lama meets the Tibetan teacher Takna Jigme Sangpo, whom China charged with "corrupting the minds of children with reactionary ideas" and imprisoned for thirty-seven years. His "crime" was to have taught schoolchildren in Tibetan, and to have given history lessons that told the truth about Tibetan history instead of Chinese propaganda. Sangpo's sentence was extended every time he refused to renounce his Buddhist faith and his respect for the Dalai Lama. He was finally released for health reasons in 2002 and thereafter lived in Switzerland until his death in 2020. Graz, Austria, October 11, 2002

215 top
At Mikhail Gorbachev's invitation, a number of Nobel Peace Prize laureates gathered in Rome in 2003, among them Shimon Peres and the Dalai Lama. Rome, Italy, November 28, 2003

215 bottom
The Dalai Lama, accompanied by Hamburg Mayor Ole von Beust, pens his entry in the Golden Book of the City of Hamburg. "I wish this famous city and its people all the best and every happiness," he wrote. The Dalai Lama was accorded a state welcome in Hamburg. As Beust told the media, he would not let the Chinese dictate who he could receive and who not. Stadthalle, Hamburg, Germany, July 19, 2007

216/217
The Dalai Lama in conversation with Rebyia Kadeer, a Uyghur human rights activist and former president of the Uyghur World Congress. Like the people of Tibet, the Uyghurs of Xinjiang Province are also oppressed by the Chinese, who send them to re-education camps and have deliberately settled Uyghur lands with Han Chinese. In 1999, Rebyia Kadeer was sentenced to eight years in prison for having wanted to send members of the U.S. Congress reports on the human rights situation in her home country. The Chinese equated this with "leaking state secrets." Hamburg, Germany, July 24, 2007

218
The Dalai Lama in conversation with Strasbourg Mayor Fabienne Keller, accompanied by his interpreter Matthieu Ricard. Strasbourg, France, October 23, 2001

219
Members of the Dalai Lama's entourage waiting for his meeting with Czech parliamentarians to end. City Hall, Prague, Czech Republic, July 3, 2002

220
Mikhail Gorbachev, former President of the Soviet Union, and the Dalai Lama joking about their lack of hair in Rome City Hall. Rome, Italy, November 28, 2003

221
The situation in Tibet is often raised in interviews such as this one with a Portuguese radio station. The Dalai Lama consistently advocates what he calls the "Middle Way," by which he means an autonomous Tibet as part of China. His demand is based on a common Buddhist concept developed by a monk called Nagarjuna in the 2nd century, which His Holiness combines with a pragmatic approach to global politics. What he seeks are not mere compromises but solutions likely to minimize the sufferings of all those affected. In the case of Tibet, his "Middle Way" serves as a model for non-violence and dialogue. Applied globally, it is an appeal for cooperation and wisdom in pursuit of peace and stability. Strasbourg, France, October 23, 2001

222/223
Preparing for an interview for "21," a television program of the Czech state broadcaster. Prague, Czech Republic, July 2, 2002

224 top
Lunch break during a Kalachakra Empowerment in Graz. The Dalai Lama takes the time to sign books for the team of organizers and volunteer helpers. Graz, Austria, October 20, 2002

224 bottom
Signing autographs. Tokyo, Japan, January 3, 2003

225
The Dalai Lama taking questions from the audience after an address at the University of Ljubljana. Talking to students, he always stresses how important it is to him to reconcile the scientific knowledge of the West with the teachings of Buddhism and traditional Indian knowledge. Law Faculty, University of Ljubljana, Slovenia, July 5, 2002

226
Lecture on "The Path to Freedom" at the Parco della Musica auditorium. Rome, Italy, November 26, 2003

227
The Dalai Lama's bodyguards have to be on high alert whenever he is addressing Buddhists from Mongolia. Unlike devotees from other countries, they seek direct physical contact, so that his bodyguards have to hold onto him for his own protection. National Graduate University, Washington, D. C., USA, September 11, 2003

228
The Dalai Lama speaking at the Capitol on the twentieth anniversary of the Congressional Human Rights Caucus (CHRC). As an informal, bipartisan group in the U.S. House of Representatives, the caucus stood up for the rights of the oppressed and marginalized groups all over the world. Following the death of its co-founder Tom Lantos in 2008, it was renamed the Tom Lantos Human Rights Commission. National Statuary Hall, Washington, D. C., USA, September 9, 2003

230/231
The Dalai Lama rarely has any downtime when traveling, but here, he was unexpectedly accorded a moment of peace. So huge was the crowd that had gathered to see him that the security checks took much longer than planned. Sports Arena, Split, Croatia, July 7, 2002

Captions

233
Ready to go. Tawang, Arunachal Pradesh, India, May 9, 2003

235
In the grounds of Prague Castle during a conference of the Forum 2000 on "Bridging the Global Gaps." The gathering dedicated to finding solutions for the future of the world assembled business leaders, politicians, and other key figures. The Dalai Lama was also among the attendees. He summed up his attitude as follows: "Knowing and doing nothing is like not knowing." Prague Castle, Prague, Czech Republic, July 3, 2002

240/241
The Dalai Lama is the recipient of many honors and awards, including honorary doctorates, honorary citizenships, and prizes for his work as an ambassador for peace. Here, the University of Graz awards him its highest honor: its Human Rights Prize. University of Graz, Austria, October 14, 2002

242/243
Mind & Life Conference 2010. This conference serves as a platform for researchers in the neurosciences, psychology, philosophy, and other scientific disciplines to share ideas on the role of the mind in our individual and collective well-being. The Dalai Lama thinks the West is too fond of viewing the mind as a product of the neuronal activities of the brain. In contrast to such mechanistic thinking, he understands the mind as a deeper reality, which alongside consciousness and perception comprises the nature of the spirit itself, which meditation and mindfulness can change. Zurich, Switzerland, April 9, 2010

244, 245
Visiting a Swiss company that manufactures Tibetan medicines. The Dalai Lama himself uses both Tibetan and Western medicine to cure his ills; he is also committed to fostering dialogue between the two different schools. Wetzikon, Switzerland, August 13, 2005

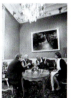
212

213

214 top

214 center

214 bottom

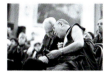
215 top

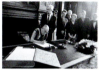
215 bottom

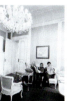
216/217

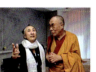
218

219

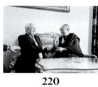
220

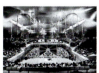
221

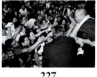
222/223

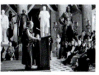
224 top

224 bottom

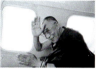
225

226

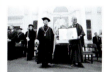
227

228

230/231

233

235

240/241

242/243

244

245

365

Captions

247
At Hamburg University, Germany, July 20, 2007

248
At the European Parliament. Strasbourg, France, October 24, 2001

249
Speaking at the Nobel Peace Prize Centennial. The Dalai Lama is accompanied by his long-standing secretary Tenzin Geyche Tethong. Oslo, Norway, December 7, 2001

251
Morning meditation. The Dalai Lama always includes all sentient beings in his prayers, including the people of China, whom he refers to as "my brothers and sisters." This reflects his belief in the global connectedness of humanity and his commitment to the promotion of compassion. Graz, Austria, October 20, 2002

253
During an interview with the author Howard C. Cutler for their *Art of Happiness* series at Lány Castle, the summer residence of the Czech president. In his books, Cutler shows that the Dalai Lama's understanding of happiness is more nuanced and more profound than mere positive thinking. His Holiness understands happiness as a faculty that can be acquired by schooling the mind and engaging in compassionate and ethical practices in pursuit of inner peace. Lány Castle, Czech Republic, June 30, 2002

255
The Dalai Lama and his interpreter Matthieu Ricard in dialogue with members of the European Parliament's Tibet Intergroup. Strasbourg, France, October 23, 2001

256
Backstage at the Fleet Center which seats 19,600 people. Boston, Massachusetts, USA, September 14, 2003

257 top and bottom
After meeting President George W. Bush, the Dalai Lama holds a press conference accompanied by Kasur Lodi Gyaltsen Gyari, his special envoy to the United States and Executive Chairman of the International Campaign for Tibet. To strengthen its position, the Tibetan government-in-exile sends permanent representatives to all the world's centers of power. White House, Washington, D.C., USA, September 10, 2003

258/259
The Dalai Lama during an audience for believers of Mongolian descent. His conviction that every individual has the power to change the course of the world is palpable: "If you believe you are too small to make a difference," he says, "try sleeping with a mosquito in the room." Lány Castle, Czech Republic, July 1, 2002

264/265
The Dalai Lama pondering a sunless day in the Norwegian town of Tromsø, north of the Arctic Circle. Tromsø, Norway, December 5, 2001

266/267
The Dalai Lama enjoying a moment of peace while the author Howard C. Cutler prepares the next interview for his *Art of Happiness* series. Lány Castle, Czech Republic, June 30, 2002

268 top
An airport welcome. Cusco, Peru, May 8, 2006

268 bottom
Representatives of the indigenous Q'ero people, who are thought to be descendants of the Inca, welcoming the Dalai Lama to the Qoricancha Sun Temple. As wittily self-deprecating as ever, the Dalai Lama asks if it is true that llamas are still ritually sacrificed in Peru. Should he be worried, given that he, too, is a Lama? Cusco, Peru, May 8, 2006

269
The Dalai Lama leaves Cusco City Hall after a meeting with the mayor. Cusco, Peru, May 8, 2006

270/271
At the Kofukuji Temple. Nara, Japan, November 5, 2003

272/273
Lunch break. Ise, Japan, November 4, 2003

275
An encounter at the Todaiji Temple. Nara, Japan, November 5, 2003

280/281
Memorial service at the National Cathedral on the second anniversary of the terrorist attacks of September 11, 2001. Among those present is the Dalai Lama. The cathedral was so full that many people simply sat down silently in front of it to demonstrate their compassion. Washington, D.C., USA, September 11, 2003

282
In an anteroom of the Cathedral of St. John the Divine, which was built as a house of prayer for all people. Interreligious dialogue is a matter close to the Dalai Lama's heart. People should not fight each other on grounds of faith, he says. "We are not born as members of a particular religion," he once remarked to the author Franz Alt. For him, all religions are equal and they all lead to the same destination, even if by different routes. All religions, therefore, have a fundamental core in common, which is love. Fostering and cherishing this love, and with it compassion, is an aspiration we all share. New York City, USA, September 20, 2003

283 top
Darshan, or "auspicious sight," in a Sikh temple. The reciprocal experience of seeing and being seen through the divine, is practiced in Hinduism, Buddhism, and Sikhism. Out of respect for Sikh scripture, the Dalai Lama covers his head with a cloth. Gurdwara Rewalsar Sahib, Rewalsar, Himachal Pradesh, India, March 1, 2004

283 bottom
There are now more Chinese than Tibetans living in the cities of Tibet. That is why the Dalai Lama is so interested in the fate of other minorities, in this case the Sámi, whose representatives he has come to meet in snowbound Norway. He especially wants to know how autonomous the Sámi really are. He has called for Tibet to be granted "genuine autonomy" as part of China, so that his people can cherish and preserve their own cultural, religious, and social identity. Tromsø, Norway, December 5, 2001

284/285
On his pilgrimages to Bodh Gaya, the Dalai Lama also visits the local Muslims, whose mosque is located nextdoor to the Buddhist stupa. In Bodh Gaya, in other words, two religions co-exist peacefully alongside each other. Zeya-Oloomul Mosque and Madrasa, Bodh Gaya, Bihar, India, January 16, 2003

286
Cardinal Christoph Schönborn guides the Dalai Lama through St. Stephen's Cathedral in Vienna. His Holiness deems the striving for inner peace more important than membership of any particular religion. Compassion, kindness, and a sense of universal responsibility can all be developed irrespective of religious or philosophical background, he says. Vienna, Austria, May 27, 2012

287
Memorial service at the National Cathedral on the second anniversary of the terrorist attacks of September 11, 2001. The Dalai Lama and Bishop John Bryson Chane praying together. Washington, D.C., USA, September 11, 2003

288/289
No matter where the Dalai Lama is, his day always begins with meditation. "There are only two days a year when you cannot do anything," he says. "One is yesterday, the other tomorrow." Zurich, Switzerland, April 10, 2010

290
Preparations for a teaching at the Palais Omnisports de Paris-Bercy. Paris, France, October 16, 2003

291
On the *khora* (pilgrimage path) of the Tibet-Institut Rikon, accompanied by the Venerable Lama Tenzin Jottotshang. Rikon, Switzerland, August 13, 2005

292/293
Waiting expectantly for the Dalai Lama in front of the "Haus der Religionen." Bern, Switzerland, October 12, 2016

294
In front of St. Stephen's Cathedral. Vienna, Austria, May 26, 2012

295
Addressing the crowd on the Heldenplatz. "A person who does something for someone else should not become smug or expect anything in return. What should matter to them is not the reward but solely the other's happiness," says the Dalai Lama. Vienna, Austria, May 25, 2012

296/297
The Dalai Lama addressing a crowd of 65,000 on the subject of peace and inner happiness. His first appearance in Central Park twelve years earlier had attracted only 5,000 people. Central Park, New York City, USA, September 21, 2003

302 top
"I should dispel the suffering of others, because it is suffering like my own suffering." The Dalai Lama is fond of quoting these words from Shantideva's *The Bodhicaryavatara*, and they inform his actions, too. Frankfurt, Germany, May 14, 2014

302 bottom
Kursaal, Bern, Switzerland, October 13, 2016

303
Tibet-Institut Rikon. Rikon, Switzerland, April 8, 2010

304
Interview with Amira Hafner-Al Jabaji as part of the "Sternstunde Religion" series by Swiss public broadcaster SRF 1. Kursaal, Bern, Switzerland, October 12, 2016

305
Visit to Switzerland. Zurich, Switzerland, October 13, 2016

306
Nueden Taksham, born in Switzerland as the 9th Shiwalha Rinpoche and educated at the monastery in exile in India, recently shed his robe and left the monastery. Here, he asks His Holiness to understand his decision, to which the Dalai Lama replies: "It doesn't matter what clothes you wear. What matters is that you lead a meaningful life." Kongresshaus, Zurich, Switzerland, April 9, 2010

307
Arrival in Hamburg, Germany, July 19, 2007

308
The German state of Hesse accords the Dalai Lama the highest honors. Frankfurt, Germany, July 13, 2015

309 top
There are eight thousand Tibetans living in Switzerland. Here, a delegation dances and sings to traditional Tibetan music for the Dalai Lama. Zurich, Switzerland, June 22, 2024

309 bottom
The Dalai Lama's journey continues. Tibetans gather in front of the hotel in the early hours of the morning to bid him farewell. Zurich, Switzerland, August 26, 2024

310/311
The stadium is still empty, but the Dalai Lama is already preparing for the *Rigzin Dungrup* Empowerment. The aim is to strengthen the bond with the practitioner's spiritual teacher and to develop the capabilities of a "knowledge holder" so that he or she can support others on the path to enlightenment. Zurich, Switzerland, August 11, 2005

312
A crowd of 15,000 people has gathered to hear the Dalai Lama's teaching and to be present at a Long Life Ceremony. Hallenstadion, Zurich, Switzerland, August 25, 2024

313
Long Life Ceremony. Hallenstadion, Zurich, Switzerland, August 25, 2024

314/315
The Dalai Lama teaching. Hallenstadion, Zurich, Switzerland, August 25, 2024

316, 320 bottom
An audience with the Dalai Lama. Dharamsala, Himachal Pradesh, India, May 15, 2024

317, 318, 320 top, 321 top and bottom
An audience with the Dalai Lama. Dharamsala, Himachal Pradesh, India, November 8, 2024

322/323
The Dalai Lama receives a delegation of Buddhist monks and nuns from Vietnam. Dharamsala, Himachal Pradesh, India, November 8, 2024

328/329
Rizong Rinpoche and the Dalai Lama read and discuss a text dating from the 5th century written by Arya Asanga, one of India's great Buddhist thinkers. The Dalai Lama knows the text well, but tradition demands that Rizong Rinpoche recite it to him. Study, the Dalai Lama's residence, Dharamsala, Himachal Pradesh, India, August 15, 2004

331
Reading before lunch. Despite the many wars and disasters, the Dalai Lama remains fundamentally optimistic and does not see pandemics like SARS and Covid as a sign that disease in general is on the rise: "While some ancient Tibetan texts suggest that the outbreak of epidemics is a sign of an era in decline," he says, "I do not trust such predictions, and do not lend much credence to them." The Dalai Lama's residence, Dharamsala, Himachal Pradesh, India, May 18, 2003

333
Notwithstanding his great age, the Dalai Lama still refers to himself as a "student." He never tires of adding to his knowledge and enjoys poring over texts he knows well for new insights. The Dalai Lama's residence, Dharamsala, Himachal Pradesh, India, May 18, 2003

334
Prayer texts. The Dalai Lama's residence, Dharamsala, Himachal Pradesh, India, August 15, 2004

335
Sunday lunch. The Dalai Lama's residence, Dharamsala, Himachal Pradesh, India, May 18, 2003

336/337
Visit to Thupten Dorje Drak Ewam Chogar Chökhor Namgyal Ling Monastery. The Dalai Lama enjoying some moments of peace during a break. Kasumpti, Shimla, Himachal Pradesh, India, June 16, 2002

338/339
His physician urged him to offset the many hours he spends meditating by exercising on a treadmill, says the Dalai Lama. Whereas initially, he regarded those 15 minutes a day as a waste of time, he soon noticed that he could put the time to good use by praying for all sentient beings. The Dalai Lama's residence, Dharamsala, Himachal Pradesh, India, August 15, 2004

340/341
Early morning on the balcony of his residence. Dharamsala, Himachal Pradesh, India, May 18, 2003

343
Half past five in the morning at Tawang Monastery. The Dalai Lama calls his own meditation practice "analytical." His aim is to scrutinize his own motivation for compassion and to transform negative into positive emotions. "On waking up every morning, I remind myself that I am no different from anyone else: We all want to be happy. I am therefore using my life to ensure that others are happy. It is not anger and hatred but compassion that brings us peace." Arunachal Pradesh, India, May 8, 2003

345, 347, 349
The Dalai Lama is believed to be the manifestation of Chenrezig (avalokiteshvara), the Bodhisattva of Compassion. Bodhisattvas have achieved enlightenment, but choose to be reborn that they may support others. Bodhisattvas will pass into Nirvana only when all the world's sufferings have been eradicated. For those still on the path to enlightenment, therefore, the Dalai Lama has the following message: "On waking up every day, remind yourself: Today I have the good fortune to be alive. I am in possession of a precious human life and I shall not squander it. I shall devote all my energies to developing myself and opening my heart to others, and so achieve enlightenment for the benefit of all." The Dalai Lama's residence, Dharamsala, Himachal Pradesh, India, August 16, 2004

Captions

༈ རྗེ་སྲིད་ཟམ་མཁན་གནས་པ་དང་། །
འགྲོ་བ་རྗེ་སྲིད་གནས་གྱུར་པ། །
དེ་སྲིད་བདག་ནི་གནས་གྱུར་ནས། །
འགྲོ་བའི་སྡུག་བསྔལ་སེལ་བར་ཤོག །

Calligraphy penned by Shiwalha Rinpoche Nueden Taksham,
the 9th reincarnation of Shantideva.

The principle frequently cited by the 14th Dalai Lama as underpinning his work is drawn from the works of the Buddhist scholar Shantideva (685–763 A.D.):

"As long as space abides and as long as the world abides, so long may I abide, destroying the sufferings of the world."

Shantideva
The Bodhicaryavatara, Chapter 10, Verse 55

Śāntideva, *The Bodhicaryāvatāra,* translated by Kate Crosby and Andrew Skilton, Oxford University Press, 1995

Gaden Phodrang Foundation of the Dalai Lama
Beautifully photographed by Manuel Bauer and enriched by profound essays by Thupten Jinpa, this photo book presents His Holiness the Dalai Lama as a global ambassador for peace, a source of hope for the Tibetan people, and in private moments. With this publication, the Gaden Phodrang Foundation of the Dalai Lama invites readers to explore His Holiness's lifelong commitment to promoting basic human values, interfaith harmony, and the preservation of Tibetan culture and the environment—causes that the Foundation actively supports. This work should serve as a reminder of our shared humanity and inspire us to cultivate compassion and warmth in our daily lives.
www.dalailamafoundation.org

Thupten Jinpa is an internationally known Buddhist scholar and former Tibetan monk. He has been the principal English translator to His Holiness the Dalai Lama since 1985, has traveled with him extensively, and has assisted him on numerous books, including the *New York Times* bestsellers *Ethics for the New Millennium* and *The Art of Happiness*. Jinpa's own publications include works in Tibetan as well as English translations of major Tibetan texts such as *A Fearless Heart: How the Courage to be Compassionate Can Transform Our Lives* and *Tsongkhapa: A Buddha in the Land of Snows*. Jinpa is a noted speaker on the dialogue between Buddhism and science, secular adaptations of mindfulness, and compassion practices. He is a co-founder and president of the Compassion Institute, Chair of the Mind & Life Institute, founder of the Institute of Tibetan Classics, and an adjunct professor at the School of Religious Studies at McGill University. Jinpa lives in Montreal and is married with two daughters.

Manuel Bauer is a Swiss photographer, book author, cameraman, and lecturer in photojournalism. He creates long-term reportages about social justice and the environment, and has received international awards such as World Press Photo and Picture of the Year. He has been documenting the life of the 14th Dalai Lama since 1990. He was the only photographer to date to accompany Tibetans on their perilous escape across the Himalayas in 1995. For ten years, he was involved in the village of Sam Dzong in Mustang. When it had to be abandoned owing to climate change, Bauer helped the climate refugees build a new village. He is the co-author and cameraman of the documentary *Wisdom of Happiness—A Heart-to-Heart with the Dalai Lama*. He is also the founder of TruePicture, a talent development program for photojournalism.

Christian Schmidt is a freelance author and journalist in Zurich. He writes for *Reportagen*, *Das Magazin*, *Geo*, and *Greenpeace*, among others. Schmidt was twice awarded the Hansel-Mieth-Preis for journalism and in 2007 won the Zürcher Journalistenpreis. He was shortlisted for the Schweizer Reporterpreis and Zürcher Journalistenpreis in 2019 and for the Reporter-Forum Schweiz in 2020. He and Manuel Bauer travel all over the world for their work. In 2004 Schmidt conducted a series of interviews with the Dalai Lama for Manuel Bauer's photo book *Journey for Peace*. His 2009 book *Exil Schweiz. Tibeter auf der Flucht—12 Lebensgeschichten* was also produced in collaboration with Manuel Bauer.

Acknowledgements

Sincere thanks go to the secretaries Tenzin Geyche Tethong, Tenzin Namdhak Taklha, and Tseten Samdup Chhoekyapa for opening so many closed doors for me. I would also like to thank Kelsang Gyaltsen, Tempa Tsering, Ngodup Dongchung, and Tenzin Sewo for their openness and valuable support.
A knowing thank you goes to Tendzin Choegyal for all the laughter we shared on the road. I am also grateful to Tenzin Choejor and Don Eisenberg for their expertise and the pleasure of working with them. I would also like to thank the Dalai Lama's chamberlains for extending to me such cordiality and warmth, and the Dalai Lama's bodyguards for allowing me to work in such close proximity to him.

Thanks are also due to Andreas Reinhart and the Volkart Stiftung for having supported my work for so many years.
Ritu Sarin and Tenzin Sonam: You took me under your wing right at the start, for which I am deeply grateful.
Tashi Albertini-Kaiser: Thank you for all the good that you do.
Shiwalha Rinpoche Nueden Taksham: I treasure your friendship and your wise counsel.

Most of all, I would like to thank His Holiness Tenzin Gyatso, the 14th Dalai Lama, for the great gift and privilege of being able to create these photographs and with them an eye-witness record of history as it unfolds.

Sponsors

Manuel Bauer, the Gaden Phodrang Foundation of the Dalai Lama, and the publishing house Scheidegger & Spiess are deeply grateful for the generous financial support extended to them by the following individuals and institutions:

Monlam & Hanspeter
Maurer-Adotsang

Dr. h. c. Kaspar M. Fleischmann,
Rüschlikon

Hamasil Stiftung

Sabine Sauter

FPC-Tibet

Foundation for the Preservation of the Culture of Tibet
and for the Promotion of Intercultural Exchange

Imprint

Concept:	Manuel Bauer
Editor:	Gaden Phodrang Foundation of the Dalai Lama
Texts:	Thupten Jinpa
Captions:	Christian Schmidt
Selection of photographs:	Manuel Bauer, Clemens Widmer, Thomas Kramer
Translation of the captions:	Bronwen Saunders, Basel
Copy editing and Proofreading:	Bronwen Saunders, Basel
Design:	Clemens Widmer, Zurich
Scans and image processing:	Christian Spirig, Bilderbub GmbH
Pre-press:	DZA Druckerei zu Altenburg, Thüringen
Printing and binding:	Gugler Medien GmbH, Melk/Donau

© 2025 Manuel Bauer, Winterthur, and
Verlag Scheidegger & Spiess AG, Zurich

© for the photographs: Manuel Bauer / Agentur Focus / Fotostiftung Schweiz
© for the texts: Thupten Jinpa
© for the captions: Christian Schmidt

Verlag Scheidegger & Spiess AG
Niederdorfstrasse 54
8001 Zurich
Switzerland
www.scheidegger-spiess.ch
+41 44 262 16 62
info@scheidegger-spiess.ch

Product safety
Responsible person pursuant to EU Regulation
2023/988 (GPSR):
GVA Gemeinsame Verlagsauslieferung
Göttingen GmbH & Co. KG
Post Box 2021
37010 Göttingen
Germany
+49 551 384 200 0
info@gva-verlage.de

Scheidegger & Spiess is being supported by the
Federal Office of Culture with a general subsidy
for the years 2021–2025.

All rights reserved; no part of this publication may be
reproduced, stored in a retrieval system or transmitted
in any form or by any means, electronic, mechanical,
photocopying, recording, or otherwise, without the prior
written consent of the publisher.

English edition:	ISBN 978-3-03942-238-8
German edition:	ISBN 978-3-03942-237-1
French edition:	ISBN 978-3-03942-272-2